ANDY WARHOL

LEONARDO DA VINCI

PAUL GAUGUIN

PAUL CÉZANNE

BOB DYLAN

ART & LANGUAGE

VINCENT VAN GOGH

THE
THE

LIFE & WORK

ART AND BIOGRAPHY

EDITED BY CHARLES G. SALAS

PUBLISHED BY THE GETTY RESEARCH INSTITUTE

The Life and the Work: Art and Biography
Edited by Charles G. Salas
Diane Mark-Walker and Libby May, *Manuscript Editors*
Diane Mark-Walker, *Production Editor*

This volume evolved from two conferences tied to the Getty Research Institute's 2002/2003
Scholar Year on the theme "Biography."

© 2007 The J. Paul Getty Trust
Published by the Getty Research Institute, Los Angeles
Getty Publications
1200 Getty Center Drive, Suite 500
Los Angeles, California 90049-1682
www.getty.edu

Printed in China

11 10 09 08 07 5 4 3 2 1

Library of Congress Cataloging-in-Publication Data
The life and the work : art and biography / edited by Charles G. Salas.
 p. cm.
 Includes bibliographical references and index.
 ISBN 978-0-89236-823-5
 1. Creation (Literary, artistic, etc.) 2. Subjectivity in art. 3. Authorship. 4. Art criticism.
I. Salas, Charles G. II. Getty Research Institute.
 N71.L54 2007
 700.1–dc22
 2006038677

Contents

Acknowledgments vi

Introduction: The Essential Myth? 1
Charles G. Salas

Who Comes after the Subject? 28
Rosalind Krauss

Leonardo's Modernity: Subjectivity as Symptom 34
Robert Williams

Paul Cézanne's Primitive Self and Related Fictions 45
Paul Smith

Biography, Brush, and Tools: Historicizing Subjectivity; 76
The Case of Vincent van Gogh and Paul Gauguin
Debora L. Silverman

Partial Accounting: Art & Language 97
Charles Harrison

Lives of Allegory in the Pop 1960s: Andy Warhol and Bob Dylan 108
Thomas Crow

Biographical Notes on the Contributors 150

Illustration Credits 152

Index 156

Acknowledgments

The theme of the Getty Research Institute in 2002/2003 was "Biography," and this book is comprised of essays presented at two symposia during that year. Rosalind Krauss, Debora Silverman, Paul Smith, and Robert Williams participated in the "Art History and Biography" workshop in January 2003 developed with the Clark Art Institute's Research and Academic Programs. Thomas Crow and Charles Harrison gave versions of their essays three months later in Cambridge at the conference "Biographical Knowledge" sponsored by the Research Institute together with the University of Cambridge's Centre for Research in the Arts, Social Sciences, and Humanities. So special thanks are due to the Clark's Michael Ann Holly and the Centre's Ian Donaldson. Thanks also go to the more than thirty scholars who were in residence at the Research Institute during the "Biography" year. The idea for this book stemmed from what they said—and didn't say. In fact, relations between the artist's life and the artist's work were seldom confronted. Followers of Barthes were adverse to the matter, while others, focused on different issues, saw little that could profitably be said. The general feeling was that the biographer who took the path between life and work, espying connections overhead, risked falling into fallacies of various sorts and twisting a scholarly knee or (if deemed hopelessly old-fashioned) fracturing a scholarly career. Concern about reading life and work through each other has a long history, and I've attempted to provide a selective overview in the introduction, relying heavily on quotations rather than paraphrase so as to give voices their due and not drain the life from the language. I'm grateful to Thomas Crow, William L. Fox, Charles Harrison, Roberta Panzanelli, Michael S. Roth, and Marianne Perry Salas for their comments on that attempt. I'm grateful, also, to manuscript editors Libby May and Diane Mark-Walker for their close attention to detail and useful suggestions. Diane went well beyond the call of duty and proved an extremely helpful interlocutor. Michele Ciaccio and Jannon Stein did some heroic behind-the-scenes work, carrying out meticulous fact-checking and tracking down many of the illustrations, and Catherine Lorenz proved herself both creative and flexible in arriving at design solutions. Thanks also go to Julia Bloomfield for keeping watch over the publication in her inimitable fashion, and to Gail

Feigenbaum, who upon hearing my convoluted proposal for an as-yet-untitled book on the life and the work, responded, "Just call it *The Life and the Work.*" Sometimes the obvious is best. So too with the life and the work. It is pointless to deny that the life can shape the work and in turn be shaped by it. Even my desire to assemble this volume, as I think about it, resonates with my own past. Mathematics is one field where the life is generally deemed irrelevant to the work, yet, having collaborated for many years with my father, S. L. Salas, I have been struck by how his clear and elegant presentation of the calculus (familiar to well over a million students by now) has been shaped and colored by the man he is. And so, I'm pleased to exercise my prerogative as editor and dedicate this book to him.

— Charles G. Salas

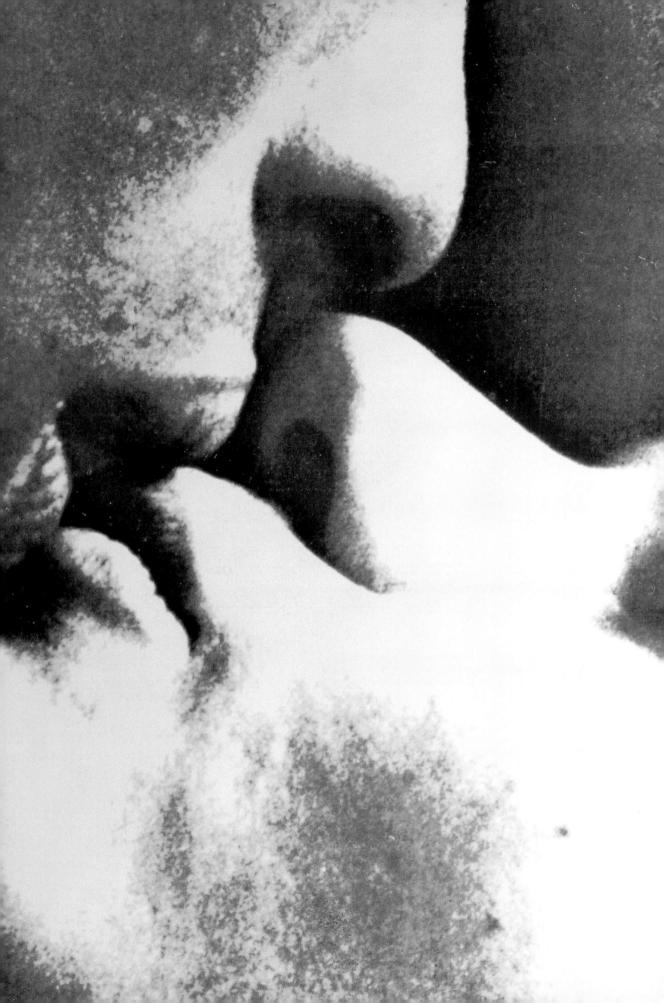

CHARLES G. SALAS

THE STYLE IS THE MAN

THE ESSENTIAL MYTH

Cause and effect. Creator and creation. With paired terms like these, each term implies the other. A creation implies a creator, a painting a painter.[1] We may not always know the painter's name, but when we do, we attach it to the painting. A name, in turn, is attached to a life, and the question of how that life is connected to the work naturally arises.[2] The more we know about an artist's life and work, the more possibilities there are for finding connections between them. An age-old assumption is that something of the artist's nature lies in the work. "Every painter paints himself," the proverb goes, too ambiguous and regulatory (not to mention sexist) for our purposes, except as a provocation.[3] For if painters do paint themselves, then paintings say something about painters. But what? A dark painting may indicate that the painter was evil (Caravaggio?) or despairing (Mark Rothko?) or just that the painter was exploring the physical properties of dark paint. As we shall see, the problematic examples of Caravaggio and Rothko point to just how strong the desire to find connections between "the style" and "the man" can be. Such connections—and the desire to find them—are what this volume is about.

In the essays here, you will find that Vincent van Gogh registers feeling in the thickness of paint; that Leonardo da Vinci privileges sight, fashioning himself into a mirror of nature; that Paul Cézanne paints as he sees *and* feels. Where Émile Zola looks in a painting "above all for a man, not a picture," Andy Warhol fuses the two: "Just look at the surface of my paintings and films and me, and there I am," he tells us, "there's nothing behind it." There is nothing behind anyone save language, say theorists, making attention to artists' lives *in theory* beside the point. But in the art world, attention to the individual life is part and parcel of career building, and a number of artists submit to the use of the collective name Art & Language to evade the specifically individualistic form of careerism characteristic of late modernism.

Figure 1
Andy Warhol (American, 1928–87)
Kiss (detail), 1965, screenprint
on Plexiglas, 160 × 108.3 cm
(63 × 42 ⅝ in.)
Pittsburgh, Andy Warhol Museum

The life-and-work model has long been part and parcel of humanistic disciplines, nowhere more so than in art history.[4] Despite claims by theorists that an unbridgeable gulf exists between artist and artwork, bridges continue to be built, though how much weight they can bear is an open question. As Debora Silverman puts it in her essay here: "The exploration of 'the life and the work' requires a continuous move back and forth from cultural formation to stylistic practices and technical procedures, from biography to brush and tools." Most would agree that it is the quality and quantity of the observations carried back and forth that determine the success of that exploration.

Bridging the gap between work and life (be it the artist's intention, personality, experience, or social location) is one way of describing our biographical problem. There are many ways in which the work and the life are said to stand in relation to or act upon each other. Citing only the historians and critics referred to in the following pages, we find that the work is an *index to* or *marked by the imprint of* the life; that it can be a *projection, transmutation,* or *key to the mysteries of* the life; that it *opens onto, reflects, reveals, illuminates, embodies,* or *expresses* the life. We find that the life is *present, visible, sealed,* and *buried* in the work; that the life is *of a piece with* or *shapes the meaning of* the work. We find that the life and the work *harmonize, overlap, dovetail;* that the life and the work are *imbricated, slightly peripheral, interfused, interpenetrating, interfertile, intertwined, bonded, divorced,* or *parallel;* that they are *correlated variables;* that they *exist in dynamic communion;* that they are *in proximity* or have *shifting borders.* The rich diversity of these descriptions would be daunting if we were seeking to either resolve the life-and-work problem or close it off altogether. The problem admits no general solution; nor will it go away. This introduction offers a cursory look at observations over the centuries on this issue—at times disarmingly simple, at times inexhaustibly complex.

————————

> For the invisible things of him from the creation of the world are clearly seen, being understood by the things that are made.
> — Paul[5]

This foundational notion that the creator is to be understood (to some degree) by the creation was famously targeted by Roland Barthes in *S/Z* (1970):

> The *author* is always supposed to go from signified to signifier, from content to form, from idea to text, from passion to expression; and, in contrast, the *critic* goes in the other direction, works back from signifiers to signified. The *mastery of meaning,* a veritable semiurgism, is a divine attribute, once this meaning is defined as the discharge, the emanation, the spiritual effluvium overflowing from the signified toward the signifier: the *author* is a god (his place of origin is the signified); as for the critic, he is the priest whose task is to decipher the Writing of the god.[6]

Followers of Barthes viewed this kind of decipherment as impossible, thus freeing them to search for meanings in the text regardless of what the author meant to say. The anti-authorial argument, in brief, went as follows: Language is not a window on the world; it constitutes the world; it is not the self that controls language but language that controls the self (the self is no longer objectively rational and self-determined; the self is now other-determined, constituted by language); texts belong to language, not to authors; the author is merely a channel through which language speaks, not a god-like source guaranteeing the unity of the work. Art theorists were quick to take Barthes on board. As the critic Thomas McEvilley put it:

> In our time, Roland Barthes expressed the impersonality of semiotic trans-actions as "the death of the Author": it is not an individual who speaks, he said, but Language that speaks through the individual. In the same sense, it is not the individual who makes images, but the vast image bank of world culture that images itself forth through the individual. That image bank (like language) can be viewed as a vast transpersonal mind aimlessly and relent-lessly processing us through its synapses.[7]

If it is not the individual who makes images, why pay attention to the indi-vidual life? Attention should be paid to how the work is received, not its origin in the artist's putative self. This idea of the self as constituted by language was a far cry from the traditional idea of the unified and coherent (and perhaps ensouled) self that was naturalized in classical political economy, and this was part of the point. Hostility to the author/artist as god-like source was part of a broader hostility to patriarchal, bourgeois society and its liberal-humanist subject. In this atmosphere, building bridges between the work and the (now destabilized) life seemed both tenuous and politically tendentious.[8]

The story of the death of the author at the hands of Barthes, Michel Foucault, and Martin Heidegger is reviewed by Rosalind Krauss in the open-ing essay of this volume. Perhaps the most prominent literary critic to pro-pound such "deconstructionist" ideas in the 1960s and 1970s was Paul de Man, who denied that there was any relationship of interest between a writer's work and life. When later it was discovered that de Man had been concealing his anti-Semitic background, critics did not fail to notice that his undermining of humanist terms like *self, intention,* and *responsibility* harmonized rather well with his own reprehensible past. And Heidegger, who supposedly claimed that there was nothing of interest about Aristotle except his ideas—"He was born. He lived. He died."[9]—had been a Nazi with good reason to prefer his ideas to be judged independently of his life. As for Foucault, his sadomasochistic homoeroticism has often been linked to his ideas on discipline, power, and the self. It is worth noting that these three thinkers, who contributed so much to the severing of life and work *in theory,* have (fairly or not) had their own lives brought back into consideration of their ideas.

We should not be surprised that thinkers so hostile to the pillars of Western society—individualism, science, and commercial culture—would have enemies who took delight in discrediting their ideas based upon biographical details. It need hardly be said that such attacks are often reductionist, in the most vulgar way, that they fall prey to the genetic fallacy (because Heidegger

was a Nazi, his later ideas must be Nazi-like), or that they simply assign guilt by association. Still, the point here is how easily the life can come back to haunt the work, though it need not do so.

Judging the soundness of an assertion based upon the qualities of its source can be a powerful, if fallacious, rhetorical tool. Discrediting an idea by discrediting the person offering it (the ad hominem argument) and praising a work based on the positive qualities of its creator (the appeal to authority or argumentum ad verecundiam) are logical fallacies not infrequently committed by those who make connections between life and work—from critics with political axes to grind to dealers with expensive paintings to sell.

Philosophers have traditionally taken the position that ideas—pure in themselves—should be kept aloof from the messiness of personal lives. But in recent years a number of biographies of philosophers have questioned this stance. Danny Postel asked philosophers Michael Krausz and Alexander Nehamas their views on "the life and the mind," and their responses mutatis mutandis go to the heart of our problem.[10] Krausz indicated to Postel that philosophers have become more impressed by "historicist notions like the rootedness of the self and the social embeddedness of consciousness," from which, Krausz held, it is a "'quick step to including the life story of the creator in order to understand the nature of the work.'" For Nehamas, "the relevance of a philosopher's life depends on the nature of his thought":

> Kant's biography, for example, reveals "what was bothering him at particular times and therefore what caused him to take up certain issues," says the Princeton professor, but it "doesn't explain the view that he held on the issue." Because Kant's philosophy was abstract and systematic—dealing, for example, with questions about the horizons of human knowledge and the nature of aesthetic judgment—his ideas are "quite independent" of his particular personality. The personalities of Nietzsche and Foucault, on the other hand—thinkers who addressed themselves in a highly visceral style to the human condition—are so essential to their writing that "they make it pretty impossible for you to forget that it's their ideas."[11]

> It is impossible for one to become a good poet unless he has previously become a good man.
> — Strabo[12]

The idea that the artist's life corresponds in some way to the work is an ancient one, and it has been debated for centuries, most vociferously in the realm of poetry.[13] When a biographer of the poet James Thomson observed that "it is commonly held that the life of a good writer is best read in his works, which can scarce fail to receive a peculiar tincture from his temper, manners, and habits," and that this was particularly true for Thomson, the critic Samuel Johnson judged the observation "not well-timed." Johnson explained that:

Savage, who lived much with Thomson, once told me, how he heard a lady remarking that she could gather from his works three parts of his character, that he was a "great lover, a great swimmer, and rigorously abstinent"; but, said Savage, he knows not any love but that of the sex; he was perhaps never in cold water in his life; and he indulges himself in all luxury that comes within his reach.[14]

The notion that "the life of a good writer is best read in his works" soon found a champion in William Wordsworth, who viewed the poet as a man who "rejoices more than other men in the spirit of life that is in him…[and] has acquired a greater readiness and power in expressing what he thinks and feels."[15] This expressive theory of art contributed to the heroization of the poet and to the belief in the correspondence of life and work. Thomas Carlyle observed in 1827 that the question "usual with the best of our own critics at present is a question mainly of a psychological sort, to be answered by discovering and delineating the peculiar nature of the poet from his poetry."[16] A century later, this question was judged juvenile by T. S. Eliot, who saw the mind of the mature poet as the catalyst whose presence produces poetry (new compounds of feelings and emotions) but is not itself present within that poetry. The work has emotion, but that emotion is best thought of as impersonal.[17] C. S. Lewis, too, was appalled by the *still* commonly held notion that "the end which we are supposed to pursue in reading [poetry] is a certain contact with the poet's soul; and 'Life' and 'Works' are simply two diverse expressions of this single quiddity."[18] Lewis maintained that "when we read poetry as poetry should be read, we have before us no representation which claims to be the poet, and frequently no representation of a *man,* a *character,* or a *personality* at all."[19] Aware that the problem of the life and the work—in *all* its aspects—might be irresolvable, Lewis nevertheless insisted that:

> the poet is not a man who asks me to look at *him;* he is a man who says "look at that" and points; the more I follow the pointing of his finger the less I can possibly see of *him.* … To see things as the poet sees them I must share his consciousness and not attend to it; I must look where he looks and not turn round to face him; I must make of him not a spectacle but a pair of spectacles.[20]

It is a powerful passage, but Lewis is not quite so resolute as it suggests. In his debate with E. M. W. Tillyard, Lewis conceded that the life could, in fact, make for an interesting spectacle and that much could be learned about the life from the work—while holding fast to the notion that the life is not critically relevant.[21] Lewis's distinction between what is *interesting* and what is *critically relevant* suggests the distinction (often moot) between history and criticism. In art history, as we shall see, life and work can be treated as separate spectacles and exist side by side as they do in many monographs, or each can serve as a lens (or "pair of spectacles") through which to examine the other.

René Wellek and Austin Warren, in their *Theory of Literature* (1949), cautioned those who might still wish to read the life from the work that "a work of art may rather embody the 'dream' of an author than his actual life, or it may be the 'mask,' the 'anti-self' behind which his real person is hiding, or it may

be a picture of the life from which the author wants to escape."[22] Caution about reading the work through the life received an analytical boost with the publication of William K. Wimsatt Jr. and Monroe C. Beardsley's article "The Intentional Fallacy" (1946), which launched a textualist/formalist movement known as New Criticism. "The design or intention of the author is neither available nor desirable as a standard for judging the success of a work of literary art," stated Wimsatt and Beardsley.[23] The psychology of creation may be private, but evaluation is public. Internal evidence (in the sense of its semantics and syntax, that is to say, at the level of *poem*) is public and hence the proper focus of critical inquiry. External evidence, such as information about the life, is to be eschewed.[24]

David Summers has written that the Wimsatt-Beardsley dismissal of evidence external to the work (such as the author's intentions) made "many of the assumptions about art afoot in those days, assumptions that may explain why these arguments were readily transferable to the discussion of the visual arts." As Summers puts it:

> If the work of art is truly cut loose from intention, then art becomes autonomous. Such autonomy is a familiar theme in modernism. Matisse painted to find out what he would paint, Jackson Pollock named his paintings after he had finished them, and Barnett Newman decided he was painting the stations of the cross only after he had finished four or five paintings in the series. On the historical side, the rejection of intention implies a formalist or phenomenological history, that is, history concerned with the transformation of visual elements or a history of the evident qualities of objects and images.[25]

The anti-intentionalist position supported the formalist's rejection of any biographical overlap that might interfere with the visual life of the work. The formalist critic Clement Greenberg objected to overlap of any kind, insisting that:

> better sense can be made of art, justice can be done to the experience of art *qua* art, if it is dealt with as autonomous, as being abstracted from all political, social, economic, or religious or moral issues or factors. That is, if art, so to speak, is dealt with in a vacuum. I know, that is horrendous—we're not supposed to do that. All the while we realize, of course, that art doesn't take place in a vacuum.[26]

In the realm of poetry, R. W. Stallman used the phrase "best artist" to make the Wimsatt-Beardsley case for the autonomy of art prescriptive:

> Once the work is produced, it possesses objective status—it exists independently of the author and of his declared intention. It contains, insofar as it is a work of art, the reason why it is thus and not otherwise. The difference between art and its germinal event is absolute. The best artist constructs his work in such a way as to admit of no interpretation but the single intended one; its single [intention] being a single effect, one over-all meaning, one composite theme. All parts of the work of art are, ideally, relevant or func-

tional to the whole. Irrelevant to the objective status of the work *as* art are
criteria which dissolve the work back into the historical or psychological
or creative process from which it came.

Stallman concluded à la Wimsatt and Beardsley that: "No judgment of inten-
tion has relevancy unless corroborated by the work itself, in which case it is
supererogatory."[27]

E. D. Hirsch was arguably the most notable critic of the Wimsatt-
Beardsley position and its ramifications. Hirsch judged that the anti-
intentionalist movement in aesthetics, which dealt with evaluation, was hav-
ing negative ramifications for historians interested in the excavation of
meaning.[28] Wimsatt and Beardsley had ended their article by stating that
were Eliot himself to say what it was that his poem meant, even that would be
irrelevant because "critical inquiries are not settled by consulting the oracle."[29]
Eliot, in fact, always did refuse to say what his poems meant, but, noted
Hirsch, "Eliot never went so far as to assert that he did not mean anything in
particular by his writings. Presumably he did mean something by them, and
it is a permissible task to attempt to discover what he meant."[30] Hirsch was
reacting, two decades after Wimsatt and Beardsley, to the New Critics' move
away from the life, toward the work, to the point where the work was autono-
mous and its meaning whatever it meant to the critic. Hirsch found that the
Wimsatt-Beardsley position had been vulgarized into the "popular version
which consists in the false and facile dogma that what an author intended is
irrelevant to the meaning of his text."[31] What critics like Eliot had said poetry
should be "became subtly identified with a notion of what all poetry and
indeed all forms of literature necessarily must be."[32] While Hirsch sympa-
thized with the attack on "the post-romantic fascination with the habits, feel-
ings, and experiences surrounding the act of composition," and while he
found beneficial the shift toward exegesis, he insisted that "no logical neces-
sity compels a critic to banish an author in order to analyze his text."[33]

Despite such objections, the trend in criticism toward depersonalization
accelerated in the sixties and seventies, fueled by the popularity of theory.
It was a short trip from the artistic persona (of the New Critics) to the *on dit*
(it is said) of Foucault and from the autonomy of art to the anonymity of dis-
course.[34] Jacques Derrida was taken for a time to be the high priest of anti-
intentionalism, but as with previous attempts to drain entirely the life from
the work, logic compelled a retreat. In Seán Burke's reading of Derrida, "inten-
tion is to be recognised, and respected, but on condition that we accept that
its structures will not be fully and ideally homogenous with what is said or
written."[35] After all, how could deconstruction of authorial intention take
place unless there were some conception of what that intention was? Even for
Derrida, the author (subject) isn't so much dead as "situated." Of course, if
this meant that all authors/artists were constituted more or less the same, the
examination of particular lives would hold little interest. But as Burke reminds
us, "If the author is the site of a collision between language, culture, class, his-
tory, *épistémê,* there is still every reason to assume that the resultant subject
should be constructed in each case differently, the psyche thus forged being
irreducible to any one of those forces in particular."[36] The critic of critical

theory, then, may choose to read a text in light of its author or treat it as purely textual.[37] Put another way, the question of the life and the work survives even in realms declared hostile to it.[38]

————

> Every painter paints himself.
> — Proverb

Interest in the relationship between the life and the work has been central to (and problematic for) the practice of art history since the publication of Giorgio Vasari's *Le vite de piu eccellenti architetti, pittori, et scultori* (Florence, 1550). There Vasari declares:

> I have striven not only to say what these craftsmen have done, but also, in treating of them, to distinguish the better from the good and the best from the better, and to note with no small diligence the methods, the feeling, the manners, the characteristics, and the fantasies of the painters and sculptors; seeking with the greatest diligence in my power to make known, to those who do not know this for themselves, the causes and origins of the various manners and of that amelioration and that deterioration of the arts which have come to pass at diverse times and through diverse persons.[39]

But Vasari's actual biographical practice shows that, rather than mediate between life and work, he often made the one conform to the other. Philip Sohm makes the point that "Vasari wants us to believe that art imitates life—that because Spinello [Aretino] was mugged he therefore painted figures shying away—but actually he often made life conform to art." "[Andrea del] Castagno never murdered Domenico Veneziano," Sohm writes, "but as a story it allowed Vasari to polemicize the artistic contest between Florence and Venice, to trace the genealogy of oil painting, and to explain why Castagno painted in a 'crude and harsh' style."[40]

Another painter known for being crude and harsh in life as in painting was Caravaggio, and his is an instructive example. Caravaggio's sixteenth-century biographer, Filippo Baldinucci, suggested that the artist fashioned his own artistic persona by inserting his portrait into his paintings and by painting in a way that would confirm the proverb that "every painter paints himself."[41] And the seventeenth-century critic Giovanni Pietro Bellori claimed that Caravaggio's dark appearance and turbulent temperament were reflected in his dark way of painting.[42]

It is with writers like Vasari, Baldinucci, and Bellori that the cult of the individual artist begins.[43] The cult becomes fervent with romanticism, which emphasized the emotional, the personal, and the subjective. For John Ruskin, writing in 1846, the correspondence of life and work in artists like Caravaggio, who were morally *and* artistically bad, was to be expected: "There is in all works of such men a taint and a strain, and jarring discord, darker and louder exactly in proportion to the moral deficiency." Ruskin went to the extreme of binding Caravaggio's choice of colors to his personality, stating baldly that

"vulgarity, dulness, or impiety, will indeed always express themselves through art in brown and grey."[44]

By the mid-twentieth century, such Ruskinian excesses (castigated by Eliot and others) had made art historians wary of arguing from work to life and from life to work, though the temptation with an artist like Caravaggio always remained.[45] Walter Friedlaender reconstructed an image of Caravaggio as an observant, melancholic youth from the spirit of the early paintings,[46] while Rudolf Wittkower saw in Caravaggio's works an "unbalanced personality, oscillating between narcissism and sadism."[47] In the 1960s, Caravaggio's life continued to be read from his work, with *Boy Bitten by a Lizard* (1595–1600; London, National Gallery) taken as evidence of his homosexuality. Donald Posner subsequently argued (this time from life to work) that Caravaggio's homosexual proclivities had been a necessary condition for the creation and development of his early paintings.[48] Following on the speculation about sexuality came psychoanalysis. Howard Hibbard associated Caravaggio's penchant for portraying severed heads with symbolic castration, suggesting that the painter "unconsciously feared punishment for sexual thoughts or deeds."[49] Perhaps the most famous of these particular paintings, *David with the Head of Goliath* (1609–10; Rome, Galleria Borghese), was featured in the exhibition *Caravaggio: The Final Years,* held at the National Gallery in London in 2005. The subject of that exhibition, according to reviewer Ingrid Rowland, was tied to Caravaggio's life: namely, the changes in style "wrought" by his flight and exile after the murder of Ranuccio Tomassoni. In *David with the Head of Goliath,* the artist put his own face on the severed head of Goliath, but it is David's contemplative, compassionate expression that divulges to Rowland "the other side of Michelangelo Merisi da Caravaggio, giant and monster: the tender soul that only his art could ever fully reveal."[50]

Caravaggio, for one, continues to paint himself.

———————

Clients liked seeing themselves in their old masters.
— Art dealer Joseph Duveen, on why he applied thick varnish to paintings[51]

A painting that reflects the painter may also reflect the connoisseur and collector. "The connoisseur wants to identify himself with the artist," says E. H. Gombrich, "he must be drawn into the charmed circle and share in his secret."[52] Colin Eisler observes that "the image maker is among the most powerful symbols of the freedom of the self" and that "the unique power of the creative self is seldom lost upon men and women eager to 'improve' their social station."[53] Hence the collector's interest in being identified with the artist. "What you own is who you are," adds Eisler. "If shrewdly chosen, your collection appreciates commercially as you do, socially."[54] The dealer puts a premium on seeing a life in the work—for purposes of attribution and valuation—and seeing a heroic life there can pay off handsomely. The job of rendering that life visible falls to the art historian. Aby Warburg in 1903 recognized that the "ordinary, enthusiastic, biographically oriented history of art," and

the resultant hero-worship of artists, was tied to "the propertied classes, the collector and his circle."[55] The business of that ordinary, enthusiastic, biographically oriented historian was to satisfy the desires of both connoisseur and dealer by tracing out connections between life and work that emphasized the artist's genius. When that was done well (and varnish applied equally to life and work), everyone could see someone they liked in their old masters.

The modernist biographical model was established in France in the nineteenth century. The artists then who attracted the most biographical attention were those "whose genius seemed most rooted in divine inspiration or personal emotion," according to Greg M. Thomas, who describes the biographical model as follows:

> Establishing the oeuvre unifies the work under the rubric of an originating author. The author, meanwhile, appears as a coherent and distinct individual whose coherent and distinct work derives from individual experience and genius, free of environmental influences. . . . [the historian] grounds the meaning of the work in the artist's life story; he ties artistic quality to spiritual greatness; and he uses documents, anecdotes, and pictures to reconstruct the artist's physical appearance and real historical presence.[56]

This individualistic mode of interpretation—mixing critical readings of the work with evidence of the artist's life and character (with scant attention paid to economic and social relations)—has structured the biographical approach of many art historians, exhibition organizers, and art book publishers to the present day.[57]

George Kubler judged that, in the twentieth century, artistic biography (in the form of the monograph and the catalogue raisonné) had expanded to "gigantic proportions," and he expressed a fundamental reservation about standard approaches to life and work:

> In the long view, biographies and catalogues are only way stations where it is easy to overlook the continuous nature of artistic traditions. These traditions cannot be treated properly in biographical segments. Biography is a provisional way of scanning artistic substance, but it does not alone treat the historical question in artists' lives, which is always the question of their relation to what has preceded and to what will follow them.[58]

The crucial factor in an artist's career, according to Kubler, is timing (whether the artist enters an artistic tradition early, middle, or late), but temperament and training are also important: "When a specific temperament interlocks with a favorable position, the fortunate individual can extract from the situation a wealth of previously unimagined consequences." For Kubler, genius was a "fortuitous keying together of disposition and situation into an exceptionally efficient entity," and he lamented the fact that "our conceptions of artistic genius underwent such fantastic transformations in the romantic agony of the nineteenth century that we still today unthinkingly identify 'genius' as a congenital disposition and as an inborn difference of kind among men."[59]

Art historians in the Warburgian tradition, interested in using works of art as historical documents with which to explicate *mentalités,* embraced the

correspondence of the life (writ large) and the work. In examining the prem-
ises of great Warburgians such as Fritz Saxl and Erwin Panofsky, historian
Carlo Ginzburg is struck by their handling of the problem of circularity in
reading from life to work and work to life.[60] Saxl, for example, sought to estab-
lish the nature of Hans Holbein the Younger's piety (Erasmianism) by looking
at his woodcuts, saw in Albrecht Dürer's work a reflection of the artist's reli-
gious crisis (known through his letters), and discerned the political reactions
of Philip IV of Spain from his countenances in Diego Velázquez's portraits.[61]
The danger in such a "physiognomic" approach to works of art, notes
Ginzburg, is that "the historian reads into them *what he has already learned*
by other means, or what he believes he knows, and wants to 'demonstrate.'"[62]
Ginzburg judges that Panofsky, too, risked the hazards of the physiognomic
approach in seeing Michelangelo's works as expressions or symptoms of per-
sonality (as well as of the conflict between classical and Christian ideals).

In Gombrich we find more sensitivity to the "physiognomic fallacy" and
also a swing away from the correlation of life and work.[63] "We could hardly
ever recognize an artist whom we knew only through his work," said
Gombrich. "So how far is his personality 'expressed' in it?"[64] As for work and
life writ large, where artistic style is supposed to be expressive of a certain
mentalité, he warned "that 'style' in art is really a rather problematic indica-
tion of social or intellectual change."[65] In a lecture given in 1957, Gombrich was
dismissive of facile treatments of life and work (writ large or small), remark-
ing that "the art historian who sees the styles of the past merely as an expres-
sion of the age, the race or the class-situation, will torment the living artist
with the empty demand that he should go and do likewise and express the
essence and spirit of his time, race, class or, worst of all, the self."[66]

Artists in those days *were* being tormented, of course.[67] Rothko, for one,
claimed that he was "expressing basic human emotions, tragedy, ecstasy,
doom, and so on," convinced that "the people who weep before my pictures
are having the same religious experience I had when I painted them."[68] The
critic Harold Rosenberg, writing on American action painting in the 1950s,
took the following slant on the idea that every painter paints himself:

> A painting that is an act is inseparable from the biography of the artist. The
> painting is itself a "moment" in the adulterated mixture of his life—whether
> "moment" means, in one case, the actual minutes taken up with spotting the
> canvas or, in another, the entire duration of a lucid drama conducted in sign
> language. The act-painting is of the same metaphysical substance as the
> artist's existence. The new painting has broken down every distinction
> between art and life.[69]

The idea that one hangs, say, "a Rothko" on the wall was taken quite liter-
ally by Rosenberg. In the view of Rosalind Krauss, Rosenberg was misled here
by a faulty analogy between painter and painting:

> Just as the artist is made up of a physiognomic exterior and an inner psycho-
> logical space, the painting consists of a material surface and an interior
> which opens illusionistically behind that surface. This analogy between the

psychological interior of the artist and the illusionistic interior of the picture makes it possible to see the pictorial object as a metaphor for human emotions that well up from the depths of those two parallel inner spaces.[70]

Seeing emotion in the work means seeing a life there as well. Rothko's so-called black paintings, for example, were too quickly linked by critics to his presumed mood of despair based upon the fact that he later committed suicide. When Richard Wollheim argued that "the greatness of Rothko's painting [*Red on Maroon*] lies ultimately . . . in its expressive quality . . . a form of suffering and of sorrow . . . somehow barely or fragilely contained,"[71] he was taken to task by J. R. R. Christie and Fred Orton.[72] Does this sorrowful quality stem from Rothko's state of mind? Or is there some other reason why the painting reminds us of sorrow or makes us feel sorrowful? It is hard to know. Expressionist painting is a language designed to encourage the viewer to seek emotional causes for the work,[73] but, said Christie and Orton, "there is no way in which direct, unmediated feeling can be put into, and disinterestedly taken out of, the surface of the painting."[74] Of course critics claim to do exactly this, and Christie and Orton, who were employing a self-consciously historical materialist methodology, examined the interest involved. Here they took their cue from the collective Art & Language, which had argued that critics belong to a certain class of cultural managers who appropriate the right to establish the expressive qualities of the work with reference as needed to the life.[75] In the case of *Red on Maroon* (1958–59; London, Tate Gallery), noted Christie and Orton, the personality of Rothko "becomes a crucial counter for making credible expression claims. . . . because, though paintings cannot be caused to be gloomy, suffering and sorrowful, people can."[76] Simply put, the theory of expressiveness in the work—even when no appeal is made to the artist's intention—necessarily entails reference to the life:

> Discourse making critical and stipulative expression claims is necessarily concerned with a biography of the individual artist—Rothko, for example—or of a group—the Abstract Expressionists, for example. Expression claims which stick emotions to paintings are claims inferred from what critics know or conjecture about the life of the person who made them. To this extent critics deal with the state of the discourse about the artist; and if a life does not exist in discourse it must be written, because without it critics cannot make convincingly any claims as to what a painting is to be seen as expressing. They can only claim that a painting is expressive.[77]

In certain circles in the 1960s, the idea that the work was in some emotional sense a surrogate for the artist fell into disrepute. American art at this time, says Krauss, "staked everything on the accuracy of a model of meaning severed from the legitimizing claims of a private self."[78] Krauss notes, for example, that Jasper Johns "saw the readymade as pointing to the fact that there need be no connection between a final art object and the psychological matrix from which it issued," adding that "Johns and the minimal artists insisted on making work that would refute the uniqueness, privacy, and inaccessibility of experience."[79]

Krauss herself was among the sharpest critics of the biographical approach, disparaging it as the "reduction of the visual sign to an insistent mouthing of proper names." She ridiculed the idea (held by several of her colleagues) that Pablo Picasso painted himself—that, in particular, his "art is at any one time a function of the changes in five private forces—his mistress, his house, his poet, his set of admirers, his dog (yes, dog!)."[80] To those who might feel "that there is nothing inherently objectionable to a history of proper names, since that merely adds another dimension to the interpretation of a given work," Krauss responded that "in practical fact, what we find in most cases is not addition, but restriction." More congenial to her own post-structuralist approach was that of the New Critics, who, as she put it, "gloried in the ambiguity and multiplicity of reference made available by the play of poetic form."[81]

For their part, Christie and Orton were worried about a post-structuralism that stripped the historian of such basic tools as "persons as unitary identities, authors as producers of texts, contexts as relevant to texts, sources as access to lived history, 'beginnings' and 'origins' as explanatory foundation." This seemed to them to disbar "any possible and detailed causal account of the pro-duction of the text as specific to a particular kind of person in a particularized social, ideological formation at a particular time, and any genuine analysis of how and why texts get produced as effects of impersonal and personal histori-cal agencies."[82] While happy to move beyond such assumptions of traditional biographical writing as "over-individualized accounts of artistic creation, and reductive explanations in terms of talent or genius, or incorrigible psycho-analytic interpretations," Christie and Orton held fast to a pluralized subject constituted by language yet available to Marxist analysis.[83]

From the Marxist perspective, analysis of the intersection of life and work can be in the service of bourgeois individualism or its unmasking. Nicholas Green, in his review of five monographs published in 1987, found that all assumed "that the questions to be asked centre on the expressive creativity of the artist and that answers will be found in the detailed dovetailing of life and work." "Why," he lamented, "in the late 1980s this ongoing obsession with the individual artistic creator as the structuring principle of art history? Why this deep-set investment in self-expressive individualism? And what makes it so difficult to abandon a methodology criticised long and hard for its wanton neglect of issues of social determination and effects?" Part of the answer he found in the economic bases of the art world: with art dealers, "who have an economic commitment to the uniqueness of artists," and with publishers, who market their books "with the tourist appeal of known names."[84]

From the bourgeois side of the fence, art history at this time looked very different. What Eisler saw was a lamentable flight from personality. Reflecting upon his own art-historical education in the 1950s, he guessed that "personal-ity may have played such a pathetically small role in the art-historical spec-trum of my youth because it threatened to diminish the value of the goods. If a painter was a cheat, womanizer, or drunk, it might affect the values of the merchandise."[85] Moreover, he surmised, the artist's life—as an object of study—was a poor fit for the educational process: "The creative character is one that has by and large been hung in *Kunstgeschichte's* closet because it is an area

that can be dealt with only speculatively and imaginatively. Lying beyond rigorous control, it is anathema to the Ph.Doctoral process. 'By their works shall ye know them,' but God forbid you should try to know the 'them.'"[86] A key moment for Eisler was MOMA's retrospective Picasso show in 1980:

> Few but the stoniest transpersonalists could fail to ignore the fact that this was the "show of one man." William Rubin, the curator (and professor) who arranged the magnificent obsequies, gave a lecture in Baltimore perceived by Rosalind Krauss as suggesting the possibility that a sudden, passionate involvement of Picasso's could conceivably play a significant role in his oeuvre. This conclusion was read as apostasy, as a denial of the rigorous, intellectual effort toward a "transpersonal" discourse which, together, they had fought to achieve over so many hard-won Modernist years.
>
> Not even the hardest bitten nonperson art scholar could quite blind or deafen themselves to Picasso the person, to ignore the artist's presence, or, as Krauss would say, "name."[87]

Eisler was at once admiring of Krauss's work and adamantly opposed to her transpersonal approach. What concerned Hirsch about the New Critics bothered Eisler about the triumph of the nonperson art scholar: "What we are witnessing is a displacement of the creative character of the artist to that of its critic-scholar, with the latter now perceived as, and accorded, a 'creative I,' whose far-from-transpersonal insights matter most. Two creative egos are one too many. We know which one's got to go. The work of art is now merely a foil for the flowering of the creative critic, with all its occasional hazards of criticism as narcissism. Every critic paints him/herself."[88] Eisler's railing against the transpersonal did not forget the Marxist: "Fair Harvard's flight from character—along with everyone else's—continues today, but this time not by way of the gentleman's agreement of Marshall Plan days. Now it is often Marx that provides the mindlessness, with all explained by working *Das Kapital* on the other side of the street. *Plus ça change,* etc. You just can't go far enough to get away from the self and its mysteries."[89]

Marxist approaches can happily do without the mysteries of the self, but not without the self as a creation of ideology. At the same time that Christie and Orton were crossing post-structuralism with Marxism, preserving a restricted sense of life and work, feminists thought they had found a congenial postmodern crossing of their own. Take, for instance, responses to Sherrie Levine's photographs of works by famous male photographers. Levine's "copies" were seen first as postmodernist (in that they undermined notions of authorship and originality), then as feminist. As Abigail Solomon Godeau saw it, "The notion of the author is integrally linked with that of patriarchy; to contest the dominance of the one, is implicitly to contest the power of the other."[90] At the same time, however, it was essentially the appeal to Levine as author (especially her gender and intentions) that distinguished her "copies" from ordinary reproductions and made them artworks in their own right.[91] Feminism was plainly ambivalent toward the author: sympathetic to collaborative art practice and supportive of individual women artists, critical of authorship and invested in it. When feminist art historian Griselda Pollock (1989) lamented that the Barthian death of the author had so far made little

impact on art history, revealing "just how central the author system remains to the mass of critical, art historical and art practical discourses—to the production, economic consumption and historical appraisal of the visual arts,"[92] Linda Klinger (1991) judged that the "crossing" of feminism with postmodern critical theory was proving problematic for a movement that sought to empower the woman artist since the voiding of the author/artist takes the work out of her hands and places it "in the hands of another author who negotiates the 'text.'"[93]

In support of Pollock's point about art history's resistance to theory and the death of the author, witness, for instance, the stubborn commitment of Irving Lavin to his assumption that "every work of art is a unique statement" since "no man can quite suppress his individuality" and that biographical information about the artist "is essential if we want to explain how the work came to have its particular form and meaning." Lavin promulgated this dogmatic assumption (replete with sexist language) in 1969, presented it at the annual meeting of the College Art Association in 1983, and published it in *Art Bulletin* in 1996.[94] Three decades of criticism left his assumption unchanged.

In 1997, Catherine Soussloff judged that art history remained "embedded in humanism":

> We cling to the idea of brush strokes or chisel marks as referents to and of the individual artist. The individual artist is deemed to be precisely locatable in history and perpetually visible in the work of art, as Ghiberti was for von Schlosser, precisely because the texts through which the artist and the art are interpreted, the history of art, have not been theorized. Semiotics may have shattered the unity of the author, but it did nothing to the unity of the artist, embedded in the work of art.[95]

Emphasis upon the artist's intentionality—Lavin, for instance, asserted that "everything in an art work is intentional"[96]—has, in Jack Spector's view, contributed to art history's resistance to psychoanalysis:

> The claim of art historians that their chronologically ordered array of speculations and hypotheses has scientific objectivity based on documentation, sensitive appreciation, or perceptive evaluation, has placed an obstacle in the way of their adoption of psychoanalysis; for psychohistory and psychobiography can enrich rather than validate those speculations, and may even seem to direct attention away from the art to a "catalogue déraissoné" of the artist's emotional problems. Even more repugnant to some is the psychoanalytic interest in the "unconscious," which assumes the need for special measures to understand the past, and which many like the Existentialist Sartre reject for introducing a benighted determinism that denies artists their intention, their ability to make choices.[97]

Libby Lumpkin has traced the continued interest in the artist's intentionality to the venerable assumption that "the arts of the mind are superior to the arts of practice."[98] While her preferred Barthian notion that the work's authority *ought* to be located in the character of responses to it, rather than in the character of its source (the artist's life), has impressed art historians, most

have preferred to leave the door to the life ajar, open at least to the possibility that the life has something instructive to say.

The post-structuralist critique stands out (and in many ways apart) from the venerable philosophical concern with understanding past action. The ideas of philosophers R. G. Collingwood and Karl Popper were applied to art historical thinking by Michael Baxandall in his *Patterns of Intention* (1986). "Awareness that the picture's having an effect on us is the product of human action seems to lie deep in our thinking and talking about pictures,"[99] admitted Baxandall, who reluctantly sought to determine what could be said about this human action "without becoming irrational and wild."[100] Where the (ordinary) historian seeks to understand an action (in terms of its purpose), the art historian is interested not in the action (the activity of making the picture) but in the end result: the picture itself. A picture is the result of a process involving countless decisions, each affecting the next, and thus cannot be understood in the same way that some historical actions are understood (as the result of a single intention).[101] Baxandall came to the conclusion that "we cannot reconstruct the serial action, the thinking and manipulation of pigments that ended in Piero della Francesca's *Baptism of Christ,* with sufficient precision to explain it as an action."[102] At the same time Baxandall was envious of Vasari's license in connecting Piero's life and work; in this "muscle-bound" age, Baxandall lamented, one could not make those attractive connections without more evidence.[103] That said, he did find room to exercise inferential criticism, appealing to circumstances—Piero's earlier career and what he *could* have thought or intended—to provide a sharper sense of pictorial organization. But the operative principle in this regard, he insisted, is parsimony: "Circumstances are attached to forms and colours by a sort of practical entailment we cannot break. If the character of the forms and colours does not demand or manifest them, we do not invoke them."[104] For Baxandall, the appeal to the life was at best an aesthetic-historical experiment conducted in public and resting on no special authority.[105]

In an introductory piece written for students of the Open University, Charles Harrison conducted just such an experiment with Gustave Courbet's painting *Still Life with Apples and a Pomegranate* (1871–72; London, National Gallery).[106] As a still life, the work's meaning derives largely from its relationship to other paintings, Harrison wrote, though he nevertheless found Courbet's life story worth bearing in mind. Courbet came from peasant stock and may have made this painting as a prisoner in Paris at the age of fifty-seven. Supposing this to have been the case (Courbet may actually have made the work after prison), Harrison proposed thinking of this sensuous depiction of decaying apples and chipped earthenware "as a kind of assertion of his identity, and thus by extension, perhaps, as a *form* of self-portrait; not just a picture by, but in a metaphorical sense a picture *of,* someone near the end of his life—a man locked up in an urban cell but with the self-image of an honest countryman, already suffering with the illness of which he was to die, but still, for all that, in full possession of his senses."[107] In this aesthetic-historical experiment, Harrison had Courbet painting himself. Even so, he counseled students that "it is always tempting to treat biographical information about the artist as a key to the meaning of a work of art, but we need to bear in mind

that the formal and physical characteristics of the work are there to be perceived independently of what that information may suggest."[108] Priority belongs to the work, not the life, according to Harrison. Paintings are to be seen first and foremost in their own terms (form and composition): "We should approach the experience of art as a kind of *responsive* activity, allowing the individual work to guide us in the exercise of our knowledge and imagination, rather than treating it as a peg on which to hang our already formed opinions and associations. It is by observing this demand, I believe, that we come to profit from the individuality or *originality* of works of art—that is, from their *difference* from ourselves and from their newness to us."[109] For Harrison, the relevance of the life is "best treated as an open question"—and addressed only when it fits the painting's form.[110]

Thomas Crow, author of several studies of artists' lives,[111] emphasized the discoveries that may result when life and work possess "a high degree of intuitive likeness or parallelism" without being too similar:

> The interest of the exercise depends upon there being sufficient difference to create intriguing surprises and encounters with the unexpected. In the life-and-work model, these contrary pressures generate certain effects of their own. On the one hand, the work of art will be asked to reveal the life; that means mining the work for clues latent with personal significance: life and work equated. On the other hand, the consequent danger of redundancy dictates that the life must be given a heightened remoteness or drama of its own, so that biographical discoveries can be seen to transform the visual facts as they present themselves to the uninformed eye.[112]

Crow and Harrison recommend a cautious but opportunistic stance toward relations between life and work—with bridges to be built on a case-by-case basis. Theirs is a pragmatist's approach. The life is not treated as "ground," but neither is it ignored. In the following essays, including those by Crow and Harrison, we find a variety of responses to the possibility that the complexities of the life may resonate with the complexities of the work.

———

Every artist dips his brush in his own soul, and paints his own nature into his pictures.
— Henry Ward Beecher[113]

The character of the artist doesn't enter into the nature of the art. Eliot said that art is the escape from personality, which I think is right. We know that Velázquez embezzled money from the Spanish court and wanted power and so on, but you can't see this in his art.
— Lucian Freud[114]

> Thus it is true both that the life of an author can teach us nothing and that—
> if we know how to interpret it—we can find everything in it, since it opens
> onto his work.
> — Maurice Merleau-Ponty[115]

The essays in this volume are organized in pairs: the opening two
(Krauss and Williams) explore theories of subjectivity, the next two (Smith
and Silverman) analyze individual constructions of artistic subjectivity, and
the final two (Harrison and Crow) reflect upon artistic responses to life-
and-work issues.

Rosalind Krauss begins the volume with a review of and remarks upon
the post-structuralist critique of the subject. That critique, she says, focused
on the author "because authorship represents the heightened achievements of
such a subject—the marshalling and mastering of intentions toward meaning
and implication; the projection onto a work of that special unity and consis-
tency that is the correlative of the continuity and coherence of selfhood." At
the heart of the critique was Barthes's notion that the unity of the work lies in
its reception (not its origin) and Foucault's view that the author's name serves
a largely classificatory function. But in the background was Heidegger, whose
concepts of *Gestell* (enframing) and *Gestalt* (bringing forth) Krauss relates to
Michael Fried's opposition of *presence* and *presentness.* The emphasis here
remains on responses to the work of art rather than on its origins. Krauss, in
opposition to Fried, privileges *presentness:* in particular, minimalism's demand
that the viewer circulate around the object, bringing its context into experi-
ence and "producing a basis for the collectivity of communal perception."
Krauss concludes her essay with remarks upon trauma studies (addicted to
"the life" of course, since it is the story of the shattering of a decentered and
hence vulnerable self) and multiple personality disorder.

Robert Williams is less satisfied with where the post-structuralists left
off. He focuses on the before (Renaissance art theory, Émile Zola, Jacob
Burckhardt) and the after (New Historicism). He begins with Zola's classic
formulation of the life expressed in the work: "In works of art, I seek to find
behind each an artist, a brother, who presents nature to me under a new face,
with all the power and sweetness of his personality." Williams juxtaposes this
romantic view of the artist's subjectivity as a natural resource, a given, to the
New Historicist notion of self-fashioning. The New Historicists (à la Foucault)
see the self as a discursive construct and hence a symptom of power, but
Williams finds that most self-fashioning "was and is opportunistic, reactive,
and governed by conventions." For a more active sense of the construction of
the artistic self, Williams returns to Renaissance art theory, where considera-
tion of the life-and-work problem (for all intents and purposes) began. The
contrast of the artistic self as given versus constructed is anticipated in the
early-sixteenth-century debate between Giovanni Francesco Pico della
Mirandola and Pietro Bembo, but most important to Williams is Leonardo's
assertion that "the artist must make himself over entirely according to the
demands of his vocation." Art, Leonardo maintained, demands that the artist
become a student of nature, and it is a program of study that demands "a
comprehensive personal discipline that enters into and transforms every
corner of experience, every recess of consciousness." The painter's self is

fashioned according to the demands of painting; the artist's subjectivity is a symptom of art.

Paul Cézanne was, for Williams, an artist who devoted his self to his work, and Paul Smith looks carefully at what Cézanne said about that self, and what contemporaries said about "it" as well. Smith distinguishes between Cézanne's artistic, social, and fictional selves, taking a Wittgensteinian tack that "preserves the idea that works of art correspond to the intentionality, or subjectivity, that goes on in artists when they make works of art, even while it shows that there is no such thing as the 'self,' or the 'subject.'"

Cézanne, adopting the idea from his friend Zola that art was an expression of temperament, famously declared: "I paint as I see and feel." How he saw and felt, Smith finds, was not a given (*pace* Zola) but was, at least in part, a product of the painter's identifications with others—including fictional characterizations of himself! Cézanne's friend Marius Roux wrote a fictional account of an artist (based on Cézanne) who alienates his creativity through the pursuit of fame and fortune. Roux's account served as a kind of reading (as opposed to "talking") cure for Cézanne, who let go of his worldly ambitions, allowing the creative process "to happen," and made better paintings. Cézanne saw himself as a "primitive"—a strong, manly painter but also "childlike" in the sense of seeing and feeling in ways not yet modified (corrupted) by society. And sometimes, despairing of his isolation, he identified with Phocion and Moses, taking comfort in the idea that he—like they—would be vindicated after death. Smith finds that Cézanne's "multiple identifications created an artistic self whose different aspects were united by virtue of 'family resemblance.'"

Debora Silverman's essay reviews some of the conclusions she reached in *Van Gogh and Gauguin: The Search for Sacred Art* (2000) in light of the life-and-work question. Silverman is interested in how studies of artists can "expose the pressure points of social transformation in different national contexts"; and the key pressure point exposed by the life and work of Vincent van Gogh and Paul Gauguin is religious formation. Silverman explores how the mental frameworks of these two artists were shaped by their religious upbringing and were then registered in paint. She finds that van Gogh's upbringing was characterized by competing strains of Dutch Calvinism (featuring a celebration of the visual, a sense of the arts as vehicles of divinity, and the primacy of the corporate ego) that she connects to his style of "weaving paintings" (a pictorial language of labor) and his use of color. Van Gogh's "labor theology" pressed him "to maximize the materiality of the painting surface," a technique objected to by his friend Gauguin as tied to a deficient material reality. Silverman is not surprised by Gauguin's objection, given the Frenchman's training in a Catholic seminary, which encouraged children to "engage in active interior interrogations of supernatural beings, such as angels, eliciting a state of visionary release from an irrevocably deficient earthly world." The comparative method serves Silverman well in explicating the different painterly responses by the two men to a scene in Arles they had observed together: different paintings, different kinds of interiority, different religious upbringings.

Charles Harrison reflects on life-and-work questions centered on the collective art practice Art & Language, with which he himself is associated.

Obviously the difficulties in this case are multiplied, not just because several
lives are involved but also because the collaboration is fundamentally anti-
biographical in the sense that the individuals are less visible. Indeed, Harrison
tells us that as a common authorial name, "Art & Language was intended as a
partial safeguard against possessive individualism and careerism in the world
of art." Careerism is often what generates biography. Normally, the continuity
of the artist's life is juxtaposed to the oeuvre, but does Art & Language have a
"life" in that sense? Harrison thinks it does, seeing its "life" not as a collection
of the lives of those associated with the name but as an enterprise that has a
personality and develops over time, an enterprise that learns in adapting itself
to changing external conditions.

The volume concludes with Thomas Crow's intertwining of the lives
and works of Andy Warhol and Bob Dylan. He begins with Andy Warhol's
take on the life and the work: "If you want to know all about Andy Warhol, just
look at the surface of my paintings and films and me, and there I am. There's
nothing behind it." Of course, there *are* biographical facts "behind it," and
Crow takes note of little-known aspects of Warhol's life. At the same time,
though, he accepts Warhol's challenge to "just look at the surface" of his paint-
ings and uses those surfaces to describe a Warholian world whose biographi-
cal claim does some justice to "the actual struggle, doubt, and anxiety that
attended his career." It is an allegorical world in several respects, and Crow
sees Warhol's way of allegory—in which his subjectivity was dispersed into
"an array of manageable surrogates"—as a healthy alternative to the prevail-
ing artistic culture, which insisted on the unity of abstract form and on a
corresponding (and unrealistically) "unified account of human agency and
self-knowledge (one that broke spirits and took lives)." Crow notes that the
allegorical impulse in the work was extended to the life with Warhol surround-
ing himself at the Factory with a cast of characters, "each of whom acted out
some aspect of his divided self-perception and inner life." The Factory scene
was translated "back into the register of art" through the songs of Bob Dylan.
Those songs were themselves resonant with allegory and descended from the
courtly verse romances of the Middle Ages, a genre that Crow ties also to the
work of Warhol. Personal encounters of Warhol and Dylan provide the impe-
tus for Crow's intertwinings of life and work that transform our views of each.

NOTES

1. The current appeal of the theory of intelligent design in the face of scientific
 fact points to a certain tendency to resist attributing complex products (like
 painters and paintings) to *unguided* processes (like natural selection or the gen-
 eral causal web).

2. Psychologist James M. Bering argues that humans are naturally selected to search
 for intentional causes for life events, arguing that "ultimately, it is up to the indi-
 vidual to interpret the behaviors of others in terms of underlying mental states
 if he or she is to function normally in society." (See "The Existential Theory of
 Mind," *Review of General Psychology* 6, no. 1 [2002]: 5.) That is, it is "natural" for
 us to seek causal connections between life and work because seeing events as
 products of mental causality is what our brains are designed to do. The nature of
 those connections, however, no matter how "naturalized," is a product of historical
 discursive formations. On the location of "the artist" in the discourse of history,

see Catherine Soussloff, *The Absolute Artist: The Historiography of a Concept* (Minneapolis: Univ. of Minnesota Press, 1997).

3. Filippo Baldinucci refers to this proverb as such in his *Notizie de' professori del disegno da Cimabue ... distinta in secoli, e decennali* (Florence: per Santi Franchi [et al.], 1681–1728), 3:690; quoted in Philip Sohm, "Caravaggio's Deaths," *Art Bulletin* 84 (2002): 459, 467n94. A similar phrase—"every painter paints himself well"—is attributed to Michelangelo in Giorgio Vasari's *Life of Michelangelo.* For a study of the positive and negative implications of this Tuscan proverb in the fifteenth and sixteenth centuries, see Robert Zwijnenberg, "'Ogni pittore dipinge sé': On Leonardo da Vinci's Saint John the Baptist," in Florike Egmond and Robert Zwijnenberg, eds., *Bodily Extremities: Preoccupations with the Human Body in Early Modern European Culture* (Aldershot, UK: Ashgate Publishing, 2003), 48–67.

4. As for the situation in the twenty-first century, Greg M. Thomas opines that "the biographical paradigm ... is not widely recognized as such for two reasons: it is so ingrained in the process of relating art objects to history that it hardly seems like a methodology at all; and since Vasari, no outstanding individuals have emerged (ironically enough) to theorize it—no Wölfflin or Panofsky to serve as a modern progenitor"; Greg M. Thomas, "Instituting Genius: The Formation of Biographical Art History in France," in Elizabeth Mansfield, ed., *Art History and Its Institutions: Foundations of a Discipline* (London: Routledge, 2002), 260.

5. Rom. 1:20. Interestingly, Origen reverses the order: "If we see some admirable work of human art, we are at once eager to investigate the nature, the manner, and the end of its production; and the contemplation of the works of God stirs us with an incomparably greater longing to learn the principles, the method, and the purpose of creation"; quoted in Richard Olson, *Science Deified and Science Defied: The Historical Significance of Science in Western Culture, from the Bronze Age to the Beginnings of the Modern Era, ca. 3500 B.C. to ca. A.D. 1640* (Berkeley: Univ. of California Press, 1982), 153.

6. Roland Barthes, *S/Z,* trans. Richard Miller (London: Cape, 1975), 174.

7. Thomas McEvilley, "On the Manner of Addressing Clouds," in idem, *Art and Discontent: Theory at the Millennium* (Kingston, NY: McPherson, 1991), 101.

8. The effects on biographical practice of this particular destabilization should not be exaggerated. Twentieth-century biography had already been operating in the face of the destabilizing ideas of Karl Marx (the bourgeois individual is the product of false consciousness), Sigmund Freud (the ego is not master in its own house), and then the New Critics (see below), as well as the venerable philosophical "problem of other minds." As James Walter put it, "indeterminacy, then, has long been recognized as the characteristic feature of modern biography, and the fact that biographical truth can never finally be settled, that biography is always tendentious, has inflected every other methodological strategy"; James Walter, "'The Solace of Doubt'? Biographical Methodology after the Short Twentieth Century," in Peter France and William St. Clair, eds., *Mapping Lives: The Uses of Biography* (Oxford: Oxford Univ. Press, 2002), 322.

9. Quoted in Danny Postel, "The Life and the Mind," *The Chronicle of Higher Education,* 7 June 2002, A17.

10. Postel, "Life and the Mind" (note 9).

11. Nehamas quoted in Postel, "Life and the Mind" (note 9).

12. Strabo, *The Geography of Strabo,* trans. Horace Jones (Cambridge: Harvard Univ. Press, 1949), 1:63.

13. For a history of this debate among literary critics from antiquity through the eighteenth century, see M. H. Abrams, *The Mirror and the Lamp: Romantic Theory and the Critical Tradition* (New York: Oxford Univ. Press, 1953).

14. Samuel Johnson, "Life of Thomson," in idem, *Lives of the English Poets,* ed. George Birkbeck Hill (Oxford: Clarendon, 1905; reprint, New York: Octagon, 1967), 3:297–98; cited in Abrams, *Mirror and the Lamp* (note 13), 234.

15. William Wordsworth, preface to *Lyrical Ballads: With Pastoral and Other Poems,* 2nd ed. (London: printed for T. N. Longman & O. Rees ... by Biggs & Cottle, 1802).

16. Thomas Carlyle, "The State of German Literature"; cited in Abrams, *Mirror and the Lamp* (note 13), 226.

17. See T. S. Eliot, "Tradition and the Individual Talent," in idem, *Selected Essays* (New York: Harcourt, Brace & World, 1964), 11; originally published in T. S. Eliot, *Selected Essays 1917–1932* (London: Faber & Faber, 1932). In a proto-Barthian passage, Eliot explained:

> The point of view which I am struggling to attack is perhaps related to the metaphysical theory of the substantial unity of the soul: for my meaning is, that the poet has, not a "personality" to express, but a particular medium, which is only a medium and not a personality, in which impressions and experiences combine in peculiar and unexpected ways. Impressions and experiences which are important for the man may take no place in the poetry, and those which become important in the poetry may play quite a negligible part in the man, the personality. (p. 9)

18. E. M. W. Tillyard and C. S. Lewis, *The Personal Heresy: A Controversy* (London: Oxford Univ. Press, 1939), 1–2.

19. Tillyard and Lewis, *The Personal Heresy* (note 18), 4.

20. Tillyard and Lewis, *The Personal Heresy* (note 18), 11–12.

21. Tillyard and Lewis, *The Personal Heresy* (note 18), 98.

22. René Wellek and Austin Warren, *Theory of Literature* (New York: Harcourt, Brace, 1949), 72.

23. William K. Wimsatt Jr. and Monroe C. Beardsley, "The Intentional Fallacy," in William K. Wimsatt Jr., *The Verbal Icon: Studies in the Meaning of Poetry* (Lexington: Univ. of Kentucky Press, 1954), 3. Wimsatt and Beardsley's essay was first published in the *Sewanee Review* 54 (1946): 468–88.

24. Frank Cioffi found this distinction between external and internal evidence problematic since it is rare for a critic to approach a work without knowing something about its maker: "The difficulty in obeying the injunction to ignore the biographical facts and cultivate the critical ones is that you can't know which is which until after you have read the work in light of them"; Frank Cioffi, "Intention and Interpretation in Criticism," in Joseph Margolis, ed., *Philosophy Looks at the Arts: Contemporary Readings in Aesthetics,* 3rd ed. (Philadelphia: Temple Univ. Press, 1987), 390. Cioffi's own eminently reasonable conclusion was that "it is certain that there are cases where biographical considerations are genuinely relevant and equally certain that there are cases where they are intrusions which we feel we ought not to allow to condition our response. But it is difficult to know where the line should be drawn" (p. 396).

25. David Summers, "Intentions in the History of Art," *New Literary History* 17 (1986): 306–7, 308.

26. Clement Greenberg, "Autonomies of Art" (lecture, Moral Philosophy and Art Symposium, Mountain Lake, Va., October 1980).

27. Robert W. Stallman, "Intentions," in Alex Preminger, Frank J. Warnke, and O. B. Hardison Jr., eds., *Princeton Encyclopedia of Poetry and Poetics* (Princeton: Princeton Univ. Press, 1965), s.v. "Intentions." Cf. Wimsatt and Beardsley, "The Intentional Fallacy" (note 23), 4. For more on this, see Annabel Patterson, "Intention," in Frank Lentricchia and Thomas McLaughlin, eds., *Critical Terms for Literary Study* (Chicago: Univ. of Chicago Press, 1990), 135–46.

28. E. D. Hirsch Jr., *Validity in Interpretation* (New Haven: Yale Univ. Press, 1967), 2.

29. Wimsatt and Beardsley, "The Intentional Fallacy" (note 23), 18.

30. Hirsch, *Validity in Interpretation* (note 28), 10–11.

31. Hirsch, *Validity in Interpretation* (note 28), 11–12.

32. Hirsch, *Validity in Interpretation* (note 28), 1.

33. Hirsch, *Validity in Interpretation* (note 28), 3, 2.

34. See Patterson, "Intention" (note 27), 144.

35. Seán Burke, *The Death and Return of the Author: Criticism and Subjectivity in Barthes, Foucault and Derrida* (Edinburgh: Edinburgh Univ. Press, 1992), 140–41.

36. Burke, *Death and Return* (note 35), 156.

37. Theory cannot resolve the issue. As Burke puts it, "Though criticism can in prac-
 tice read a text in terms of its tropes, aporias, rhetorics, words on the page, and
 also read in terms of biography, psychological dynamics, authorial inscription,
 and do so without obvious contradiction, the propagation of a theory of reading
 and of writing which takes stock of all these determinants is awesomely difficult
 to conceive"; Burke, *Death and Return* (note 35), 173.

38. In the theorizing of "authorship," works of art are often treated generically, as if in
 this regard there were no important differences between a poem and a painting.
 The relevance of the interpreting of works consisting of words to the interpreting
 of works made of marble or paint may be wondered at. Michael Baxandall has
 noted that we read (but do not see) linearly. In seeing a painting, we quickly form
 an impression of the whole, and this is an activity quite different from the pro-
 gressive activity of reading; Michael Baxandall, "The Language of Art History,"
 New Literary History 10 (1979): 453–65. And yet, seeing is not describing. Baxandall
 later points out that when we write about works of art, we are describing not the
 actual works but our thought about them; Michael Baxandall, *Patterns of Intention:
 On the Historical Explanation of Pictures* (New Haven: Yale Univ. Press, 1986), 58.
 This point is extended in the direction of language by Martin Kemp: "I would go
 further and say that what we are describing are those aspects of our thought about
 a picture that are susceptible to verbal equivalences." Kemp recognizes that this
 places the interpreter of painting or sculpture at a disadvantage:

 There surely is a mode of thought about a picture which remains profoundly
 inaccessible to even the most evocative verbaliser. I do not mean this in a spirit
 of mystification, but in the sense that there is an aspect of the simultaneity or
 at least near-simultaneity of the various perceptions through which we obtain
 meanings—that it is a picture, that it is of a landscape, that it has red trees, that
 it is unpleasant, that it looks like a Derain, that I "ought" to like it, that I am
 blocking the view of the lady behind me etc. etc.—which are ultimately incom-
 mensurable with the sequential properties of language.

 Martin Kemp, review of *Patterns of Intention: On the Historical Explanation of
 Pictures,* by Michael Baxandall, *Zeitschrift für Kunstgeschichte* 50, no. 1 (1987): 132.

39. Giorgio Vasari, *Lives of the Most Eminent Painters, Sculptors and Architects,* trans.
 Gaston du C. De Vere (London: Macmillan & Medici Society, 1912–15; reprint, New
 York: AMS, 1976), 2:78; cited in Soussloff, *The Absolute Artist* (note 2), 155.

40. Sohm, "Caravaggio's Deaths" (note 3), 451.

41. Quoted in Sohm, "Caravaggio's Deaths" (note 3), 459. For Leonardo's view of
 the notion that "every painter paints himself," see Robert Williams, "Leonardo's
 Modernity: Subjectivity as Symptom," this volume, pp. 37–38. For more on this
 notion in terms of Caravaggio, see David M. Stone, *"In Figura Diaboli:* Self and
 Myth in Caravaggio's *David and Goliath,"* in Pamela M. Jones and Thomas
 Worcester, eds., *From Rome to Eternity: Catholicism and the Arts in Italy, ca.
 1550–1650* (Leiden: Brill, 2002), 19–42.

42. Bellori writes in his *Le vite de' pittori, scultori et architetti* (Rome: Per il succeso, al
 Mascardi, 1672):

 Caravaggio's way of working corresponded to his physiognomy and appear-
 ance. He had a dark complexion and dark eyes, black hair and eyebrows and
 this, of course, was reflected in his paintings. His first manner, with its sweet
 and pure color, was his best; in it he made the greatest achievements and
 proved himself to be the most excellent Lombard colorist. But later, driven by
 his peculiar temperament, he gave himself up to the dark manner, and to the
 expression of his turbulent and contentious nature.

 Quoted in Walter Friedlaender, *Caravaggio Studies* (New York: Schocken, 1969),
 253.

43. See Martin Kemp, "'Equal Excellences': Lomazzo and the Explanation of
 Individual Style in the Visual Arts," *Renaissance Studies* 1 (1987): 1–26; cited in
 Soussloff, *The Absolute Artist* (note 2), 77.

44. John Ruskin, *Modern Painters,* ed. David Barrie (New York: Knopf, 1987), 239–40,
 402.

45. The temptation stems from the harmony of Caravaggio's life and work in coeval
 sources. Life and work harmonize in part because they were forced to do so by
 early biographers, who interpreted Caravaggio's paintings in light of his life and
 told his life story in light of his works. As is shown by Sohm, Caravaggio is sup-
 posed to have died after running along the beach in the hot sun chasing a vessel
 with his belongings on board, but that story was constructed by critics who had
 the artist's unfashionable pictorial naturalism in mind: that is, nature takes
 revenge upon the artist for his preference for superficial appearance over hidden
 ideals. The story of Caravaggio's death was constructed in order to bridge the
 gap between life and work. See Sohm, "Caravaggio's Deaths" (note 3), 455.

46. Friedlaender, *Caravaggio Studies* (note 42), 117.

47. Rudolf Wittkower, *Art and Architecture in Italy, 1600 to 1750,* 3rd rev. ed. (Baltimore:
 Penguin, 1958), 56. Wittkower (perhaps with Wimsatt and Beardsley in mind) was
 more cautious later, noting that while "Caravaggio's unruly conduct and brutal
 realism have often been linked together," it is "a *fallacy* [italics mine] to believe
 that an unbridled personality and a revolutionary style are complementary";
 Rudolf Wittkower and Margot Wittkower, *Born under Saturn: The Character and
 Conduct of Artists; A Documented History from Antiquity to the French Revolution*
 (London: Weidenfeld & Nicolson, 1963), caption to pl. 47. Wittkower's position here
 is worth quoting at length:

 > Every work of art bears, of course, the personal stamp of its maker. In support
 > of this obvious statement we will only say that we can recognize an artist's
 > style as we do a person's handwriting, and the style tells us something about
 > the man; even if we are uncertain about the artist's biography and name, his
 > work bespeaks a distinct personality. But it remains an open question whether
 > a work can be regarded as a mirror-image of its creator.
 >
 > There are certainly cases in history where the nature of an artist and of his
 > work would seem to harmonize. One might argue that the characters of
 > Raphael and Rubens, of Frans Hals, Brouwer and Caravaggio speak consis-
 > tently and unmistakeably from their works. But having made this statement,
 > we must pause and reflect for a moment. We are not equipped to enter into a
 > philosophical discussion of the difference between personality and character.
 > In everyday parlance, the terms are almost interchangeable, though person-
 > ality has, perhaps, the wider connotations. If conduct and behaviour are
 > outward manifestations of character, it will at once be clear how cautious we
 > should be in our interpretations: there is no way of divining, for instance,
 > Caravaggio's unruly conduct from the fierce quality of his paintings. Assuming
 > such a deduction were possible, the patently absurd generalization could be
 > made that all painters working with a fierce brush lead an unruly life.

 Wittkower and Wittkower, *Born under Saturn* (this note), 281–82.

48. Donald Posner, "Caravaggio's Homo-Erotic Early Works," *Art Quarterly* 34 (1971):
 306. Richard Spear finds this dubious, concluding that "it is difficult not to asso-
 ciate the new obsession with Caravaggio's sexuality with the sexual revolution of
 the 1960s and Gay Liberation"; Richard E. Spear, "The Critical Fortune of a Realist
 Painter," in *The Age of Caravaggio,* exh. cat. (New York: Metropolitan Museum of
 Art, 1985), 25.

49. Howard Hibbard, *Caravaggio* (New York: Harper & Row, 1983), 262.

50. Ingrid D. Rowland, "The Battle of Light with Darkness," *The New York Review,*
 12 May 2005, 11.

51. Attributed to Joseph Duveen in Edmund Fawcett, "A Rogue Dealer and Old
 Masters," review of *Duveen: The Story of the Most Spectacular Art Dealer of All Time,*
 by S. N. Behram, and *Duveen: A Life in Art,* by Meryle Secrest, *Los Angeles Times
 Book Review,* 19 September 2004, R7.

52. E. H. Gombrich, "Psychoanalysis and the History of Art," in idem, *Meditations on
 a Hobby Horse and Other Essays on the Theory of Art* (Chicago: Univ. of Chicago
 Press, 1963), 35–36.

53. Colin Eisler, "'Every Painter Paints Himself': Art History as Biography and
 Autobiography," *Social Research* 54 (1987): 76.

54. Eisler, "'Every Painter Paints Himself'" (note 53), 77.

55. Draft of a letter from Aby Warburg to Adolph Goldschmidt, dated August 1903;
 quoted in E. H. Gombrich, *Aby Warburg: An Intellectual Biography* (London:
 Warburg Institute, 1970), 141–44; cited in Soussloff, *The Absolute Artist* (note 2), 87.

56. Thomas, "Instituting Genius" (note 4), 264.

57. See Nicholas Green, "Stories of Self-Expression: Art History and the Politics of
 Individualism," *Art History* 10 (1987): 529–30.

58. George Kubler, *The Shape of Time: Remarks on the History of Things* (New Haven:
 Yale Univ. Press, 1962), 5, 6.

59. Kubler, *The Shape of Time* (note 58), 7, 8.

60. Carlo Ginzburg, "From Aby Warburg to E. H. Gombrich: A Problem of Method," in
 Myths, Emblems, Clues, trans. John Tedeschi and Anne C. Tedeschi (London:
 Hutchinson Radius, 1990), 31–35.

61. Ginzburg, "From Aby Warburg to E. H. Gombrich" (note 60), 31–35.

62. Ginzburg, "From Aby Warburg to E. H. Gombrich" (note 60), 35.

63. Ginzburg, "From Aby Warburg to E. H. Gombrich" (note 60), 46.

64. E. H. Gombrich, "Visual Metaphors of Value in Art," in idem, *Meditations on a
 Hobby Horse and Other Essays on the Theory of Art* (Chicago: Univ. of Chicago
 Press, 1963), 26; cited in Ginzburg, "From Aby Warburg to E. H. Gombrich" (note
 60), 187n118.

65. E. H. Gombrich, "The Social History of Art," in idem, *Meditations on a Hobby Horse
 and Other Essays on the Theory of Art* (Chicago: Univ. of Chicago Press, 1963), 91;
 cited in Ginzburg, "From Aby Warburg to E. H. Gombrich" (note 60), 48.

66. E. H. Gombrich, "Art and Scholarship," in idem, *Meditations on a Hobby Horse and
 Other Essays on the Theory of Art* (Chicago: Univ. of Chicago Press, 1963), 118–19.

67. Artists have long had to deal with tropes about the artistic personality established
 by Renaissance biographers; see Wittkower, *Art and Architecture* (note 47), and
 Soussloff, *The Absolute Artist* (note 2). Greg Thomas finds it insidious that avant-
 garde artists in nineteenth-century France "adopted many of the tenets of bio-
 graphical discourse.... [acting] out in various ways the lives that biography
 expected of them"; Thomas, "Instituting Genius" (note 4), 261. Paul Smith finds
 this to have been more or less the case with Cézanne; see Paul Smith, "Paul
 Cézanne's Primitive Self and Related Fictions," this volume, pp. 45–75. See also
 Carl Goldstein, "The Image of the Artist Reviewed," *Word and Image* 9 (1993): 9–18.

68. Mark Rothko, quoted in Selden Rodman, *Conversations with Artists* (New York:
 Devin-Adair, 1957), 93–94. However, what the artist meant to express was not
 always received as such. Dore Ashton recalls a conversation with Rothko in 1956
 in which the artist remarked that "most people, upon seeing the bright yellow and
 red, thought of *No. 5/No. 22* as an optimistic painting. But no, he explained, it rep-
 resented tragedy"; Dore Ashton, "Rothko's Frame of Mind," in Glenn Philips and
 Thomas Crow, eds., *Seeing Rothko* (Los Angeles: Getty Research Institute, 2005), 14.

69. Harold Rosenberg, "The American Action Painters," *ARTnews* 51, no. 8 (1952): 23.

70. Rosalind Krauss, *Passages in Modern Sculpture* (New York: Viking, 1977; reprint,
 Cambridge: MIT Press, 1983), 256.

71. Richard Wollheim, "The Work of Art as Object," *Studio International* (1970): 235;
 quoted in J. R. R. Christie and Fred Orton, "Writing on the Text of the Life," *Art
 History* 11 (1988): 547.

72. Christie and Orton, "Writing on the Text" (note 69), 544–64.

73. Hal Foster, "The Expressive Fallacy," *Art in America* 71, no. 1 (1983): 80–81; cited in
 Christie and Orton, "Writing on the Text" (note 71), 551.

74. Christie and Orton, "Writing on the Text" (note 71), 551.

75. On Art & Language, see Charles Harrison, "Partial Accounting: Art & Language,"
 this volume, pp. 97–107.

76. Christie and Orton, "Writing on the Text" (note 71), 553.

77. Christie and Orton, "Writing on the Text" (note 71), 553.

78. Krauss, *Passages in Modern Sculpture* (note 70), 266.

79. Krauss, *Passages in Modern Sculpture* (note 70), 259.

80. Rosalind Krauss, *The Originality of the Avant-Garde and Other Modernist Myths* (Cambridge: MIT Press, 1985), 25.

81. Krauss, *Originality of the Avant-Garde* (note 80), 39.

82. Christie and Orton, "Writing on the Text" (note 71), 558.

83. Christie and Orton, "Writing on the Text" (note 71), 558.

84. Green, "Stories of Self-Expression" (note 57), 530, 527, 531.

85. Eisler, "'Every Painter Paints Himself'" (note 53), 91.

86. Eisler, "'Every Painter Paints Himself'" (note 53), 84.

87. Eisler, "'Every Painter Paints Himself'" (note 53), 86.

88. Eisler, "'Every Painter Paints Himself'" (note 53), 87.

89. Eisler, "'Every Painter Paints Himself'" (note 53), 95.

90. Abigail Solomon Godeau, "Winning the Game When the Rules Have Been Changed: Art Photography and Postmodernism," *Screen* 25, no. 6 (1984): 91. For more on this juxtaposition, see Hans Bertens, *The Idea of the Postmodern: A History* (London: Routledge, 1995), 93. Feminist life-writers such as Liz Stanley, interested in gender-specific ways of knowing and being, have supported the postmodern challenge to the traditional notion of the self, preferring to emphasize fragmentation, polyphony, and situatedness; see Liz Stanley, "Process in Feminist Biography and Feminist Epistemology," in Teresa Iles, ed., *All Sides of the Subject: Women and Biography* (New York: Teachers College, 1992), 109–25; cited in Walter, "'The Solace of Doubt'?" (note 8), 329n45.

91. That the problem of indistinguishable counterparts requires some recognition of authorship and authorial intention was a point addressed at some length by Arthur Danto; see Arthur Danto, *The Transfiguration of the Commonplace: A Philosophy of Art* (Cambridge: Harvard Univ. Press, 1981).

92. Griselda Pollock, "Agency and the Avant-Garde," *Block* 15 (1989): 8.

93. Linda S. Klinger, "Where's the Artist? Feminist Practice and Poststructural Theories of Authorship," *Art Journal* 50, no. 2 (1991): 46. See also Cheryl Walker's objections to the erasure of the woman artist as author of her work in "Feminist Literary Criticism and the Author," *Critical Inquiry* 16 (1990): 551–71. With all identity-based art—be it women's art, African American art, or outsider art—biography prima facie matters. The question remains: How much does it matter?

94. Irving Lavin, "Art History and Its Crisis," *Art Bulletin* 78 (1996): 15.

95. Soussloff, *The Absolute Artist* (note 2), 111.

96. Quoted in Jack Spector, "The State of Psychoanalytic Research in Art History," *Art Bulletin* 70 (1988): 63n79.

97. Spector, "State of Psychoanalytic Research" (note 96), 63.

98. Libby Lumpkin, *Deep Design* (Los Angeles: Art Issues, 1999), 121.

99. Baxandall, *Patterns of Intention* (note 38), 6.

100. Baxandall, *Patterns of Intention* (note 38) 135.

101. Baxandall, *Patterns of Intention* (note 38), 63.

102. Baxandall, *Patterns of Intention* (note 38), 13. The issue of intentionality has continued to be debated in the realm of aesthetics. In "Intention, Meaning, and Substance in the Phenomenology of Abstract Painting," *British Journal of Aesthetics* 46 (2006): 42, philosopher Dale Jacquette refers to paintings as "windows opening onto an artist's thoughts and feelings from the past, the states of mind that gave rise to each particular artwork, of the artist's personality and characteristic way of thinking." Most fall into the "partial-intentionalist" camp, agreeing that artworks are intended (consciously or unconsciously, incorporating deliberation or spontaneity), while observing that works can be put to a variety of uses and interpretations unintended by the artist. See, for instance, Paisley Livingston, *Art and Intention: A Philosophical Study* (Oxford: Clarendon, 2005).

103. Baxandall, *Patterns of Intention* (note 38), 117.

104. Baxandall, *Patterns of Intention* (note 38), 132.

105. Baxandall was close enough to traditional art history here to incur sharp criticism from Adrian Rifkin; see Adrian Rifkin, "Brief Encounters of the Cultural Kind," review of *Patterns of Intention: On the Historical Explanation of Pictures,* by Michael Baxandall, *Art History* 9 (1986): 275–78. Rifkin saw Baxandall's inferential criticism as establishing "a narrow, empiricist limit on historical method" (p. 276) and he associated Baxandall's fallibilist spirit with an anti-intellectualism typical of his privileged place as a white upper-class male in the British cultural establishment. Clearly the appeal to the life (situatedness) serves reviewers of art history texts as well. Another reviewer, Martin Kemp, sides with Baxandall in placing "more weight on a traditional kind of art history based on the story of artists in the context of cultural history than on the more abstract and hermetically sealed interpretative systems that have lately become fashionable"; Kemp, review of *Patterns of Intention* (note 38), 141. As Kemp put it, the art historian seeking to untangle the causal web is faced with the fact "that our vocabulary and categories of discrimination are too crude—that we need a far more subtley defined series of categories, involving immediate circumstances, efficient causes, necessary conditions, inviolable constraints etc. Embedded in each of these are human intentions with their special compounds of conventionality and creative untidiness" (p. 134).

106. Charles Harrison, "Block 1, Form and Reading" in *An Introduction to the Humanities* (Milton Keynes, U.K.: Open University, 1997), 34.

107. Harrison, "Block 1" (note 106), 34.

108. Harrison, "Block 1" (note 106), 34.

109. Harrison, "Block 1" (note 106), 40.

110. Harrison, "Block 1" (note 106), 34. By this he means a question that is "relevant and useful to bear in mind but not necessarily desirable to resolve" (p. 38).

111. The opening sentence of Thomas Crow's *Emulation: Making Artists for Revolutionary France* (New Haven: Yale Univ. Press, 1995) is indicative of his approach: "What follows is a history of missing fathers, of sons left fatherless, and of the substitutes they sought" (p. 1). Personal histories (Jacques-Louis David and his followers Jean-Germain Drouais and Anne-Louis Girodet de Roucy-Trioson all lost their fathers early) and private desires are fused with historical events (the end of the monarchy) and republican ideology—with outcomes to be found in paint. Crow studies works of art through the spectacles of the life: grinding together refractory compounds of biographical contingencies, psychological complexities, and historical constraints.

112. Thomas Crow, *The Intelligence of Art* (Chapel Hill: Univ. of North Carolina Press, 1999), 2. An example of "intriguing surprises" can be found in his recent work on Gordon Matta-Clark's relation to alchemy; see Thomas Crow, "Gordon Matta-Clark," in Corinne Diserens, ed., *Gordon Matta-Clark* (London: Phaidon, 2003), 7–132.

113. Henry Ward Beecher, *Proverbs from Plymouth Pulpit: Selected from the Writings and Sayings of Henry Ward Beecher* (New York: D. Appleton & Co., 1887), 229.

114. Michael Kimmelman, *Portraits: Talking with Artists at the Met, the Modern, the Louvre, and Elsewhere* (New York: Random House, 1998), 103.

115. Maurice Merleau-Ponty, "Cézanne's Doubt," in idem, *Sense and Non-Sense,* trans. Hubert L. Dreyfus and Patricia Allen Dreyfus (Evanston: Northwestern Univ. Press, 1964), 25; cited in Soussloff, *The Absolute Artist* (note 2), 5.

ROSALIND KRAUSS

The title of this essay is borrowed from Eduardo Cadava's canny reminder of the vicissitudes through which the very concept of a subject-of-consciousness has gone since the 1960s.[1] Because authorship represents the heightened achievements of such a subject—the marshalling and mastering of intentions toward meaning and implication; the projection onto a work of that special unity and consistency that is the correlative of the continuity and coherence of selfhood—the status of authorship was vulnerable to attack by the advance guard of the post-structuralist critique of the centered subject, mounted throughout the 1960s.

The most notorious of these onslaughts was surely Roland Barthes's essay "The Death of the Author" (1968), essentially a promissory note for the magnificent study *S/Z* (1970), in which Barthes would demonstrate what he meant by that "birth of the reader" to which "the death of the author" would give rise. "A text," he explained,

> is made of multiple writings, drawn from many cultures and entering into mutual relations of dialogue, parody, contestation, but there is one place where this multiplicity is focused and that place is the reader, not, as was hitherto said, the author. The reader is the space on which all the quotations that make up a writing are inscribed without any of them being lost; a text's unity lies not in its origin but in its destination.[2]

By 1971, in "From Work to Text," Barthes underscored the implications of the death of the author: if the unity of the work could no longer be secured by its point of origin, it must be sought in the contrapuntal pleasures of its reception—in a burgeoning nexus that Barthes now baptized *text.*

Having thus dispatched the "author," Barthes did not abandon the writers he had learned to love but continued to explore what he now called "the pleasure of the text," linking that pleasure to "the amicable return of the author."[3] "Of course," he cautions, "the author who returns is not the one identified by our institutions (history and courses in literature, philosophy, church discourse); he is not even the biographical hero. The author who leaves his

text and comes into our life has no unity; he is a mere plural of 'charms,' the site of a few tenuous details, yet the source of vivid novelistic glimmerings, a discontinuous chant of amiabilities, in which we nevertheless read death more certainly than in the epic of a fate; he is not a person, he is a body."[4]

To elaborate this idea of "charms," Barthes writes:

What I get from Sade's life is not the spectacle, albeit grandiose, of a man oppressed by an entire society because of his passion, it is not the solemn contemplation of a fate, it is, *inter alia,* that Provençal way in which Sade says "milli" (mademoiselle) Rousset, or milli Henriette, or milli Lépinai, it is his white muff when he accosts Rose Keller, his last games with the Charenton linen seller (in her case, I am enchanted by the linens); what I get from Fourier's life is his liking for *mirlitons* (little Parisian spice cakes), his belated sympathy for lesbians, his death among the flowerpots; what I get from Loyola's life are not the saint's pilgrimages, visions, mortifications, and constitutions, but only his "beautiful eyes, always filled with tears." For if, through a twisted dialectic, the Text, destroyer of all subject, contains a subject to love, that subject is dispersed, somewhat like the ashes we strew into the wind after death (the theme of the *urn* and the *stone,* strong closed objects, instructors of fate, will be contrasted with the *bursts* of memory, the erosion that leaves nothing but a few furrows of past life): were I a writer, and dead, how I would love it if my life, through the pains of some friendly and detached biographer, were to reduce itself to a few details, a few preferences, a few inflections, let us say: to "biographemes," whose distinction and mobility might go beyond any fate and come to touch, like Epicurean atoms, some future body, destined to the same dispersion; a marked life, in sum, as Proust succeeded in writing his in his work.[5]

One year later, Michel Foucault presented "What Is an Author?" to the Collège de France as a response to the outcry against the way he had manhandled proper names in *The Order of Things* (1969). Spinning various corpuses of work into the threads of complex fabrics he called *épistémês* Foucault had woven together Georges Cuvier, Charles Darwin, Georges Buffon, and Carolus Linnaeus into what were decried as "monstrous families."[6]

Beginning his discussion in "What Is an Author" with the historical conditions that gave rise to the figure of the author, Foucault asked his listeners to remember the time when most texts were anonymous and the names of their authors were invoked merely as what he called "the index of truthfulness," as when it is written: "Hippocrates said"[7] With the development of copyright law in the eighteenth century, authorship took on a juridical status and the author was institutionalized as a way of handling no-longer-anonymous texts. Authorship was now invoked "as a standard level of quality," "as a certain field of conceptual or theoretical coherence," as a form of "stylistic uniformity," and "as a definite historical figure in which a series of events converge."[8]

The author, thus constructed, Foucault concludes, is "a function of discourse,"[9] making authorship the linchpin of the organization of knowledge into separate branches or disciplines. Foucault's decision to telescope the idea of an academic discipline into the term *discourse* is related to the operations on that term mounted by the structuralist linguist Émile Benveniste, who

preached the strict division of expository language into what he called *narra-tive,* on the one hand, and *discourse,* on the other. *Narrative,* the term for neu-tral transmissions of information, such as history or biography, is marked, Benveniste pointed out, by the use of third-person pronouns and the special historical past tense, the preterite.[10] *Discourse,* referring to live interchange, engages the first- and second-person pronouns and the present tense. For Foucault, the events of May 1968 enforced the special trauma of a collapse of this neat distinction, as the police were summoned into the Sorbonne at the invitation of the university's administration (something that had not hap-pened since the Middle Ages) and the careful decorum of the university was imploded. As a consequence, discourses—whether in the form of the police interrogation or the university exam—were suddenly understood to be *disci-plinary.* This was the source of Foucault's decision to organize the promulga-tion of knowledge (discourse) around the imposition of power (discipline). Authorship, he concludes in "What Is an Author," is a function of disciplinary order: "The name of an author serves as a means of classification," he wrote. "The name of the author remains at the contours of texts—separating one from the other, defining their form, and characterizing their mode of exis-tence; it does not move from the interior of a discourse to the real person out-side who produced it."[11]

 With these two conceptual markers—*text* and *function*—post-structuralism consolidated its moves against the biographical, empirical person of the author. Any account of this must, however, appear enigmatically arbitrary without a sense of the strong impact of Martin Heidegger's thought on French philosophy in the interwar period and of Heidegger's own assault on the legiti-macy of the post-Enlightenment idea of the centered subject.[12] In Heidegger's view in "The Age of the World Picture," the source of this disruption in the concept of the subject lay in the mistranslation of the Greek word for sub-stance—*hypokeimenon*—into the Latin word *subiectum* (subject), or relational center, with the result that man becomes the only being upon which all that is, is grounded, as regards the manner of its Being and its Truth.[13] Understanding himself as such a subject, man sets up his representations as a form of objec-tification: phenomena are made visible by being seen within the perspective of a ground-plan, which is projected in advance, "mathematically" (as in the geometrical projection of perspective that maps out the ground-plan, which Heidegger writes as *Grundriss*).[14] Organized on such a ground-plan, the phe-nomena are grasped as a picture, such that, as Heidegger says: "The word 'pic-ture' [*Bild*] now means the structured image [*Gebild*] that is the creature of man's producing which represents and sets before."[15]

 It is in the slightly later essay, "The Question Concerning Technology" (1955), that one first finds an explanation of the malign connotations of the idea of *Gebild,* which in the analysis of technology will reappear as *Gestell,* another variant of the idea of picture, or *Gestalt.* Having decided that technol-ogy is a way of revealing, Heidegger defines it as a kind of challenging-forth that is also a storing-up, as in the way the dam on the river makes it possible to store-up energy in order to call upon it later. Such storing-up Heidegger will call *standing-reserve,* or *Bestand,* the transformatory potential of which will turn everything within its purview into a stock-part, a cog in the machine of standing-reserve. In addition to this reification of nature, Heidegger argues,

as the administrator of the standing-reserve, man himself becomes standing-reserve. Further, since *Bestand* implies orderability and substitutability, objects will necessarily lose their autonomy. The system that gathers things together as standing-reserve Heidegger calls *Gestell,* or enframing, and he ties this concept back to the idea of the world projected onto the ground-plan and thus grasped as reified picture.

If the enframing operations of *Gestell* represent a challenging forth, which falls upon and insults objects, the opposite can be said of the poetic operations of *Gestalt,* or bringing forth, which reveal the object's connection to its projection-plan in terms Heidegger calls *rift-design* (a simultaneous distinction and connection of object and ground).

The paired opposition between *Gestell* and *Gestalt* will reappear in Michael Fried's important essay "Art and Objecthood" (1967), the Heideggerian overtones of which are easy to trace and will key this discussion not only to contemporary aesthetic production but also to contemporary scholarship. "Art and Objecthood" turns on the opposition between the linked terms *presence* and *presentness,* the former connected to something like the Heideggerian *Gestell* and the latter to *Gestalt.* For Fried, *presence,* like *stage presence,* is a form of gesturing to and playing for the members of an audience such that they are turned into the subjects of the inert and self-aggrandizing objects of what Fried condemns as *literalist* art (minimalism). *Presentness* counters this in ways cognate with the idea of *Gestalt:* "At every moment the *work itself is wholly manifest,"* Fried writes, in a "continuous and entire present-ness, amounting, as it were, to the perpetual creation of itself, that one experi-ences as a kind of *instantaneousness:* as though if only one were infinitely more acute, a single, infinitely brief instant would be long enough to see everything, to experience the work in all its depth and fullness, to be forever convinced by it."[16]

A brief digression is needed here to open Fried's condemnation of mini-malism to question, or at least to detach it from the Heideggerian parallel I have been setting up. If Heidegger associates *Gestalt* with poesis, and thus the saving destiny of art, he does so because the contour of a form (which he also calls *rift-design*) brings its context into relief, making a socius appear.[17] Fried's *instantaneousness,* by contrast, eclipses this socius, driving the context into permanent obscurity, and, indeed, it is only minimalism (think here of Donald Judd, Robert Morris, Carl Andre, and Robert Smithson), with its demand that the viewer circulate around the object, that brings the world, or context of the object, back into experience, producing a basis for the collectivity of commu-nal perception.

To return for a moment to "Art and Objecthood," we can see that Fried's project is at one and the same time to destroy the subject-of-presence and restore the subject-of-presentness, the viewer who, seeing everything, is able, in Fried's terms, "to experience the work in all its depth and fullness." Fried thus realizes in this essay what Barthes had called the "twisted dialectic" of the Text, as this "destroyer of all subjects" nonetheless "contains a subject to love," one that is "dispersed, somewhat like the ashes we strew into the wind after death."[18]

It is not Text, however, that is currently resurrecting the biographical subject for contemporary scholarship; rather, it is the "twisted dialectic" called trauma that is presently doing this job.

To grasp the logic of this particular set of reversals through which trauma defeats Text and resurrects the author, we must review Freud's elementary lesson of trauma from "Beyond the Pleasure Principle" (1920), in which trauma befalls a subject who was unfortunately absent—too distracted or decentered to defend him- or herself properly at the time of attack. The life story of the traumatic subject is thus the account of a fundamental absence and lack of preparation. Because of this, trauma studies is addicted to biography, which is to say, to the reconstruction of decentering and the shattering that is its result. Shoshana Felman has become the Oprah Winfrey of trauma studies and her book *Testimony* (coauthored with Dori Laub in 1992) is one account after another of the immobilization of the trauma victim, as in Paul de Man's experience of the impossibility of witnessing, Albert Camus's depiction of suicide in *The Fall,* and Walter Benjamin's suicide.[19]

For some years it has seemed that the taste for trauma would never abate and that the Shoah Business would go on forever. But trauma has mutated recently and the form of biographical scholarship will undoubtedly run in this new direction. The latest guise of trauma studies is multiple personality disorder: a burgeoning of subjects at the site of infantile traumas. Ian Hacking's *Rewriting the Soul* (1995) is an early investigation of what the jacket copy describes as this "hot topic." Reading Hacking's book makes it clear that if "who comes after the subject" is a multiple personality, nothing will restore the concept of identity, of the centered, autonomous subject, immediately present to himself, that has served us for many centuries.

NOTES

1. See Edouardo Cadava, Peter Connor, and Jean-Luc Nancy, eds., *Who Comes after the Subject?* trans. Michael Syrotinski et al. (New York: Routledge, 1991).

2. Roland Barthes, "The Death of the Author," in idem, *Image, Music, Text,* trans. Stephen Heath (New York: Hill & Wang, 1977), 148.

3. Roland Barthes, *Sade, Fourier, Loyola,* trans. Richard Miller (New York: Hill & Wang, 1976), 8.

4. Barthes, *Sade, Fourier, Loyola* (note 3), 8.

5. Barthes, *Sade, Fourier, Loyola* (note 3), 8.

6. Michel Foucault, "What Is an Author?" in idem, *Language, Counter-Memory, Practice,* trans. Donald F. Bouchard (Ithaca: Cornell Univ. Press, 1977), 114.

7. Foucault, "What Is an Author?" (note 6), 126.

8. Foucault, "What Is an Author?" (note 6), 128.

9. Foucault, "What Is an Author?" (note 6), 124.

10. Émile Benveniste, "The Nature of Pronouns," in idem, *Problems in General Linguistics,* trans. Mary Elizabeth Meek (Coral Gables, Fla.: Univ. of Miami Press, 1971), 217–22.

11. Foucault, "What Is an Author?" (note 6), 123.

12. Heidegger's impact on French philosophy is especially clear in Jacques Derrida's consideration of the subject. See Jacques Derrida, "The Double Session," in idem, *Dissemination,* trans. Barbara Johnson (Chicago: Univ. of Chicago Press, 1981), 173–286; Jacques Derrida, "The Violence of the Letter," in idem, *Of Grammatology,*

trans. Gayatri Chakravorty Spivak (Baltimore: Johns Hopkins Univ. Press, 1974), 101–40; and Jacques Derrida, *Speech and Phenomena: And Other Essays on Husserl's Theory of Signs,* trans. David B. Allison (Evanston, Ill.: Northwestern Univ. Press, 1973).

13.　On *hypokeimenon,* see Martin Heidegger, "The Age of the World Picture," in idem, *The Question Concerning Technology and Other Essays,* trans. William Lovitt (New York: Harper & Row, 1977), 128.

14.　Heidegger, "The Age of the World Picture" (note 13), 119.

15.　Heidegger, "The Age of the World Picture" (note 13), 134.

16.　Michael Fried, *Art and Objecthood* (Chicago: Univ. of Chicago Press, 1998), 167.

17.　In "The Age of the World Picture" (note 13), 133, Heidegger writes:

> The interweaving of these two events, which for the modern age is decisive—that the world is transformed into picture and man into *subiectum*—throws light at the same time on the grounding event of modern history, an event that at first glance seems almost absurd, namely, the more extensively and the more effectually the world stands at man's disposal as conquered, and the more objectively the object appears, all the more subjectively, i.e., the more importunately, does the *subiectum* rise up, and all the more impetuously, too, do observation of and teaching about the world change into a doctrine of man, into anthropology. It is no wonder that humanism first arises where the world becomes picture.

18.　See Barthes, *Sade, Fourier, Loyola* (note 3), 8–9.

19.　Shoshana Felman and Dori Laub, *Testimony: Crises of Witnessing in Literature, Psychoanalysis, and History* (New York: Routledge, 1992), 137, 157, 165–67, 155; and Shoshana Felman, "Benjamin's Silence," *Critical Inquiry* 25 (1999): 201–34.

Leonardo's Modernity: Subjectivity as Symptom

ROBERT WILLIAMS

How we understand the purpose and value of biography for the history of art depends on what we believe the relationship between art and subjectivity to be. Their association is neither natural nor necessary; rather, it is historically constructed. Yet this association has become so close in modern times as to suggest that the two terms are crucially interdependent, even that their interdependence may be essential to the achievement of artistic modernism. Interrogating the nature and value of subjective experience is very nearly the function of art in the modern world, the specific work that our culture calls upon it to perform. Our interest in artistic biography—which survives despite the critique of subjectivity that climaxed in post-structuralism—can be taken to reflect the cultural-historical fact that subjectivity is fundamental to the content of art, that what is at stake for us in art is nothing less—nor more— than ourselves.

Perhaps the classic formulation of the modern association of art and subjectivity is found in Émile Zola's essay on Éduoard Manet. Zola saw the work of art as the document of a "temperament," "a personal mark, an individuality": "In works of art, I seek to find behind each an artist, a brother, who presents nature to me under a new face, with all the power or all the sweetness of his personality. The work, thus seen, tells me the story of a heart and of a body, speaks to me of a civilization and of a locality."[1]

Temperament, for Zola as for Baudelaire before him, distinguishes a painting from the mechanical impersonality of the photograph, but it also distinguishes the genuine modern painter from the academic painter. The academic painter alters, extends, and shapes himself; the modern artist avoids such self-manipulation as dishonest. As Charles Baudelaire said in one of his discussions of Eugène Delacroix: "it is necessary . . . to accept the destiny of a talent, and not try and bargain with genius."[2] Zola put it perhaps even more beautifully: to be an artist, he wrote, "you must abandon yourself bravely to your nature and try not to lie to yourself."[3]

Both Baudelaire and Zola speak of subjectivity as something given, natural, instinctively felt, and strongly marked; something revealed in spontaneous sympathies and antipathies; something we just know about ourselves and, in

that sense, something unproblematic. Baudelaire, as a romantic, emphasizes subjectivity as a truly personal possession—associating it with "the invisible, the impalpable, the dream, the nerves, the *soul*"[4]—and thus as existing in opposition to the objective conditions of life in society. Zola sees it as permeated by impersonal conditions, "a heart and ... a body," but also "a civilization and a locality," phrasing that reveals the influence of scientific positivism—the "race, milieu, and moment" of Hippolyte-Adolphe Taine.[5] Either way, subjectivity is understood as a kind of natural resource, the native strength and abundance of which allows the artist to cast off the fetters of convention, to create a new language, one that may be limited—in that it is his or her own—but one that is also capable of expressing a kind of truth we can all share.

Subjectivity is thus a *critical* resource, and mobilizing it a strategy of opposition to the prevailing social and cultural order. We have no problem recognizing this heroic individualism as a legacy of romanticism and as a defensive response to the real conditions of individuality in the modern world—to the dehumanizing disciplinary regimes of industrial capitalism, perhaps to the suppressed fear that real individuality is already extinct. And though we—even those of us least sympathetic to post-structuralism— are likely to find Zola's formulation too simple, too romantic, we still retain a degree of sympathy for it, surely because we are still subject to such coercive forces. The notion of art as an expression of temperament or personality is still widespread in our culture, but it has lost almost all of its critical edge. Art is commonly regarded as the realm where people "express" themselves, not only artists but we, the public, as well. We are free to have preferences and to indulge them, and we move through art museums in much the same way we move through department stores, sampling the wares.

Zola's sensitivity to the two-sidedness of subjectivity, to the fact that it is both personal and impersonal, points to something problematic, unresolved if not contradictory, in his apparently simple formulation. For us, a more obvious limitation is indicated by his overly simplistic reading of Manet: Zola claimed that Manet had "tried to forget everything that he had studied in the museums"[6]—that is, in the course of his academic training—yet, as has often been pointed out, that is not what Manet did. A picture like *Luncheon on the Grass* (1863; Paris, Musée d'Orsay) depends on its engagement with older art: only by using a Renaissance masterpiece as a kind of armature can Manet say what he has to say.[7] Our own approach to Manet is different: we might be inclined to insist, for example, that such a picture—in contrast to those of Gustave Courbet—exposes the fact that the "real" cannot be approached directly but emerges only in a critical engagement with illusion, the personal and original in critical engagement with the conventional and traditional.

The problematic nature of Zola's formulation is cast into even greater relief by his own strategy as a writer, which involved deliberately suppressing his personality in the interests of a scientific objectivity. The same man who said that to be an artist "you must abandon yourself bravely to your nature" also planned his own novels as relentlessly systematic demonstrations of "scientific" principles.[8] And however much his remarks about Manet seem to insist upon the importance of subjectivity, Zola was not subjective enough for the symbolist writers of the next generation. Both the notion of art as pure, personal expression and the notion of subjectivity as natural are problematic:

they are oversimplifications that indicate nevertheless, in their reciprocal dependency, how important the connection between art and subjectivity is. A similar tension is found in Baudelaire's idea that Delacroix—or Constantin Guys—possessed both "naïveté" and "cosmopolitanism."[9] Such terms expose a complexity they ostensibly are trying to suppress, and in the case of Manet, we realize that such naïveté is in fact anything but naive.

The historian Jacob Burckhardt was a contemporary of Zola's, and it was he who defined the great achievement of the Italian Renaissance as the discovery of modern subjectivity.[10] Subsequent Renaissance scholarship has revised Burckhardt's formulation, and we have no problem recognizing that it, too, is overly simplistic, a projection back onto the Renaissance of an ideal-ized subjectivity that is also a reaction against the realities of modern life. Burckhardt was an outspoken conservative and bourgeois apologist, and by displacing the origins of heroic individuality back several hundred years, he robbed it of much of the critical content that it held for Zola. Burckhardt's notion of Renaissance individuality is still very much alive in middlebrow cul-ture, in what we might call the "Miramax Renaissance": movies that represent the Renaissance as a time when people gave themselves to sensuality, mate-rialism, and the lust for power and did so without the kinds of misgivings that inhibit most of us, allowing us to establish an idealized relation to all those selfish impulses that in fact prove so useful in modern life.

The New Historicist studies of Elizabethan literature during the 1980s and 1990s can be said to follow Burckhardt in that they emphasize the impor-tance of subjectivity as an achievement of Renaissance culture; they depart from him, however, by insisting that it is not something given or natural but a product of self-conscious posturing, of "self-fashioning." Borrowing the con-ceptual tools of French post-structuralism, the New Historicists understood subjectivity as a discursive effect, an effect of representation, and they tended to speak of "subject positions" or "subjectivity effects" rather than of subjec-tivity itself.[11] The influence of New Historicism has made its way—slowly—into the study of Renaissance art. Joseph Koerner's study of self-portraiture in German Renaissance art, for example, involves a discussion of the elaborate strategies at work in Albrecht Dürer's *Self-Portrait* (1500; Munich, Alte Pinakothek).[12]

New Historicism exposes the relation of subjectivity to larger social forces—capitalism, racism, sexism—and presents it as a symptom of power; it also recognizes self-fashioning as a strategy of both complicity and resistance. Stephen Greenblatt's reading of Hans Holbein the Younger's *The Ambassadors* (1533; London, National Gallery) not only stresses the tension between the plenitude of the world, indicated by the confident bearing of the figures and their array of books and instruments, and the consciousness of death, indi-cated by the anamorphic skull, but it also calls attention to the radical incom-patibility, the mutual exclusivity, of the two perspectives.[13] In its emphasis on the fact that neither point of view entirely satisfies, and that we are yet unable to reconcile them, Greenblatt's reading holds out for a world beyond represen-tation, and this position can be said to imply—in however attenuated a fash-ion—some kind of "natural" subject. We might call it a "sublime subject" in that its presence is glimpsed only in the inadequacies of representation. New Historicism tends to reinforce a naturalistic reading of Renaissance art and

literature and thus only partly undermines the naturalistic assumptions of the modernism evident in someone like Zola.[14]

Koerner recognizes that the heroic conception of the artist reflected in Dürer's picture was developed in Italy, yet, like many scholars of Northern Renaissance art, he also argues that something more is at stake in images such as Dürer's.[15] Koerner would have us believe that Dürer's identification with Christ is distinctly unlike that expressed by Leon Battista Alberti, who remarked that the painter able to represent convincingly whatever he wishes, and hearing himself praised, "will feel himself to be another god,"[16] or by Vasari, who insisted on the divinity of artists such as Leonardo da Vinci, Michelangelo Buonarroti, and Raphael,[17] or by Leonardo in his own writings.[18] In all three cases, the artist emerges as a uniquely empowered subject; we even get the suggestion—derived from ancient rhetorical theory—that the artist represents the highest form of subjectivity, that it is in the artist that individuality achieves its ideal form. In Italian art and art theory the artist-subject derives its authority from the ability it acquires—primarily through the sustained and disciplined study of nature—to transcend its own limitations. The emphasis on this process of self-objectification and what might be called self-overcoming redefines the artist's work in a fundamental way: not only does it displace interest from the production of specific objects to the kind of ongoing dialogue with "nature" that elevates art from a manual craft to a scientific or philosophical vocation but it also exposes the relentlessly self-critical, all-consuming personal discipline involved.

For Leonardo, such discipline is required to achieve a truly "scientific" painting.[19] Every waking moment must be turned to account. The painter must not avoid practicing drawing on feast days, for example.[20] He must take care to organize his time in the most efficient manner, and no time is to be wasted: to avoid mental fatigue the painter should take frequent walks, and he should use these walks to observe the things he sees.[21] The artist's leisure time is thus reabsorbed back into his larger work. In observing the world, the painter should look at everything, not just people, landscape, and light effects but bits of old wall, piles of ashes, clouds, and mud-puddles, "which can mean whatever you want [them] to."[22] Even lying in bed at night, before he falls asleep, the painter should "run the imagination over the surface delineations of forms previously studied, or other remarkable things encompassed within subtle speculation," a "most praiseworthy activity … useful for fixing things in the memory."[23] Art is work, both in the sense of application to particular tasks and as a comprehensive personal discipline that enters into and transforms every corner of experience, every recess of consciousness. The artist must make himself over entirely according to the demands of his vocation. Art requires a mobilization of all the resources of subjectivity: it is not just a reactive and provisional form of self-fashioning; rather, it demands a sustained and systematic effort to establish the conditions of the possibility of all self-fashioning.

This all-encompassing and self-reflexive discipline involves cultivating solitude and independence of mind, distancing oneself from one's colleagues, or, if working in their company, doing so only in order to stimulate one's natural competitiveness and so spur oneself on to greater efforts.[24] One should be attentive to criticism, especially to that of one's enemies, since they are

likelier to be more honest. The need to use other people goes hand in hand
with a deep mistrust of them: one has to be on guard against false friends who
praise us only so that we will go on making the same mistakes.[25]

The painter must look at everything, must absorb everything, but he
must maintain a rigorous, self-conscious isolation. He must dedicate himself
to nature, but he must practice a discipline that is profoundly unnatural: "The
painter ought to keep his own company and reflect upon that which he sees.
He should debate with himself and choose the most excellent parts of the
kinds of things he sees. He should be like a mirror which is transformed into
as many colours as are placed before it, and, doing this, he will seem to
become a second nature."[26] Through this relentless discipline, the artist over-
comes the limits of his own subjectivity: he ceases to be merely himself and
becomes a "second nature."

The most extreme indication of the kind of rigorous self-consciousness
that Leonardo advocates is his advice that the painter have his own body
measured so that he may understand exactly how his proportions differ from
the norm. Because the soul—according to the Aristotelian physiology preva-
lent in Leonardo's day—shapes the body as well as all the products of the
body, painters will automatically represent figures that share their own physi-
cal characteristics. To circumvent this tendency—which Leonardo deplores
and claims to see evidenced everywhere around him—the artist must compen-
sate in a calculated way so that his figures are appropriately varied in form.[27]
In the effort to represent the world truthfully, the painter must thus work
against the very faculties that condition his perception of the world: he must
work *against himself* at the very deepest levels and in the most aggressive way.
If painting is fundamentally a study of nature, it is also fundamentally a work
of self-criticism, of self-overcoming, and, ideally, of self-transcendence. Art
aspires to the attainment of an objective truth but also to the fashioning of an
ideal subjective disposition toward the world, an overall existential poise, and
this disposition is fundamentally *critical.* Art transforms subjectivity itself into
a critical principle.

Similar concerns, and a similar kind of critical negativity, are evident in
the early sixteenth-century debate between Giovanni Francesco Pico della
Mirandola and Pietro Bembo over imitation in literature. Pico maintained that
one should freely borrow from many different models, allowing oneself to be
guided by instinct; one's choices, he believed, would in fact be governed by
an innate idea of style, implanted in each of us by nature. Bembo, by contrast,
insisted that there was no innate idea: "For my part, I assure you that I saw
no form of style, no image of eloquence in myself until many years of reading
the ancient books, great mental effort, and much practice writing had made
me one."[28] Bembo did not doubt the existence of an idea of perfect style in the
mind of God, and he maintained that because our minds always prefer the
best, each writer must try to approach that ideal as nearly as possible. But pre-
cisely because that ideal is an ideal, it is singular, and anyone's degree of suc-
cess in approximating it can be objectively measured. One writer must come
nearer to it than all others, and that writer must thus be our principal guide to
perfection. This reasoning led Bembo to his belief that it was best to imitate
Cicero when writing Latin prose, Virgil when writing Latin poetry, and
Giovanni Boccaccio and Francesco Petrarch when writing in the vernacular.

Bembo's position, which seems so dogmatic and authoritarian to us at
first glance, was the more popular in his time, at least in Italy; Pico's won out
over the long term, and especially in northern Europe, where it was endorsed
by Erasmus, among others. The preference for Bembo over Pico is still usually
interpreted by modern scholars as an indication of the backward-looking
nature of Italian humanism.[29] But Bembo is effectively saying that there is no
natural subject position, that identity must be—can only be—itself an artistic
construct, and, since that is the case, the artist's guide can only be the highest
possible conception of art: artistic identity can only be deduced from the
larger ideal totality of art. I would suggest that Bembo's position is less naive
than Pico's, that it reveals a sense of the infinite volatility of the subject that
we recognize as near to our own, and that it makes art into a crucially impor-
tant instrument of self-articulation and self-realization in a manner that
remains operative for us. Bembo redefines art as the medium through which
subjectivity becomes possible. Both Bembo and Leonardo are forced to their
exalted conception of art by their sense of the profoundly problematic nature
of subjectivity—and theirs is the moment at which the modern association of
art and subjectivity is established.

Raphael's career also documents this moment of association. Having
mastered at a young age a somewhat provincial late-fifteenth-century style,
derived from his putative master, Perugino, Raphael reinvented himself, bor-
rowing the best elements from the work of forward-looking artists such as
Leonardo and Michelangelo. "Out of many styles," Vasari says, "he fashioned
one" that became "his," but not only his, for in constructing himself this way,
he provided a model for all younger artists to follow.[30] Raphael demonstrates
the importance of conscious self-fashioning, and the principle of "synthetic
imitation" that he developed becomes the model for all self-fashioning, his
synthetic identity becomes the model for all artistic identity in the academic
tradition, and his selfless selfhood becomes the model for all selfhood.

Again, it is worth noting how much *work* this involves: Raphael surveys
and comprehensively integrates the stylistic alternatives surrounding him.
Where Leonardo stressed the mastery of nature, Raphael's emphasis is on the
mastery of cultural codes. The transition from Leonardo to Raphael is thus
to be understood as something like the transition "from nature to culture."[31]
The comprehensiveness of Raphael's work is evident not only in his choice
and combination of styles, which points to an objective system of styles, but
also in his application of the principle of decorum, which points to a system
of representational codes, the systematicity of representation itself.[32] Another
important aspect of Raphael's achievement, as far as his contemporaries
were concerned, was his ability to orchestrate large numbers of assistants so
that each of their different capabilities contributed to a unified finished
product. This approach pointed to an impersonal, hence more objective,
creative process.

Michelangelo, too, though his artistic strategy is in many ways unlike
that of Leonardo or Raphael, participates in this effort to mobilize—simul-
taneously to instrumentalize and transcend—subjectivity. Though Michel-
angelo's art is exclusively concerned with the body, he avoids portraiture; his
dedication to idealism involves negating and reconstituting the world.
Michelangelo's sense of the problematic nature of identity is colored by

Christian Neoplatonism—in which the self is only a provisional reality—but he
also expresses at several points in his poetry the need to deduce himself from
art, in a manner similar to that which we observe in Leonardo, Bembo, and
Raphael. Michelangelo's susceptibility to beauty, for instance, demands that
he feed himself, so to speak, on all beauty:

> My eyes, desirous of beautiful things,
> And my soul, likewise, of its salvation,
> Have no other means to rise
> to heaven, but to gaze at all such things.[33]

Michelangelo, too, must deduce himself from his work as an artist; even his
susceptibility to beauty has to become a comprehensive discipline, in which
both his physical and spiritual appetites find satisfaction.

We forget how radical such dedication to beauty could be: the Pietà
(1497–99; Vatican City, Basilica of Saint Peter) was criticized for being too
idealistic; the Virgin Mary, critics pointed out, is too young. Michelangelo later
maintained that he had made her that way in order to show that "chaste
women maintain their freshness longer than those who are not chaste,"[34] but
his real motivation is perhaps better indicated by the contract for the work,
which survives, with its codicil promising that the finished sculpture "will be
the most beautiful marble which can be seen in Rome today."[35] Perhaps
Michelangelo simply wanted to make it as beautiful as possible, and in so
doing, demonstrate his ability to surpass ancient sculpture. When someone
complained that the effigies in the Medici Chapel did not resemble the people
whom they supposedly represented, Michelangelo is reported to have said
that he "made them that way in order to earn them more praise, and that in a
thousand years, there will be no one to say that they looked otherwise."[36] This
radical edge—the critical negativity of idealism—is present even in a later
work like *The Last Judgment* (1536–41; Vatican City, Sistine Chapel), which was
attacked by some contemporaries for its indifference to decorum, its insis-
tence on the display of artifice.[37]

The evidence suggests, then, that the Italian Renaissance was not so
much the great age of individuality described by Burckhardt as it was the
moment when individuality was discovered to be fundamentally problematic,
fundamentally a matter of representation, and thus the moment when art
and subjectivity became mutually dependent at the deepest level. This devel-
opment was the result of a set of specific cultural pressures: the simultaneous
integration and diversification—the rationalization—of economic and social
life exposed people to new patterns of coercion and demanded of them not
only an increased level of personal organization and discipline but the *inter-
nalization* of discipline described by historical sociologists such as Max Weber,
Norbert Elias, and Michel Foucault.[38] The resources of the self were instru-
mentalized with a new invasiveness; being a self called for a new degree and
a new kind of work, and art responded to that need. Art came to be redefined
in relation to a technique of *self*-coercion or *self*-instrumentalization; it accom-
modated external pressures while reconfiguring them in ideal form. It thus
became a means of defining selfhood in ideal terms. Because self-definition
took place in representation—and in the system of representation we call

culture—it was particularly the systematicity of representation that the most sophisticated artists were concerned to address.

To define the Renaissance achievement in this way is to move beyond the old notion of a natural subjectivity associated with Burckhardt and to move beyond New Historicism as well. Most self-fashioning was and is opportunistic, reactive, and governed by conventions, but the idea of art developed in Renaissance Italy involved something more: it was a response to the need for an ideally comprehensive and rigorous critical practice, one that also necessarily subsumed the practice of the self. If New Historicism establishes the fact that subjectivity is a symptom of power, culture, and representation, the case being made here is that subjectivity is a symptom of art, and, furthermore, that such a realization produces a more critical, more modern conception of both art and subjectivity. The concern with rigor and systematicity is not just a critique of natural selfhood but of all more casual—"naïve"—kinds of self-fashioning.

Modern art seems to have renounced self-coercion and the aspiration to systematicity, identifying them with academic practice, but modernism, too, was a response to cultural pressures and involved an all-consuming kind of work. To return to the moment inaugurated by Zola, we might remember the old Claude Monet, describing how he sat by his water lily pond, trying to capture the elusive effects of light and color,[39] or the old Paul Cézanne, telling his son that he had found a spot by the river from which he could make an endless number of pictures, just by turning his head a little to one side or the other.[40] These two artists sound very much like Leonardo. They may not aspire to a complete scientific understanding of nature, but they do seek an ideal subjective disposition toward the world, an ideal existential poise. For them, as for Leonardo, the ability to paint the right kind of pictures depends on a comprehensive art of the self. Not only is modernist naïveté not naive, modernist irrationality is not irrational. Subsequent forms of modernism that have cultivated unreason—from Arthur Rimbaud to the Surrealists to Gilles Deleuze and Félix Guattari—involve not only strategic gestures within a highly self-conscious and critically focused performance of subjectivity but also a demanding personal discipline. Rimbaud famously described his project as "a long, gigantic and rational *derangement* of *all the senses*,"[41]—*rational* derangement—while actually attempting to live out the kind of nomadic or rhizomatic post-subjectivity advocated by Deleuze and Guattari in *Anti-Oedipus* would involve at least as much work as being the kind of artist described by Leonardo.[42]

I have argued that Italian Renaissance artists saw into the abyss of the self in a way that anticipates modernism, and also that their awareness of the way in which subjectivity depends on representation both prefigures post-structuralist notions of subjectivity as an effect of discourse and points beyond them. By the same token, the Renaissance sense of representation as an instrument of coercion, but also, potentially, of liberation, bespeaks a critical engagement that we customarily associate only with modern art. Though the Renaissance artist's aspiration to the ideal of an all-comprehending subject, or the belief in the possibility of deducing oneself from art, may no longer seem to be a realistic option, we are still answerable to the larger context—the cultural system—within which our creative activity occurs. The

lesson of this example is perhaps more relevant than ever at a time when sub-
jectivity seems about to undergo some still more profound transformation at
the hands of technology—of artificial intelligence, on one side, and genetic
engineering, on the other. Someday soon, *Anti-Oedipus* may well begin to look
like an old-fashioned humanist treatise.

One final suggestion involves "work" as an idea around which artistic
biography, even art history as a whole, might be built. Art is work: physical
and intellectual, but also cultural. The artist, the art object, the viewer—even
the critic and the art historian—each do a kind of work on which culture
depends. Selfhood is also work: producing, consuming, doing all the things
we do, having feelings, having thoughts, all of which contributes to—indeed,
sustains—culture. Work is where art and subjectivity meet; *it is the real ground
of their historical interrelation.* Thinking of art as work allows us to integrate
it into history more deeply, it makes art's historicity more tangible, and it
offers a way of integrating biography back into art history, a perspective from
which human interest is not incidental.

NOTES

1. Émile Zola, "Édouard Manet (1867)," in Joshua C. Taylor, ed. and trans., *Nineteenth-
 Century Theories of Art* (Berkeley: Univ. of California Press, 1987), 422.

2. Charles Baudelaire, *Art in Paris, 1845–1862: Salons and Other Exhibitions Reviewed
 by Charles Baudelaire,* ed. and trans. Jonathan Mayne (London: Phaidon, 1970), 59.

3. Zola, "Édouard Manet" (note 1), 428.

4. Charles Baudelaire, *The Painter of Modern Life and Other Essays,* ed. and trans.
 Jonathan Mayne (London: Phaidon, 1964), 43.

5. Taine's influential formulation is found in the introduction to his *History of
 English Literature,* trans. Henry van Laun (New York: P. F. Collier, 1900), 1:13–19.

6. Zola, "Édouard Manet" (note 1), 421.

7. For Manet's relation to the traditions of high art, see esp. Michael Fried, *Manet's
 Modernism; or, The Face of Painting in the 1860s* (Chicago: Univ. of Chicago Press,
 1996).

8. For an early programmatic statement of Zola's aims as a novelist—written shortly
 after his essay on Manet—see the preface to the second edition of *Thérèse Raquin*
 (Paris: Garnier-Flammarion, 1970), 59–64.

9. Baudelaire, *Art in Paris* (note 2), 56–57, 60–61; and Baudelaire, *Painter of Modern
 Life* (note 4), 6–7.

10. Jacob Burckhardt, *The Civilization of the Renaissance in Italy,* trans. S. G. C.
 Middlemore (New York: Harper & Row, 1958), esp. 143–44, 279, 303.

11. Important examples include: Stephen Greenblatt, *Renaissance Self-Fashioning:
 From More to Shakespeare* (Chicago: Univ. of Chicago Press, 1980); Joel Fineman,
 Shakespeare's Perjured Eye: The Invention of Poetic Subjectivity in the Sonnets
 (Berkeley: Univ. of California Press, 1986); and Joel Fineman, *The Subjectivity
 Effect in Western Literary Tradition: Essays toward the Release of Shakespeare's Will*
 (Cambridge: MIT Press, 1991). For an anthology of representative essays, see
 H. Aram Veeser, ed., *The New Historicism* (New York: Routledge, 1989).

12. Joseph L. Koerner, *The Moment of Self-Portraiture in German Renaissance Art*
 (Chicago: Univ. of Chicago Press, 1993).

13. Greenblatt, *Renaissance Self-Fashioning* (note 11), 17–26.

14. Koerner claims, for instance, that Dürer's art engages in a complex self-conscious
 play with the limits of representation yet is also capable of phenomenological
 revelation, that it "enables our gaze to tunnel to the *Ding an sich*"; Koerner,

Moment of Self-Portraiture (note 12), 166. A similar insistence on the way in which a Renaissance artist—in this case an Italian—might productively thematize the limitations of visual images is found in Stephen J. Campbell, *Cosmè Tura of Ferrara: Style, Politics, and the Renaissance City, 1450–1495* (New Haven: Yale Univ. Press, 1997), esp. 133, 151–53, 158–61. For another critique of New Historicist accounts of Renaissance subjectivity, different from the one proposed here, see John Jeffries Martin, *Myths of Renaissance Individualism* (New York: Palgrave Macmillan, 2004).

15. Koerner, *Moment of Self-Portraiture* (note 12), 65, 127–38.

16. Leon Battista Alberti, *On Painting,* trans. John R. Spencer (New Haven: Yale Univ. Press, 1966), 64.

17. Giorgio Vasari, *The Lives of the Most Eminent Painters, Sculptors, and Architects,* trans. Gaston Du C. de Vere (New York: Abrams, 1979), 2:778 (Leonardo); 1:19, 3:1832 (Michelangelo); 2:878, 2:914–15 (Raphael).

18. Martin Kemp, ed., *Leonardo on Painting: An Anthology of Writings by Leonardo da Vinci with a Selection of Documents Relating to His Career as an Artist,* trans. Martin Kemp and Margaret Walker (New Haven: Yale Univ. Press, 1989), 32.

19. Robert Williams, "The Spiritual Exercises of Leonardo da Vinci," in Paul Smith and Carolyn Wilde, eds., *A Companion to Art Theory* (Oxford: Blackwell, 2002), 75–87.

20. Kemp, *Leonardo on Painting* (note 18), 195.

21. Kemp, *Leonardo on Painting* (note 18), 199, 202–3.

22. Kemp, *Leonardo on Painting* (note 18), 201–2, 222.

23. Kemp, *Leonardo on Painting* (note 18), 224–25.

24. Kemp, *Leonardo on Painting* (note 18), 205.

25. Kemp, *Leonardo on Painting* (note 18), 196.

26. Kemp, *Leonardo on Painting* (note 18), 202.

27. Kemp, *Leonardo on Painting* (note 18), 204. See also Martin Kemp, "'Ogni dipintore dipinge se': A Neoplatonic Echo in Leonardo's Art Theory?" in Cecil H. Clough, ed., *Cultural Aspects of the Italian Renaissance: Essays in Honour of Paul Oskar Kristeller* (Manchester: Manchester Univ. Press, 1976), 311–23.

28. Giovanni Francesco Pico della Mirandola and Pietro Bembo, *Le epistole "De imitatione" di Giovanfrancesco Pico della Mirandola e di Pietro Bembo,* ed. Giorgio Santangelo (Florence: Leo S. Olschki, 1954), 42.
 For a good overview of the larger literary-theoretical context, see Martin McLaughlin, *Literary Imitation in the Italian Renaissance: The Theory and Practice of Literary Imitation in Italy from Dante to Bembo* (New York: Oxford Univ. Press, 1996).

29. A restatement of this view is found in Thomas M. Greene, *The Light in Troy: Imitation and Discovery in Renaissance Poetry* (New Haven: Yale Univ. Press, 1982), esp. 171–96. A perceptive critical interrogation of it is found in two essays by G. W. Pigman III: "Versions of Imitation in the Renaissance," *Renaissance Quarterly* 33 (1980): 1–32; and "Imitation and the Renaissance Sense of the Past: The Reception of Erasmus' *Ciceronianus,*" *Journal of Medieval and Renaissance Studies* 9 (1979): 155–77.

30. Vasari, *Lives* (note 17), 2:911.

31. My wording here is intended to evoke Leo Steinberg's account of the way in which the work of Robert Rauschenberg differs from that of the abstract expressionists, a differentiation that then becomes the basis for a distinction between modernism and postmodernism; see Leo Steinberg, *Other Criteria: Confrontations with Twentieth-Century Art* (Oxford: Oxford Univ. Press, 1972), 84.

32. Robert Williams, "Italian Renaissance Art and the Systematicity of Representation," *Rinascimento* 43 (2003): 309–31.

33. Michelangelo Buonarroti, *The Poetry of Michelangelo: An Annotated Translation,* trans. James M. Saslow (New Haven: Yale Univ. Press, 1991), 239 (no. 107).

34. Ascanio Condivi, *The Life of Michel-Angelo,* ed. Helmut Wohl, trans. Alice S. Wohl, 2nd ed. (University Park, Pa.: Pennsylvania State Univ. Press, 1999), 24.

35. An English translation of the document is provided in Linda Murray, *Michelangelo: His Life, Work and Times* (London: Thames & Hudson, 1984), 19–20.

36. Giorgio Vasari, *La vita di Michelangelo nelle redazioni del 1550 e del 1568,* ed. Paola Barocchi (Milan: R. Ricciardi, 1962), 3:993.

37. Bernadine Barnes, *Michelangelo's* Last Judgment: *The Renaissance Response* (Berkeley: Univ. of California Press, 1998).

38. See Max Weber, *The Protestant Ethic and the Spirit of Capitalism,* trans. Talcott Parsons (London: Routledge, 1992); Norbert Elias, *The Civilizing Process: The History of Manners and State Formation and Civilization,* trans. Edmund Jephcott (Oxford: Blackwell, 1994); and Michel Foucault, *Discipline and Punish: The Birth of the Prison,* trans. Alan Sheridan (New York: Vintage, 1979).

39. Linda Nochlin, comp., *Impressionism and Post-Impressionism, 1874–1904: Sources and Documents* (Englewood Cliffs, NJ: Prentice Hall, 1966), 44.

40. Paul Cézanne to Paul Cézanne fils, 8 September 1906, in John Rewald, ed., *Paul Cézanne, Letters,* trans. Seymour Hacker (New York: Hacker Art, 1984), 322.

41. Arthur Rimbaud, *Rimbaud: Complete Works, Selected Letters,* trans. Wallace Fowlie (Chicago: Univ. of Chicago Press, 1966), 306–7.

42. Gilles Deleuze and Félix Guattari, *Anti-Oedipus: Capitalism and Schizophrenia,* trans. Robert Hurley, Mark Seem, and Helen R. Lane (Minneapolis: Univ. of Minnesota Press, 1983). See also Gilles Deleuze and Félix Guattari, *A Thousand Plateaus: Capitalism and Schizophrenia,* trans. Brian Massumi (Minneapolis: Univ. of Minnesota Press, 1987); and Brian Massumi, *A User's Guide to Capitalism and Schizophrenia: Deviations from Deleuze and Guattari* (Cambridge: MIT Press, 1992).

Paul Cézanne's Primitive Self and Related Fictions

PAUL SMITH

Me—a name I call myself
— Oscar Hammerstein II, "Do-Re-Mi," *The Sound of Music*

"I" is not the name of a person, nor "here" of a place, and "this" is not a name.
…It is also true that it is characteristic of physics not to use these words.
— Ludwig Wittgenstein[1]

As a mature artist, Paul Cézanne made two statements referring to himself as
a "primitive." Taken at face value, they imply that he believed his work issued
from a self closely analogous to that of a pre-Renaissance primitive, or of
someone uncultivated in a more general sense.[2] There is certainly a strong
temptation to take Cézanne's comments at face value, since a number of con-
temporary artists or critics described his work as "primitive" on account of
what they perceived as its clumsiness or roughness.[3] Cézanne also made many
remarks that, while not using the word *primitive,* nonetheless affirm a link
between his artistic self and capacities widely considered primitive in the
sense of deep-seated or irreducible. Yet there are reasons for thinking that
Cézanne's use of *primitive* was not as straightforward as it seems. His claims,
and what they reveal about his work, can in particular be clarified by analyz-
ing what he meant by the word. No such account can be comprehensive, how-
ever, without examining the equally, but less obviously, important meaning
Cézanne gave the word *I.* Cézanne's assertions about being a "primitive" use *I*
in, for example, a special sense that neither posits a self of the sort described
in metaphysics nor implies any straightforward, causal correlation between
his self and his work. He also used *I* in other statements in several different
ways, to describe both the variety of selves he took on as a painter and the
diverse selves he assumed in other, sometimes related, roles. Analyzing
Cézanne's *I* can therefore help explain how he understood his own agency and
what being a "primitive" meant to him and his work. This is not to suggest that
Cézanne's own conception of himself illuminates everything that went on
when he painted, or that it arbitrates the meaning of his work. It will neverthe-
less emerge from the following discussion, however, that the artist's idea of his

self is essential to any proper explanation of his art and his practice. In other words, Cézanne the dead author still has something to say about his work.

CÉZANNE THE PRIMITIVE

Cézanne ostensibly connected his work to a primitive self in two statements that he made toward the end of his life. One of them is recorded by R. P. Rivière and Jacques Schnerb, who visited Cézanne in 1905: "Showing us one of his watercolors, he corrected with a fingernail a bottle that was not vertical and he said, as if apologizing for himself: 'I am a primitive. My eye is lazy.'"[4] Cézanne's meaning, his visitors concluded, was that he drew somewhat ineptly, like a primitive unable to master perspective. But this would have been an odd thing for Cézanne to suggest, since he confided to fellow painter Émile Bernard that he was not keen on the primitives, and he told the poet Joachim Gasquet that he actually disliked their insubstantial manner of draw-ing.[5] Rather, Cézanne's remark is better thought of as a disingenuous show of modesty, or even a Provençal *blague* or practical joke performed at the expense of his credulous interlocutors.[6] Cézanne nevertheless did think of himself as a primitive in the sense of "beginner," a meaning the term had acquired outside of art writing from its basic use in everyday language to describe something in its earliest or rudimentary form. It is clear from Bernard's recollections of Cézanne, which date to the same period, that he used the word this way, as if explain the provisional nature of his work. The younger artist recalled: "He told me that he certainly needed a follower, because as far as he was concerned he had only opened the path. 'I am too old. I have not realized, and I will not realize now. I remain the primitive of the path I have discovered.'"[7] Cézanne's meaning becomes clearer still in the light of a similar observation he made to the archaeologist Jules Borély in an earlier conversation of 1902: "'Alas, although already old, I am only a beginner.'"[8] Cézanne was also very "interested" to learn that Bernard considered himself his "pupil," and in September 1906 he told his son that he had hoped to make Bernard into a "follower of conviction."[9] His comments to Bernard were therefore not intended as a *diagnosis* of (his) self at all but were a *plea* to the younger man to pick up where he would have to leave off.[10]

The "Temperament"

Cézanne did, however, subscribe to the idea that the self was the "origin" of the (original) work of art, at least inasmuch as he believed that a particular aspect of his self—his "temperament"—was the source of his creativity.[11] He told the young painter Charles Camoin, in a letter of 22 February 1903, "Only primordial strength, that is temperament, can bring someone to the goal he is driven to attain,"[12] implying that an artist's temperament was primitive in the sense of being an irreducible power deep within him that made his work what it was. Cézanne, it would seem, had actually held this view from early on since the eponymous painter modeled on the youthful Cézanne in Louis-Edmond Duranty's caricatural story "Le peintre Marsabiel" (1867) declares: "'I have realized that painting is done with temperament (he pro-nounced the word "damnbéramminnte") rather than brushes.'"[13] Cézanne's

close companion, Émile Zola, also used the word *temperament* almost forty times to single out the quality that made an artist an artist, or gave art "originality," in the Salon reviews he published in 1866 under the title *Mon salon.*[14] And both the newspaper articles in *L'événement,* where they first appeared, and the book in which they are collected have dedications to Cézanne that acknowledge his contribution. Indeed, Zola took care to insert the dedication "To my friend Paul Cézanne" at the head of the printer's proof (fig. 1).[15] Further evidence that the Cézanne of the 1860s envisaged his artistic self as powered by *temperament* comes from another, little-known source: the novel *La proie et l'ombre* (1878) by Marius Roux, whose central character, Germain Rambert, incorporates elements of Cézanne, with whom Roux was closely acquainted in the 1860s.[16] Roux repeatedly refers to Germain's *temperament*[17] and at one point has him declare to his fellow impressionists: "'If only those idiots at the Ecole had half our temperament.'"[18]

It is only too clear from the discourse on temperament that the artistic self it (supposedly) corresponded to was specifically masculine. This conviction is particularly strong in *Mon salon,* where Zola distinguished Claude Monet, who had "temperament," from the "crowd of eunuchs" with whom he exhibited.[19] And in an article of 20 April 1866 dedicated to Cézanne, he argued that more derivative artists were "impotent."[20] Less tactfully still, Roux insinuated that deep down Cézanne/Germain—just like Cézanne/Claude Lantier later on in Zola's *L'oeuvre* (1886)—was dogged by fears of his own "impotence,"[21] although Germain at one point does call his colleagues "eunuchs" in an effort to compensate for his anxiety.[22] According to the art dealer and publisher Ambroise Vollard, for the youthful Cézanne painting was either "really ballsy" (like his own), or—if it lacked "temperament"— "not."[23] So it would seem that for Cézanne, exactly as for Zola, "the man," or the originary, masculine, and "temperamental" self that a work of art purportedly manifested, mattered at least as much as the "work of art."[24]

The "primitive" nature of the self Cézanne considered the origin of his creativity can be further fleshed out by tracking how he, and his circle, used the term *temperament* alongside other terms—such as *strength* (*force*)—within a broader theory of creativity. *Strong,* for instance, is used this way as early as the 1860s by Marsabiel's acolyte, Appollin (a character based on the painter Achille Emperaire), who says of his master: "He is a strange man, but gallantly strong."[25] And the real Cézanne returned the compliment in about 1900, when he described Emperaire to Gasquet as "very strong."[26] Cézanne's much earlier *Portrait of the Painter Achille Emperaire,* made in 1868–69 (fig. 2) is surely intended to exhibit strength in the use it makes of chiaroscuro and curvilinear, baroque brushstrokes. It may also contain some suggestion of Emperaire's own artistic "strength," which—despite his small and relatively weak body— nevertheless manifested itself in a few extremely forceful paintings and in the erotic drawings he sold to students in Aix.[27] "Strength" also figures in the remark Cézanne made to the caricaturist Stock in 1870: "'I have very strong sensations.'"[28] Zola, too, couples "strength" and "temperament" in *Mon salon.*[29] And Roux describes how, in his own view, Germain was "a very strong painter"[30] for whom "the great strength of his being, his artistic temperament, was like the unknown power of nature."[31]

Figure 1
Émile Zola (French, 1840–1902)
Manuscript title page for *Mon salon
1866,* 21 × 16.5 cm (8¼ × 6½ in.)
Los Angeles, Getty Research Institute

Figure 2
Paul Cézanne (French, 1839–1906)
*Portrait of the Painter Achille
Emperaire,* 1868–69,
oil on canvas, 200 × 122 cm
(78¾ × 48 in.)
Paris, Musée d'Orsay

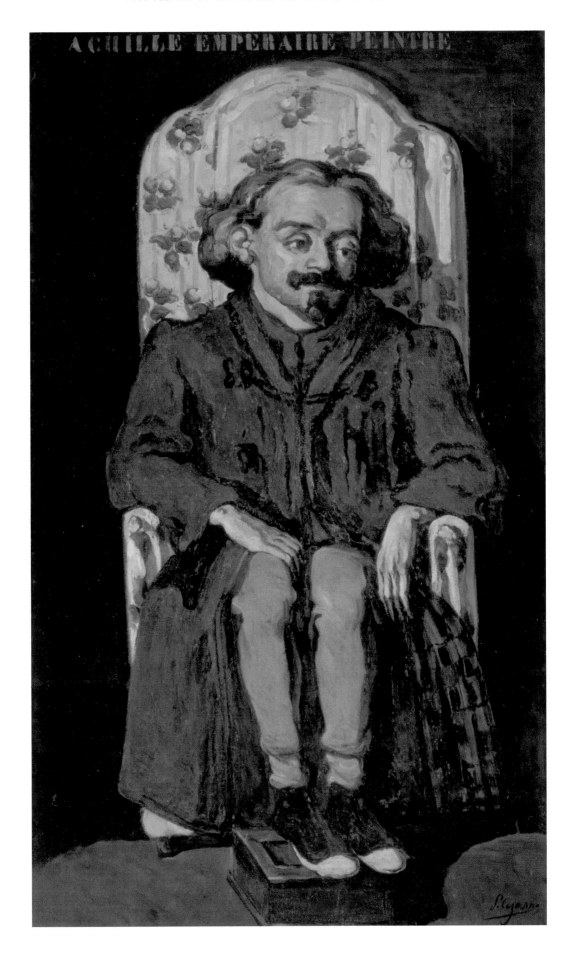

Temperament and *strength* are also used by Cézanne in conjunction with the terms *sensation* and *daring.* After telling Stock of his "strong sensations," for instance, Cézanne declared: "I dare, Monsieur Stock, I dare." All of this suggests that Cézanne viewed temperament much as Stendhal did in his *Histoire de la peinture en Italie* (1817)—a book Cézanne read at least three times and recommended highly—in which the same four terms are combined in a variety of ways.[32] The concept of temperament in Stendhal's theory of art is framed by the belief (deriving from ancient theories of character) that a painter's individual style is determined by the preponderance of one of six "humors." Cézanne was evidently bent on emulating the "bilious" painter described by Stendhal, whose "temperament" and "sensations" are characterized by their "strength." It is also likely that the "ballsy painting" Cézanne produced in his early career was inspired by Stendhal, who explicitly acknowledged the influence of the "seminal humor" on the "bilious" painter.[33]

In many of Cézanne's early works, such as *Still Life: Green Pot and Pewter Jug* (circa 1870; Paris, Musée d'Orsay), objects look bulbous or distended, and their left vertical sides are elongated and rotated slightly counterclockwise. Cézanne undoubtedly would have justified these seeming distortions with the idea that his temperamental self had its own, idiosyncratic way of seeing. He did this implicitly when he told Stock, "'I paint as I see and feel'"—at the same time echoing the *Histoire de la peinture en Italie,* which asserts: "Every artist must see nature in his own way."[34] Roux's Germain Rambert also believed his "temperament" meant that "he painted as he himself saw,"[35] and Mathilda Lewis, an American painter who met Cézanne in 1894, noted: "He doesn't believe that everyone should see alike."[36] The most explicit version of this theory was advanced by the philosopher, historian, and critic Hippolyte-Adolphe Taine, whose thinking impressed Zola,[37] in his *Philosophie de l'art* (1865). Here Taine argued that there was a causal link between the artist's temperament and perceptual eccentricity—creative "temperaments" inevitably magnifying and distorting their "sensations" as a result of a "primitive" inner impulse to do so.[38] Similarly, Cézanne may have thought of his temperamental self as one that not only justified but demanded a way of seeing that was unmistakably his own.

Identifying with fictional painters was another factor in Cézanne's cultivation of a self distinguished by its perceptual idiosyncrasy. In particular, Cézanne emulated Frenhofer,[39] the antihero of Honoré de Balzac's story "The Unknown Masterpiece," whom the author described as "a man passionate about...art, who sees above and beyond other painters."[40] Cézanne's identification with the character was so strong that one night, over dinner with Bernard, he rose at the mention of Frenhofer's name and, "striking his chest with his index finger, he admitted without a word, but by this repeated gesture, that he was the very character of the novel."[41] Furthermore, Cézanne's emulation of Frenhofer was consistent with his admiration for Stendhal's thinking, for when Cézanne told Gasquet that Emperaire had "something of Frenhofer in him," he had just before described him as "very strong."[42] Cézanne also internalized Stendhalian ideas about the relationship between a temperamental self and an individual way of seeing through reading a novel by the brothers Edmond and Jules de Goncourt, *Manette Salomon* (1867), whose protagonist, the painter Coriolis, is an embodiment of the visually

idiosyncratic artist advocated in the *Histoire*.[43] (Many of Stendahl's ideas about this type are paraphrased in chapter 16 of the novel—in an invective delivered by the critic Chassagnol[44]—and are echoed throughout.)[45] More specifically, Coriolis embodies the particular Stendhalian theory that an artist's temperament and strength endow him with a "personal way of seeing" (*optique personnelle*)—if he is faithful to "his own sensations."[46]

Cézanne's early temperamental way of seeing sometimes threatened to slide into an extreme solipsism. Like Frenhofer, one of whose paintings was intelligible to him alone,[47] and Coriolis, whose coloristic eccentricity was extreme, Cézanne displayed a perceptual idiosyncrasy that ran the risk of seeming to correspond to nothing more than "private fantasy," and the critic Jules Castagnary said as much.[48] In later life, however, even as Cézanne retained his own way of seeing, or what he described to Bernard (using the Goncourts' phrase) as "a personal way of seeing," he came to see the Goncourts, and by extension Coriolis and his own perceptual self, in more moderate terms.[49] In a letter of August 1906, for example, he praised the Goncourts and Camille Pissarro, along with "all those who have leanings towards color, which represents light and air,"[50] suggesting that he had transcended fantasy and learned what he elsewhere called "submission" to nature.[51] An important part of this development was that Cézanne had come to understand Stendhal's text (and himself) afresh some time in the 1870s, as can be seen in a letter of November 1878 in which he says of the *Histoire de la peinture en Italie:* "I had read it in 1869. But I had read it badly. I am re-reading it for the third time."[52] This shift in Cézanne's understanding of Stendhal manifested itself in his move toward a less aggressive manner of working in the mid-1870s, but this move was arguably motivated as well by his realization that he was not in fact a "bilious" type at all but what Stendhal called a "melancholic temperament," whose defining characteristics were "somber taciturn-ity," "seriousness," "sharp unevenness of a character," "bitterness," and "timid embarrassment."[53] Much later, in May 1904 and October 1905, Stendhal was still on Cézanne's mind when he told Bernard of his ambitions to develop an adequate "means of expressing sensation" and to deliver "the truth in painting,"[54] remarks that echo the novelist's recommendation that the painter should learn "the means of expression" so as to overcome "the lack of truth . . . in painting" that "inhibits sensation."[55]

The Child

Another so-called primitive aspect of the artistic and perceptual self Cézanne cultivated was childlikeness. In particular, his habit of painting "sensations" in what he called "stains" of color[56] corresponded directly to his ambition to "see like a newborn."[57] The theory underlying this way of seeing and painting has a long history[58] but likely was known to Cézanne through Taine's argument that newborn children experience "sensation," or the "primitive fact"[59] of perception, as raw "stains" of color, uncomplicated by tactile experience or knowledge of shape.[60] For Cézanne, as for Taine, the child's vision was therefore elemental or pristine. Cézanne was also responding to a more complex dimension of Taine's perceptualism. Taine believed that, in order to localize color at the correct distance on the surface of objects (and hence perceive shapes and space), very young children need to learn to correlate the patches

of color they perceive with memories of "muscular" sensations of reaching toward and touching objects.[61] Adults, however, through repeated experience, can localize color on a surface by the impoverished means of vision alone. According to Taine, therefore, painting in "stains" of color would implicitly give rise to a more richly sensuous form of vision that elicited the newborn's tactile sensations.[62] Cézanne may well have been impressed by this last idea. At any rate, some of his works, such as *Madame Cézanne in a Red Armchair* (fig. 3), appear to ask the spectator to "localize" their floating color patches (especially the wallpaper's blue crosses) on the surfaces of the objects they represent by recourse to memories of tactile sensations.[63]

What is more certain is that Cézanne's identification of his artistic and perceptual self with the child was far-reaching and amounted to a means of attaining a primitive (in the sense of basic or uncorrupted) way of seeing. Cézanne told Gasquet, "I am a little child" on one occasion,[64] and on another laid claim to being "like a child."[65] The notion that the child's way of seeing is more authentic than the adult's is, of course, a cliché, but like most clichés it trades successfully in falsehood by mixing in a grain of truth. Modern neuro-scientific explanations of visual perception tell us that Taine's argument is little more than a pseudoscientific justification of a romantic myth. But some claims about the virtues of childlike vision are more defensible. The most cogent of all the arguments known to Cézanne is found in philosopher Jean-Jacques Rousseau's *Émile; ou, De l'éducation* (1762).[66] This work begins by suggesting that children's "sensations" are innately meaningful because they carry friendly or hostile indications that make some experiences enjoyable and others painful. The meanings we attach to sensations during childhood, Rousseau then asserts, guide our behavior as we grow up, until—later in life— our "tendencies" become increasingly based on "reason." Eventually, Rousseau argues, our actions are guided by our "habits" and "prejudices" and, having lost their grounding in sensuous experience, become empty of meaning. Rousseau thus calls for a return to our "primitive dispositions," or "nature within us," because they are the foundation of all meaningful experience and lead to a salutary way of life.[67]

Rousseau's theory finds a cogent restatement in Ludwig Wittgenstein's argument that our "given" (or "primitive") "forms of life" are what make the "complicated forms of life" of adult experience possible and meaningful.[68] By extension, taking on the position of a "child" can be a way of resisting ide-ology, since it makes possible a return to a way of life that is not grounded in reasons (and hence the false beliefs that reasons are prone to contain) but in the instinctual dispositions and behaviors that we all share (to a great extent) as humans. Furthermore, being a "child" in this sense need not entail nostal-gia but can be a way to reestablish contact with aspects of ourselves that can then grow into new "complicated forms of life." Cézanne's understanding of the childlike self, which is in every sense the antithesis of ignorant or regres-sive, is certainly consistent with this possibility.[69] More specifically, in the late 1870s, Cézanne sought to cultivate such a self as part of a project shaped by populist literature—which he read at the suggestion of Pissarro and Zola—that promoted a return to the kind of instinctual human behavior thought to have existed before society was corrupted by capitalism.[70] Cézanne thus aspired to being at once a "child" and a socialist, like the protagonist of Jules Vallès's

Figure 3
Paul Cézanne (French, 1839–1906)
Madame Cézanne in a Red Armchair, ca. 1877, oil on canvas, 72.4 × 55.9 cm (28½ × 22 in.) Boston, Museum of Fine Arts

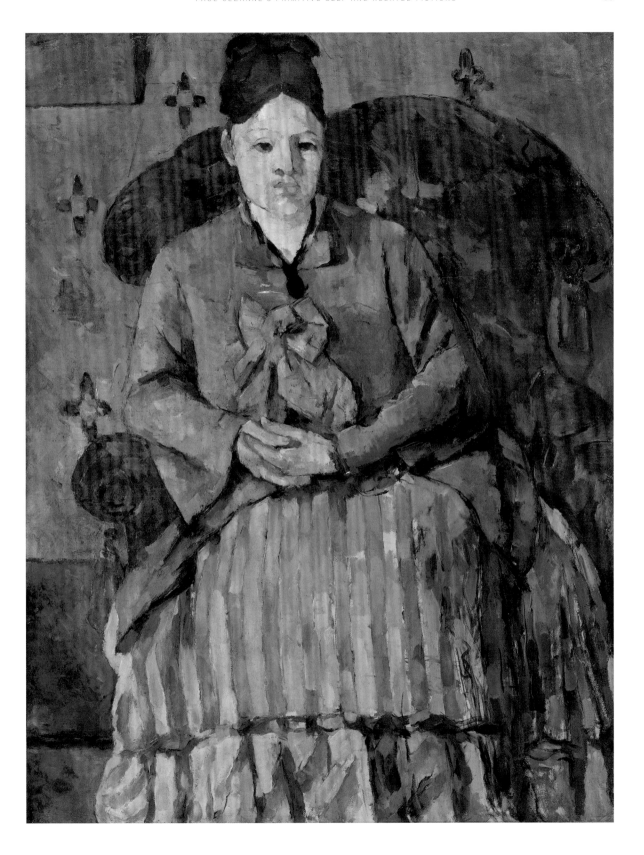

novel *Jacques Vingtras: L'enfant* (1876)—an account of a poor boy's eventual triumph over abuse and the disadvantages of a humble birth that occasioned in the painter "much sympathy for the author."[71]

Cézanne also adopted a childlike and socialist-like persona in the later 1870s, judging from *Madame Meuriot* (1890), a novel published by the painter's old friend, Paul Alexis. The Cézanne who attended salons that the writer Nina de Villard hosted for failed artists[72] appears in this work as Poldex (a contraction of "Paul from Aix"): "a sort of awkward, bald colossus, a superannuated child, naïve, genial, at once violent and timid."[73] According to Alexis, Poldex/Cézanne was also enthusiastic about Kabaner (after the socialist musician Ernest Cabaner) and would listen raptly to the composer's bizarre interpretation of the opening scene of Zola's *L'assommoir* (1877), in which the workers descend the slope from the outer boulevards into Paris.[74] Cézanne, in actual fact, was very much like Poldex. In 1878, he bought a copy of *L'assommoir* from a "democratic" bookseller, and he maintained a close friendship with Cabaner between 1877 and the musician's death in 1881, even giving him his painting *Bathers at Rest* (1875–76; Merion, Pennsylvania, Barnes Foundation), which represents a primitive self of sorts in depicting the kind of experience Cézanne had as a youth in Aix.[75] But the imagery of childhood here also has a communal, and political, dimension since it represents a time before capitalism alienated the self by undermining the physicality of experience through the phantasmagorical allure of commodity[76] and by subjecting time to the standardized, "mechanical" rhythm of the clock that regulates efficient labor.[77] The boys, who take such an intensely physical pleasure in the landscape, each at his own pace, thus present a "dialectical image" not only of individual adulthood but of the social condition of modernity as well.

Bathers at Rest may also relate to a self that Cézanne modeled on an existing literary figure—Anatole, the eternally youthful and irresponsible bohemian painter in *Manette Salomon.* At any rate, the painting's radicalism suggests that it corresponded to the "bohemian self" Cézanne cultivated until he was forty.[78] This seems all the more likely since Anatole has become a hero of sorts by the end of the novel, when he escapes the tribulations of the modern capitalist world by taking a job as an animal keeper in the Jardin des plantes, where, alone each morning among "wooden huts recalling the primitive home of humankind," he experiences "the joys of Eden" as if he were "the first man face to face with virgin Nature" at "the childhood of the world."[79]

Whatever Cézanne's actual models (or introjections) were and were not, it is incontestable that he invested in narratives in order to imagine a self that he could bring to bear on his paintings. And while this can seem a merely solipsistic activity, it is better thought of as a positive response to a more general crisis affecting identity, which arose as capitalism attained its early maturity. Following Walter Benjamin's account of the period, Cézanne was born at a time when individuals could forge a personal, but publicly meaningful, self by internalizing the narratives repeated, adapted, and shared by successive generations of their wider community. The stories that once articulated and constituted the community began to disappear, however, as the modern-era capitalist metropolis inexorably converted people into the "isolated individuals" severed from tradition (and thus from one another) whose only "story" was the novel—or what Georg Lukács called "the form of transcendental

Figure 4
Émile Zola (French, 1840–1902)
Page of an unpublished letter
to Cézanne, dated 20 July 1858,
23.7 × 17.5 cm (9⅜ × 6⅞ in.)
Los Angeles, Getty Research
Institute

modèle, le celèste Hugo, je ne mange plus du tout, et
ala depuis bien longtemps.

Mi amice, Carus Cezasinus, tibi in latinam
linguam tibi, et ne lingua gallica, rubescit
audiendo ros quidam rem impudicam, mitto
et me ardescere et amare ita virginem
pulcherrimam et quae non habet jam masculo
membro frui. Hac femina fulva fulva est
et sua color est alba et sui oculi caerulei
sunt. Vides ergo ut illa est divinitas,
simila Ceres, quae ad messes presidet. Gaude
gaude, Cezasine, vides enim amus (litteratus
qui latina lingua utitur, et qui dicit
platitudinas. (style que tu dois adopter pour
ta composition latine au bachot)

homelessness."[80] Aix, by contrast, remained substantially (although not wholly)
as Cézanne had known it as a child until late in the nineteenth century.[81] As
the first city of the first Roman province, Aix was also steeped in tradition,
appearing in many stories as the focal point of a land (Provence) where the
classical past persisted into the present. For educated middle-class boys like
Cézanne and Zola, this fantasy was alive. In a letter of 1858 to Cézanne, for
example, Zola described Aix in terms of the golden age landscape depicted by
Hesiod and Homer.[82] For readers of Horace and Virgil like Cézanne and Zola,
the pine-clad hinterland of Aix could also recall the golden age landscape of
Pelion in the days before its pines were felled to build the first ship, the Argo,
whose embarkation marked the end of the era. This perhaps explains both
why Cézanne's correspondence with Zola is scattered with references to pines
and why they have a central place in the men's recollections of a youth during
which they modeled themselves on Virgilian rustic poets.[83] In any event, some
such fantasy is responsible for the fact that Cézanne signed himself "Paulus
Cézasinus" in one letter of January 1859 to Zola, as well as for the fact that Zola
addressed his friend as "Carus Cézasinus" and "Cézasine" in an unpublished
letter of July 1858 (fig. 4).[84]

 In later life, Cézanne looked once more upon Aix as the home of an
"infant" humanity as a result of his close association with Gasquet, who
shared his love of Virgil. Gasquet even acknowledged the impact of Cézanne's
Virgilianism on his thinking by including a dedication to the painter at the
head of his poem *L'enfant* (1900), which was a reworking of the fourth
Eclogue.[85] In the original, allusion is made to the birth of a child that would
signal the return of the golden age to humankind at large; but Gasquet's
child was not simply a Virgilian avatar—he was also a messiah of sorts (born
of a long-standing tradition of interpreting *Eclogue IV* in messianic terms),
whose birth heralded the return of the ancestral Latin race of Provence to its
traditions and former glory.[86] Cézanne, in other words, was to some extent
complicit with the parochial "racism" of Gasquet's writings. It is thus not
inappropriate that Gasquet should have represented Cézanne as the mystical
Provençal painter Pierre in his novel *Il y a une volupté dans la douleur*
(1897–98).[87] But even if Pierre does represent Cézanne accurately in some
respects, it is hard to reduce the real artist, or his work, to Gasquet's invention
since the poet and the painter never quite saw eye to eye. Still, Cézanne was
eager for Gasquet's company because (for some reason) he reminded him of
Zola and, by extension, his youth in Aix. Gasquet and his friends also provided
Cézanne with a community of sorts and thus alleviated the artistic isolation
he felt, especially in Aix. All in all, Cézanne's enthusiasm for Gasquet was
something of an aberration, born of nostalgia and a deep love of Provence but
also of a loneliness resulting from a commitment to being childlike in his art
(and demeanor). Cézanne's predicament was thus betrayed by the columnist
and childhood friend Numa Coste when the latter told Zola in a letter of
March 1891 that, while Cézanne was as "shy, primitive, and younger than ever,"
he was able to maintain "the naïveté of a child" only by pursuing "work that he
is unable to deliver [*enfanter*]."[88]

The Seer

With friends like Coste (and Zola), it is not surprising that Cézanne sought to identify his artistic self with historical and literary role models of resolution and perseverance. One of the more important of these was Phocion, the Athenian general celebrated by Plutarch, whose unwavering commitment to his own perspicacious judgment caused his compatriots to put him to death and bury him ignominiously outside the walls of his beloved polis (which, ironically, he had done so much to protect). Cézanne declared this identification in several paintings of the Mont Sainte-Victoire of the later 1880s, most obviously in *Montagne Sainte-Victoire* (fig. 5), whose composition closely resembles that of Nicolas Poussin's painting *Funeral of Phocion* (1648; Wales, National Museum Cardiff, on loan from the Earl of Plymouth)[89] and thereby alludes to its iconography. The same painting also suggests an affinity between its maker (Cézanne) and a painter (Poussin) who was himself seen to be akin to Phocion.[90] In this work, therefore, Cézanne lays claim to belonging to a "family" of Stoics whose commitment to their own vision in the face of an unsympathetic community was their undoing.

Cézanne also came to terms with his dilemma by identifying with Frenhofer and Coriolis, whose own searches for perceptual truth led them to produce works of such idiosyncrasy that they met with incomprehension and ridicule. Frenhofer's discouragement over his situation was so extreme—at least according to the version of Balzac's text that Cézanne owned—that he died of despair (or perhaps committed suicide). Frenhofer and Coriolis were

Figure 5
Paul Cézanne (French, 1839–1906)
Montagne Sainte Victoire, ca. 1887,
oil on canvas, 66.8 × 92.3 cm
(26¼ × 36⅜ in.)
London, Courtauld Institute
of Art Gallery

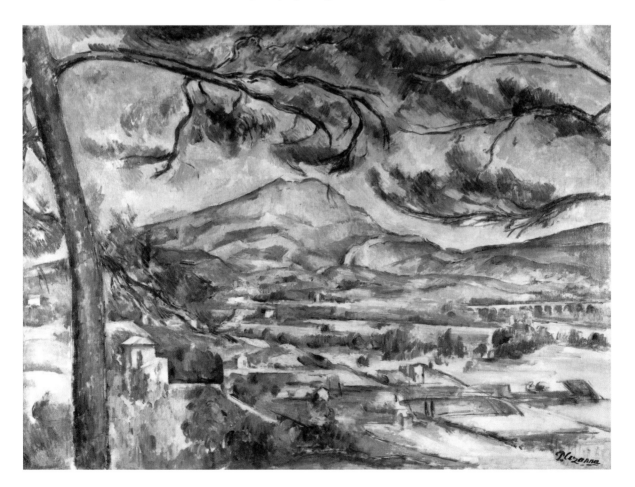

also prone to despair and doubt, and there is more than a suggestion in Balzac and the Goncourts that they were victims of solipsistic delusions.[91] It nevertheless remains a possibility that Frenhofer despaired, not because he realized he had been painting incoherently but because he lost hope that his audience would ever see the coherence in his work. In like fashion, Cézanne was committed to seeing in his own way, and, although subject to uncertainty and hopelessness,[92] he sometimes blamed his audience for being unable to see his works for what they were.[93] Identifying with Frenhofer and Coriolis thus had two consequences for Cézanne: it allowed him to face the possibility that his commitment to originality could easily lead to an empty solipsism, and it helped him reconcile himself to the lonely solitude that he would face even if he overcame this danger. Sometimes, however, the thought of isolation overwhelmed him. And so, although he wrote in a letter of January 1903 to Vollard that he saw himself as "the great Hebrew leader" Moses pursuing the "promised land," he identified more deeply with the despairing Moses of Alfred de Vigny's poem "Moïse" (1826), even choosing as his epitaph the prophet's plea to God to let him die rather than endure the continual loneliness of being a "magus."[94]

Notwithstanding these difficulties, and as might be expected from an artist who did in fact achieve much, Cézanne's identification with isolated seers ultimately helped him maintain his practice. Cézanne, put simply, worked in the hope that his way of seeing, and his reputation, would be vindicated after his death. This had happened not only to Moses but also to Phocion, whose remains were eventually, and symbolically, restored to their rightful place, an event celebrated in the pendant Poussin made to his painting of Phocion's burial: *Ashes of Phocion* (1648; Liverpool, Walker Art Gallery).[95] That *Montagne Sainte-Victoire* resembles this last work (at least as much as Poussin's more pessimistic painting of the burial) suggests that Cézanne's identification with Phocion allowed him to hope that his life's work would also find a posthumous audience. The same wish is expressed in Cézanne's fondness for Gustave Geffroy's "Le sentiment de l'impossible," an allegorical ghost story about the power of art to give the artist an "afterlife."[96] Cézanne could also have found moral support in Geffroy's article "Les vrais primitifs" (1902), which describes how, throughout history, certain "primitive" artists managed to keep the guttering flame of art alive in times of darkness by envisioning a future where their efforts would be continued by others.[97] Whether or not Cézanne knew of Geffroy's article can not be conclusively demonstrated, but the artist did state that his art addressed both the past and the future in a letter of January 1905 to Roger Marx, where he told the critic: "One does not substitute for the past, one only adds a new link to it."[98] Cézanne thus came to accept, and even embrace, the likelihood that his "primitive" artistic self would find its audience only in death.

CÉZANNE'S SELF

It becomes clear that, although Cézanne used the word *temperament* until the end of his life to describe the primordial strength supposedly lying behind his work, his conception of this changed as he matured. Moreover, although the

youthful Cézanne was at pains to demonstrate how a powerful, masculine temperament characterized his whole personality (not least by delivering his statement to Stock in outrageously bohemian costume, with his paintings in a handcart, outside the Palais de l'industrie on the occasion of his rejection from the Salon), his more mature practices increasingly came to belie this posture.

In the first place, after about 1875 Cézanne made no particular connection between temperament and masculinity. Even more significantly, he acknowledged a separation between the various personalities he adopted as an artist, friend, and public figure. In a letter of about 1878 to Roux, for example, Cézanne both acknowledges an explicit separation between his public persona and his real self and attempts to apologize for (and hence repudiate) his earlier temperamental identity by telling his erstwhile friend, "I would hope you may wish to separate my small personality as an impressionist painter from the man himself, and remember only the companion."[99] Cézanne then drew a distinction between Roux's artistic personality and his personality as a person (or compatriot), saying, "It is not the author of *L'ombre et la proie* that I call upon, but the Aquasixtain who saw the light of day under the same sun as I did." Cézanne's use of the word *I* also acknowledges that the artistic self could be different from, and more authentically satisfying than, other aspects of self. He unambiguously used *I* this way in a letter to Zola in May 1881, in which he tried to console Zola: "I hope you soon recover your normal state of mind in work, for it is, I think, and in spite of all the alternatives, the only refuge where one can be at peace with oneself."[100] And in an attempt to elaborate his admiration for Poussin, Cézanne told Gasquet: "I want to be in touch with a master who takes me back to myself. Every time I emerge from being with Poussin, I know better who I am."[101]

In practice too, Cézanne acknowledged that his own artistic self was multifarious (and not unitary). So, while he could claim to "be" Frenhofer, he also thought he "was"—in addition—Coriolis, Phocion, Moses, and Cézasinus. He must have realized, too, that there was more than a smattering of Duranty's Marsabiel and Louis Séguin in him, along with elements of Roux's Germain Rambert, Gasquet's Pierre, and the various Cézannes represented in Zola's writings, such as Paul, Bernicaud, and several Claudes, including Claude Lantier.[102]

None of this means, however, that Cézanne had no coherent artistic personality.[103] On the contrary, his multiple identifications created an artistic self whose different aspects were united by virtue of "family resemblance."[104] Hence, while some features of Cézanne's artistic self were almost constantly in play, others would drop out of the picture for some time, only to reappear later. But the mix would always preserve an identity worthy of the name. Seen this way, the disparate selves that Cézanne performed as an artist, a public figure, and a person are also part of a larger unity and as a consequence have a strong mutual influence. Not least, Cézanne's letter of 1881 to Zola shows that when an artist is content with his artistic self, it has a salutary effect on his personal self. Conversely, it can be argued that Cézanne's public persona had a powerfully inhibiting effect on Cézanne's artistic personality. Cézanne's various selves are thus of real, instrumental significance to his paintings.

I/ntentionality

The issue here can be brought into sharper focus by considering Wittgenstein's remarks about the meanings and uses of the word *I* (cited in the epigraph). Brutally summarized, these suggest that although *I* is never the *name* of a *thing* such as a self or subject, *I* is nevertheless essential to any proper description of human actions and artifacts (especially art) because it describes the subjectivity, or intentionality (i.e., the consciousness directed at them), that is part and parcel of what makes these *what they are.* It is thus essential to the interest they hold.[105] Physics, by contrast, has no need to resort to *I* as the things it describes (or at least used to) are purely and simply (third-person) facts.

All the same, the illusion that *I* is a name that refers to an object (of sorts) like a self is hard to shake off until we look closely at its use in everyday language, where *I* serves as "different instruments" in different language-games and has at least two quite different "grammars."[106] The first of these is its "use as object."[107] This *I* occurs in statements where someone describes facts about herself or himself, and especially her or his body. Cézanne's remark in a letter to Madame Paule Conil of September 1902, "I am still of this world," uses *I* as object.[108] The second grammar of *I* is its "use as subject." Cézanne used *I* this way when he told Philippe Solari in a letter of July 1896 written in Talloires, "I miss Aix."[109] The intentional *I* also occurs in a letter to Gasquet of April 1896, in which Cézanne wrote to his friend, "I am deeply in love with the lie of my own land."[110] It could seem that this use of *I* does indeed posit a self, but it is better thought of as describing what something is like for the person involved.[111] Put another way, the subjective use of *I* does not denote a self as such, so much as indicate the perspectival nature of thought and feeling. Indeed, according to Lewis, Cézanne's use of *I* was often self-consciously perspectival, and even "selfless," inasmuch as he habitually prefaced his statements with "For me..." (or some similar phrase) precisely out of a concern that they should be taken as nothing more than personal opinions.[112]

The subjective *I* as used by Cézanne also encapsulates something of the intentional dimension of his art. For this reason it must be included in any proper description of the work. Much post-structuralist theory, of course, takes a very different view, arguing that only the sign itself, and not any authorial intention, matters to meaning. Both Marxist and psychoanalytic theory also cast suspicion on the veracity of first-person accounts of art because they often envisage artists as unqualified to know what they are actually doing. But while it is important to avoid equating the meaning of a work of art and the (everyday) life of the "author," just as it is vital to see that someone's stated reasons for acting may not accurately reflect the real causes of their behavior, none of this means that an artist's sense of self is irrelevant to the work of art or its meaning. The simple reason for this is that neither ideology nor repression, fixation, or the like do anything on their own; but they only work at all *through* the intentionality of the agent—even when they do not manifest themselves explicitly *in* her or his description of this.

A Wittgensteinian way of establishing the importance of intentionality to art, and meaning, is to emphasize the importance we attach to it in our intuitive behavior toward individual works of art. We do this most clearly

when we take the intentional structure that the artist puts into the work as the yardstick of its meaning.[113] Gustave Courbet's *The Stone-breakers* (1849; whereabouts unknown, formerly in Dresden), for instance, is not a picture of a landowner and his son doing menial work in lieu of paying local taxes, although his models were doing precisely this when the idea for the painting came to Courbet. Instead, it is a picture of two people forced into an unending cycle of "misery," as Courbet stated—not *because* Courbet said this, but because its repeated surface accents and rhythms (among other things) show that the son will inevitably turn into the same kind of figure as his father.[114] Similarly, Cézanne could well have realized an intention in *The Eternal Feminine* (circa 1877; Los Angeles, J. Paul Getty Museum) that it should illustrate a passage in Zola's *Nana* (1880) about the supposed power of prostitutes over society at large, even if no one noticed until recently how the intentional structure of the painting becomes coherent only when it is seen to recruit this text.[115] A painting only adds up, as it were, once the artist's intention is known; but once this happens, its meaning is altered forever.

The converse of this situation is that we find it hard to regard the products of chance, natural forces, or industrial manufacture as the same kind of things as those objects that have traditionally constituted art. Even when such things can be seen as signs—as when clouds look like faces, or when an objet trouvé or manufactured object is put forward as art—they do not always command us to behave toward them in the same way as we behave toward "art."[116] (Such reluctance could be seen merely as an effect of [conservative] ideology, but this would get things the wrong way round. What matters here, to paraphrase Wittgenstein, is that we behave as we do first and foremost because we are inclined to do so by our instincts; and ideology only gets a foothold on our behavior because it can successfully harness these.) It seems to follow that any interpretation of a pictorial sign must rest in practice on an assumption that intentions, or intentionality, set limits to what that sign represents—otherwise it could mean anything, and there would be no signs at all because they would all be (equally) useless. It is therefore not only possible to preserve the centrality of intentionality to art without invoking a subject (or some self "behind" the work) but essential.

The most basic reason why intentionality does not reduce to a subject or self is that the intentionality in an activity like painting is highly fluid. It therefore corresponds to a mutable self, which cannot be a self proper (or metaphysical self) because this is always conceived of as unitary and indivisible (a "subject-object"). Artistic intentionality transmutes in two particular and closely related ways when an artist like Cézanne paints: first, in response to the changes the painting undergoes as it emerges, and second, as the artist fulfills different roles as a consequence of regarding his work alternatively from the standpoints of its agent and its spectator.

Cézanne's intentionality was particularly liable to change in the course of painting because he customarily formed his intention for a work as it developed. Cézanne, in other words, did not rely solely on "prior intention" when painting, or simply follow preconceived rules about how and what to paint. He usually devised his intention "in action" by continually responding to the way that the emerging painting affected him.[117] One way to clarify this process is to give due weight to the peculiar fact—emphasized by Adrian Stokes and

Richard Shiff, among others—that Cézanne's dialogue with the painting was very like a dialogue with a person inasmuch as his works have properties that appear to be imported, or borrowed, from the human body: the paintings cohere fluidly like a body, they possess an expressive tactility, they stand and look back at the artist.[118] As a consequence, a painting by Cézanne can serve as what Wittgenstein called the "criterion" of a specific (bodily) feeling in much the same way that a smile or gesture serves as a criterion of feeling in a real person.[119] But an artist like Cézanne does not only shape the feeling that the painting exhibits by shaping *it;* he also alters the emotional direction the painting takes by responding to the feeling that emerges from it as it comes along. As the painting changes, therefore, so does the artistic self—the "Cézanne"—it expresses, or stands for.

Cézanne's intentional self also shifted as he took on different roles in front of the work. As Richard Wollheim and Flint Schier have elucidated, an artist like Cézanne cannot paint as he does solely by looking at the painting as its agent, or *with* the eyes. He also looks at the painting as its (first) spectator—looking "*for* the eyes"—and allows this kind of looking to feed back into the seeing he does as an agent.[120] The artist is thus caught up in a dialectic between two quite different intentionalities or "selves."[121] This dialectic had deeper effects on the artist's self too. For example, as Cézanne developed the painting, he could assume a spectatorial self very different from the one with which he began the work. This process could in turn alter his conception of the audience appropriate to the painting, and hence his idea of the sort of person he wanted to become by joining that community.

Cézanne's artistic self was not just highly mutable; as Cézanne himself recognized, it could also become quite distinct from his everyday self. Being an artist who let the work of art speak for itself, in other words, Cézanne could find a self in *it* that only it could furnish. The poet Arthur Rimbaud famously suggested something not dissimilar in two letters of 1871, where he maintained that his everyday self and his poetic self were different, or that "'I' is someone else."[122] While Cézanne never tried anything quite as drastic as Rimbaud's wanton dissipation to free his artistic self from the influence of his everyday self, it is nevertheless clear from his letter of 1881 to Zola that he came to a reflexive realization of the distinctiveness of this particular artistic self. A sense of art's ability to reveal a self peculiar to it is also contained in the avowal Cézanne made in a letter of September 1874 to his mother: "I must strive after finish [in my work] only for the pleasure of working in a truer and wiser way."[123]

I/dentification and I/magination

There is a third *I,* with its own grammar, that Cézanne used in reference to the intentionality at work in his paintings: the *I* that describes his self-image, or self-conception. Cézanne used *I* this way in several letters and statements, most reflexively in a moving letter of July 1868 to Coste, in which he questions whether the self he had once "been" with his erstwhile painter-friend had survived their separation. Thus Cézanne muses: "I don't know whether I am living through, or simply remembering things, but everything makes me think. . . . how difficult it would be for us at this hour . . . to be ourselves . . . even where here only a few years ago we were."[124]

The grammar of this *I* is a little unusual, even though it is common in our everyday language-games, since it describes the wholly "fictional object" that we see when we stand back from ourselves, or when I regard my self *as if* I were an object.[125] This *I* is at work in Cézanne's remarks to Bernard about being a mere "primitive," and it turns up in a letter of September 1879 to Zola, where Cézanne declares, "I am still striving hard to find my way as a painter."[126] Forming self-images serves a disciplinary function by constraining what we can imagine ourselves doing, but the activity is nonetheless simultaneously enabling, especially when it allows us to identify our deep-seated characteristics and dispositions, and thus "project a coherent future for ourselves" (as Hans Sluga put it).[127] And clearly enough, the *I* of self-conception helped Cézanne determine what he was good at (and not) and what was really important to him (and not) as an artist. This enabling *I* is most plainly at work in Cézanne's observations about the characters with whom he identified, where they show how he could both initiate and sustain his practice as a painter by imagining himself "centrally" as (or playing at being) someone else.[128] Statements of this kind include the rhetorical identifications he made with Moses in his letter to Vollard and the exclamation he reportedly made about Frenhofer: "That's me."[129]

Precisely because it helped Cézanne channel his artistic imagination, the *I* of self-conception is an important element of the intentionality at work in his paintings. His self-objectification is, in other words, part and parcel of his paintings' intentional content—not only because it affected the kind of person he was when he painted but because his imaginary identifications played a significant role in shaping the structure and meaning of the work. This is true, for example, of works such as *Montagne Sainte-Victoire* (see fig. 5), in which Cézanne declared his identification with Phocion. More obviously, many of Cézanne's self-portraits allowed him to objectify himself or, more precisely, to imagine an "objective" self with which he could identify and thereby discover who he was as a painter.[130] Of course, it took Cézanne a long time to accept who he was, both as a person and as a painter, and many of his earlier attempts at self-objectification must be seen as failures brought about by an inability to face himself honestly. His *Self-Portrait* of circa 1866 (fig. 6) is one example. Here indeed, Cézanne seemed to concoct an image of himself as a forceful, virile artist, and hence the work shows what is in effect an imago: a specular *I* whose completeness and power he desired yet lacked.[131] Later self-portraits are quite different. Some, like the painting of circa 1875 (fig. 7), which features Cézanne in front of a landscape by Armand Guillaumin, convey an altogether more realistic self-image, one that expresses Cézanne's belief in "submission" to "nature." The parodic objectification of Cézanne's early painterly persona in some of the texts and images by Duranty, Stock, and Roux undoubtedly played a role in his shift away from his earlier self-conception. And, more creatively, so did Pissarro's portrait of Cézanne as a radical, nature-loving artist around 1875.[132] Cézanne's *Self-Portrait* of circa 1875 was likely affected by this work, or perhaps it was painted as part of a dialogue with Pissarro about the meaning of being an artist. In any event, it shows Cézanne experimenting with a self-image that was foundational to his character as a painter later in his life.

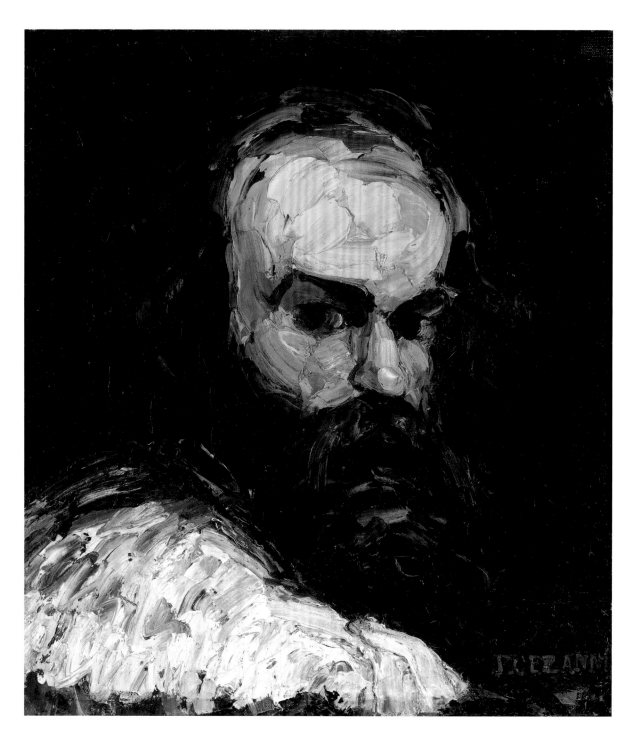

Figure 6
Paul Cézanne (French, 1839–1906)
Self-Portrait, ca. 1866, oil on canvas,
45 × 41 cm (17 1/2 × 16 1/4 in.)
Private collection

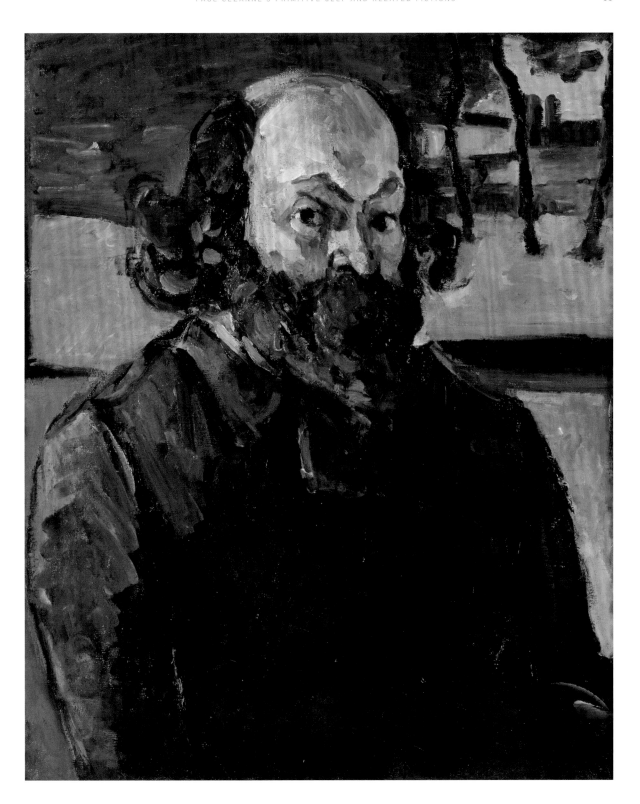

Figure 7
Paul Cézanne (French, 1839–1906)
Self-Portrait, ca. 1873–76, oil on
canvas, 64 × 53 cm (25¼ × 20⅞ in.)
Paris, Musée d'Orsay

I/mpressionism

It would appear from this discussion that in a successful painting by Cézanne, his initial intentionality, the intentionality he worked out in response to the emerging painting, and the intentionality pertaining to his self-conception(s) all came together to make the painting such that it satisfied him deeply. This cannot be proven empirically, but it is significant that something close to the opposite of this situation obtained when the painting—and the "self" in it— went wrong.

This failure is most apparent in Cézanne's early works, where the artist deployed an exaggerated chiaroscuro and an idiosyncratic manner of drawing for effect, or to persuade the public (and himself) that his work was an efflux of his forceful temperament. To paraphrase Stokes: it is difficult to believe that Cézanne was more than superficially content with these early "modeled" works, since they are organized by violent tonal contrasts and sometimes strong baroque diagonals that almost grab the spectator—that is, they exhibit a merely pre-stylistic manner that is almost directly antithetical to the cooler and more "carved" style Cézanne developed in his thirties and that must have gratified him since he retained it for the rest of his life.[133] Cézanne, in other words, for a long time failed to form the style he was capable of, if "style" is considered a natural outgrowth of the physical and psychical capacities with which an artist is born.[134]

Cézanne's early show of "strength" could, of course, be attributed to his lack of confidence, but there is reason to think that Cézanne affected a forceful self in his paintings—and his public behavior—for other reasons. Not the least of these was his ambition to benefit from the fact that by the 1860s "temperament" had become a valuable commodity in the art market.[135] Cézanne, put bluntly, painted in a temperamental fashion in the 1860s because he held ambitions at the time to make "commercial art."[136] For all its unfamiliarity, the idea that the young Cézanne painted for money also accounts for the public displays of temperament he staged with Stock, and others, and the fact that he gleefully distributed Stock's caricature among his friends.[137] A letter of 1868 from Cézanne's colleague Fortuné Marion to the German musician Heinrich Morstatt even intimates that Cézanne performed his boorish public persona with calculation, as part of a concerted campaign of self-"publicity."[138] This would explain why Cézanne was so successful at courting notoriety that he was branded the enfant terrible of the avant-garde in several pieces of criticism and in Duranty's and Roux's fiction.[139] Roux's novel is unusual, however, in stating explicitly that venal motivations lay behind Germain's/Cézanne's behavior and in suggesting that his whole personality, including his artistic self, was stifled under their weight.

Cézanne for his part seemed to acknowledge the truth of Roux's novel in his apologetic letter of 1878 to his former friend. But Cézanne also hinted that Roux's tale had helped him shed the baleful influence of his earlier self. At the very least, therefore, *La proie et l'ombre* encouraged Cézanne to develop his new self of the later 1870s: an artist who painted solely for the aesthetic satisfaction that the activity afforded. Roux thus reinforced a process of self-discovery that Pissarro probably initiated when, in the mid-1870s, he undertook Cézanne's education in radical politics at the same time as his education in painting "nature." The effect of Cézanne's reevaluation of his artistic self is

plain in his mature work, but Cézanne's new self also surfaced in a remark-
able letter of September 1879, in which he told Zola of his dismay at the greed
exhibited by the people of Marseilles: "Marseilles is the [olive] oil capital of
France, as Paris is for butter...this fierce population...has but one instinct,
which is for money. It is said they make plenty of it, but they are ugly—their
ways of communicating are wiping out the distinguishing features of the dif-
ferent types. In a few centuries it will be quite futile to be alive; everything
will be flattened out."[140]

What Cézanne says in this letter is almost uncannily consistent with the
Marxist idea that capitalism makes money seem so magical that it can convert
all quality into quantity (or put a price on anything) and can even supplant
quality as a desideratum with its own fetishistic allure.[141] Cézanne, in other
words, realized that the peculiarly modern love of money was profoundly
inimical to painting like his own, whose contents—he was discovering—were
qualitative, like richness of "sensation."[142] His decision to form his artistic
self in line with the kinds of satisfaction he was beginning to experience as a
painter thus had a political dimension. But it also had moral and aesthetic
dimensions inasmuch as it entailed being honest about himself in a way that
he had previously been unable to manage. To use words that Cézanne bor-
rowed from Stendhal: it was only in the late 1870s that Cézanne did in fact
"dare to be himself" enough to be able to deliver "sensation" or "the truth
in painting."

THE FICTIONAL SELF

While Cézanne's mature artistic self depended on his experiences while paint-
ing, it is clear that it was also shaped by his efforts to gain a reflexive under-
standing of himself as a painter. This reflexivity may not always have been
explicit in his thinking, but it was close enough to the surface to inform his
practice and color the thoughts he expressed in his letters. In the last analysis,
therefore, Cézanne acted according to the fact that his "true" self was a com-
plex function of the thoughts and sensations (or intentionalities) that he expe-
rienced both in his ordinary, nonartistic life and during the process of paint-
ing. So, too, his practice of identifying with fictional painters and seers shows
that he regarded his "true" self as no less immutable. Cézanne was thus no
"primitive," except to the extent that this term implied a commitment to con-
tinual research and to the unfolding of an always provisional painterly self.
Typically, Cézanne put the matter succinctly when he told Bernard: "I make
progress every day, and that's the most important thing."[143]

NOTES

I am greatly indebted to Dietrich Thomae and Charles Salas for their manifold contri-
butions to this essay, and to the Leverhulme Trust, the Getty Trust, and the Arts and
Humanities Research Board for their generous sponsorship of the research it contains.

1. Ludwig Wittgenstein, *Philosophical Investigations,* trans. G. E. M. Anscombe
 (Oxford: B. Blackwell, 1953), 123e (§410).

2. The French word *primitif* is not always synonymous with the English *primitive,*
 especially in nineteenth-century usage. See Stephen F. Eisenman, *Gauguin's Skirt*
 (London: Thames & Hudson, 1997), 79–85.

3. For observations on the "primitive" and "awkward" qualities of Cézanne's work by
 Maurice Denis, Gustave Geffroy, Georges Lecomte, and others, see Richard Shiff,
 *Cézanne and the End of Impressionism: A Study of the Theory, Technique, and
 Critical Evaluation of Modern Art* (Chicago: Univ. of Chicago Press, 1984), 166–73,
 189–90, 194, 283n33, 284n43.

4. See R. P. Rivière and Jacques F. Schnerb, "L'atelier de Cézanne," *La grande revue,*
 25 December 1907, 812. Unless otherwise noted, all translations are my own.

5. See Émile Bernard, "Souvenirs sur Paul Cézanne," *Mercure de France* 69 (1907):
 396; and Joachim Gasquet, *Cézanne* (Paris: Éditions Bernheim-Jeune, 1926), 70, 163.

6. On Cézanne and the Provençal *blague,* see Edmond Jaloux, *Les saisons littéraires,
 1896–1903* (Fribourg: Librairie de l'Université, 1942), 1:104.

7. See Émile Bernard, "Souvenirs sur Paul Cézanne," *Mercure de France* 70 (1907): 614.
 Cf. Gasquet, *Cézanne* (note 5), 70. See also Shiff, *Cézanne* (note 3), 194.

8. Jules Borély, "Cézanne à Aix," *L'art vivant* 2 (1926): 491.

9. Émile Bernard, "Souvenirs" (note 5), 390. Paul Cézanne to Paul Cézanne fils, 13
 September 1906, in Paul Cézanne, *Correspondance,* ed. John Rewald (Paris: B.
 Grasset, 1978), 325.

10. Cf. Frenhofer's remark to Porbus in "The Unknown Masterpiece": "Mabuse had
 but one pupil, which was me. I have not had any, and I am old!" See Honoré de
 Balzac, "Le chef d'oeuvre inconnu," in idem, *Études philosophiques* (Paris: A.
 Houssiaux, 1865), 1:291. On Cézanne's interest in this work, see note 39 below. On
 the function of expressions like this, see Wittgenstein, *Philosophical Investigations*
 (note 1), 89e (§244); and Hans Sluga, "'Whose House Is That?': Wittgenstein on
 the Self," in Hans Sluga and David G. Stern, eds., *The Cambridge Companion to
 Wittgenstein* (Cambridge: Cambridge Univ. Press, 1996), 340.

11. See Shiff, *Cézanne* (note 3), 29–30, 55–69.

12. Cézanne, *Correspondance* (note 9), 293. Cf. the letter in which Cézanne tells Zola of
 "the temperament or creative force" in Zola's novel *Une page d'amour* (1878); Paul
 Cézanne to Émile Zola, Wednesday evening, 1878, in Cézanne, *Correspondance*
 (note 9), 163. See also Shiff, *Cézanne* (note 3), 188–89, 293n6.

13. See Louis-Edmond Duranty, "Le peintre Marsabiel," *La rue: Paris pittoresque et pop-
 ulaire,* 20 July 1867, 6; and Marcel Crouzet, *Un méconnu du réalisme: Duranty
 (1833–1880), l'homme, le critique, le romancier* (Paris: Librairie Nizet, 1964), 247,
 613–15. In Duranty's story, Marsabiel/Cézanne also declares: "'Nature is bourgeois!
 I give it temperament!'"

14. Zola's articles were first published in *L'événement,* between 19 April and 20 May
 1866, and then in the book *Mon salon, augmenté d'une dédicace et d'un appendice*
 (Paris: Librairie Centrale, 1866), which also contained additional material. Zola
 acknowledged his debt to Cézanne in the article of 20 April 1866 bearing the dedi-
 cation, "To my friend Paul Cézanne," by noting: "For ten years now we have talked
 about art and literature." Cf. Gasquet, *Cézanne* (note 5), 51; and Ambroise Vollard,
 En écoutant Cézanne, Degas, Renoir (Paris: B. Grasset, 1938), 22.

15. This document, now in the Research Library at the Getty Research Institute, is in
 fact largely pasted up from the printed *L'événement* texts and would appear to be a
 mock-up of the book. Zola manuscripts in the Bibliothèque Méjanes in Aix-en-
 Provence suggest another version of the text may have been used by the printer.

16. See Marius Roux, *La proie et l'ombre* (Paris: Dentu, 1878). On Roux's relationship
 with Cézanne, see Clive Thomson, "Un correspondance inédite (première partie):
 Vingt-sept lettres de Marius Roux à Émile Zola (1864–1869)," *Revue de l'Université
 d'Ottawa* 48 (1978): 335–70. The present author has edited an annotated edition of
 Roux's novel (in translation) to be published by Pennsylvania State University
 Press (in press).

17. See Roux, *La proie* (note 16), 138, 140, 146, 203, 336.

18. Roux, *La proie* (note 16), 77.

19. "Les réalistes du salon," *L'événement,* 11 May 1866; in Zola, *Mon salon* (note 14), 51–52.

20. Zola, *Mon salon* (note 14), 9.

21. Roux, *La proie* (note 16), 35, 327. Cf. Émile Zola, *L'oeuvre* (Paris: G. Charpentier, 1886), 44, 50, 53, 62, 94, 112, 234, 245, 257, 297, 363. See also John Rewald, *Cézanne: Sa vie—son oeuvre, son amitié pour Zola* (Paris: A. Michel, 1939), 124, which cites Zola's notes for *L'oeuvre* describing Lantier's despair over his "impotence" as a painter.

22. Roux, *La proie* (note 16), 222.

23. Vollard, *En écoutant* (note 14), 20.

24. Cf. Émile Zola, "Le moment artistique," *L'événement,* 4 and 11 May 1866; and *Mon salon* (note 14), title, 33, 49. On "temperament" and its connection with masculinity, see Nina M. Athanassoglou-Kallmyer, *Cézanne and Provence: The Painter in His Culture* (Chicago: Univ. of Chicago Press, 2003), 27–28, 259n59.

25. Duranty, "Le peintre Marsabiel" (note 13), 6.

26. Gasquet, *Cézanne* (note 5), 39.

27. See John Rewald, "Achille Emperaire and Cézanne," in idem, *Studies in Impressionism,* ed. Irene Gordon and Frances Weitzenhoffer (London: Thames & Hudson, 1985), 57–68.

28. *Stock Album* (Paris, 1870). This obscure, ephemeral publication is cited in John Rewald, "Un article inédit sur Paul Cézanne en 1870," *Arts,* 21–27 July 1954. See also Robert Ratcliffe, *Cézanne's Working Methods and Their Theoretical Background* (London: n.p., 1960), 353, 365; and Shiff, *Cézanne* (note 3), 293n6, on the connection between "sensation" and "force."

29. Zola argued that Manet deserved a place in the Louvre, like "any artist of an original and strong temperament"; see Émile Zola, "M. Manet," *L'événement,* 7 May 1866; and Zola, *Mon salon* (note 14), 47.

30. Roux, *La proie* (note 16), 249; see also 81, 154, 202, 210.

31. Roux then uses the word *temperament* twice more, and the word *strength* five times, in the same episode to describe Germain's inflated opinion of himself. See Roux, *La proie* (note 16), 187–91.

32. See Stendhal, *Histoire de la peinture en Italie* (Paris: M. Levy frères, 1868 [1817]), 285, 289, 278, 307, 338. Cézanne's interest in and use of concepts from Stendhal is extensively analyzed in Ratcliffe, *Cézanne's Working Methods* (note 28), 312–27. See also Bob Kirsch, "Paul Cézanne: *Jeune fille au piano* and Some Portraits of His Wife: An Investigation of His Painting of the Late 1870s," *Gazette des Beaux-Arts,* ser. 6, 110 (1987): 21–24.

33. See Stendhal, *Histoire* (note 32), 215, which states how the "seminal humor" affects the bilious type.

34. Stendhal, *Histoire* (note 32), 117.

35. Roux, *La proie* (note 16), 188.

36. See William H. Gerdts, *Monet's Giverny: An Impressionist Colony* (New York: Abbeville Press, 1993), 118, 253n6, for Lewis's letter to Mrs. Stillman. This is also cited in Adelyn D. Breeskin, *The Graphic Work of Mary Cassatt: A Catalogue Raisonné* (New York: H. Bittner, 1948), 33; and Rewald, *Correspondance* (note 9), 241, but in both places is attributed to Mary Cassatt.

37. See Frederick Brown, *Zola: A Life* (London: Papermac, 1996), 86–88.

38. See Hippolyte Taine, *Philosophie de l'art* (Paris: Germer Baillière, 1865), 61–62. On Taine's likely relevance to Cézanne, see Shiff, *Cézanne* (note 3), 24–29, 36, 42–45.

39. In the document known as "Mes confidences," a questionnaire filled in by Cézanne, the artist replied to the question "Which character in a novel or play [is most sympathetic to you]?" with "Frenhoffer" [*sic*]; see Adrien Chappuis, *The Drawings of Paul Cézanne: A Catalogue Raisonné,* trans. Paul Constable et al. (London: Thames & Hudson, 1973), 1:50–51. See also Chappuis, *The Drawings,* 1:77–78 (nos. 128, 129); and Gasquet, *Cézanne* (note 5), 67, 152.

40. Balzac, "Le chef d'oeuvre inconnu" (note 10), 296. For other views shared by Frenhofer and Cézanne, see Balzac, "Le chef d'oeuvre inconnu" (note 10), 294;

Léo Larguier, *Le dimanche avec Paul Cézanne: Souvenirs* (Paris: L'Édition, 1925), 135–36; Émile Bernard, "Paul Cézanne," *L'occident* 6 (1904): 23–24; and Rivière and Schnerb, "L'atelier" (note 4), 814–15. Gasquet recalls Cézanne's "tattered" copy of the *Études philosophiques* in enough detail to suggest it was from the *Oeuvres complètes* of 1842–48, 1865, 1874, or 1877. Cf. Jean de Beucken, *Un portrait de Cézanne* (Paris: Gallimard, 1955), 21.

41. Bernard, "Souvenirs" (note 5), 403.

42. Gasquet, *Cézanne* (note 5), 39. Emperaire looked "radiant" with joy.

43. Edmond de Goncourt and Jules de Goncourt, *Manette Salomon,* 2 vols. (Paris: Librairie Internationale, 1867). Cézanne's expressions of enthusiasm for *Manette Salomon* are recorded in Ratcliffe, *Cézanne's Working Methods* (note 28), 372. Ratcliffe also points out that Gasquet mentions Goncourt in the same breath as Stendhal.

44. See Goncourt and Goncourt, *Manette Salomon* (note 43), 1:83–84, and cf. 2:307. Hence, although Cézanne did not read Stendhal's text until 1869, he could have encountered its key ideas two years earlier.

45. See Goncourt and Goncourt, *Manette Salomon* (note 43), 1:18, 1:51, 1:79, 1:84, 1:201–2, 1:232, 1:280, 2:116, 2:141, 2:208, 2:266.

46. Goncourt and Goncourt, *Manette Salomon* (note 43), 2:265.

47. On Frenhofer and solipsism, see Marc Gotlieb, "The Painter's Secret: Invention and Rivalry from Vasari to Balzac," *Art Bulletin* 84 (2002): 485.

48. See the review of the first impressionist exhibition by Castagnary in Ruth Berson, ed., *The New Painting: Impressionism, 1874–1886: Documentation* (San Francisco: Fine Arts Museums, 1996), 1:17. Cf. the remarks made by Marc de Montifaud; see Berson, *The New Painting,* 1:29–30.

49. Bernard, "Paul Cézanne" (note 40), 22.

50. Paul Cézanne to Paul Cézanne fils, 2 August 1906, in Cézanne, *Correspondance* (note 9), 318–19.

51. Bernard, "Paul Cézanne" (note 40), 21; cf. Paul Cézanne to Émile Bernard, 26 May 1904; see Cézanne, *Correspondance* (note 9), 303; and Gasquet, *Cézanne* (note 5), 72, 194.

52. Paul Cézanne to Émile Zola, 20 November [1878], in Cézanne, *Correspondance* (note 9), 176–77; cf. Ratcliffe, *Cézanne's Working Methods* (note 28), 365.

53. Stendhal, *Histoire* (note 32), 224.

54. Paul Cézanne to Émile Bernard, 4 May 1904 and 23 October 1905, in Cézanne, *Correspondance* (note 9), 303, 315. Cf. Paul Cézanne to Émile Zola, 20 November [1878], which mentions Stendhal's *Histoire de la peinture en Italie* and soon afterward uses the phrase "means of expressing sensation"; see Cézanne, *Correspondance* (note 9), 176–77.

55. Stendhal, *Histoire* (note 32), 74; cited in Ratcliffe, *Cézanne's Working Methods* (note 28), 321.

56. Gasquet, *Cézanne* (note 5), 136: "I see. In stains."

57. See Borély, "Cézanne" (note 8), 493; cf. Cézanne, *Correspondance* (note 9), 270–71.

58. See Joel Isaacson, "Constable, Duranty, Mallarmé, Impressionism, Plein Air, and Forgetting," *Art Bulletin* 76 (1994): 427–50.

59. Hippolyte Taine, *De l'intelligence* (Paris: Librairie Hachette, 1870), 1:190. See also Shiff, *Cézanne* (note 3), 19, 27, 45 (on *De l'intelligence*). See also Borély, "Cézanne" (note 8), 493, in which Cézanne describes a tree as "palpable, resistant, [a] body" immediately before declaring his ambition to see like a newborn.

60. See Taine, *De l'intelligence* (note 59), 2:121. On Taine and impressionism, see also Charles F. Stuckey, "Monet's Art and the Act of Vision," in John Rewald and Frances Weitzenhoffer, eds., *Aspects of Monet: A Symposium on the Artist's Life and Times* (New York: Harry N. Abrams, 1984), 106–21.

61. See Taine, *De l'intelligence* (note 59), 2:73–148, esp. 2:110–33.

62. On painters and color-patch vision, see Taine, *De l'intelligence* (note 59), 2:122.

63. See Paul Smith, *Interpreting Cézanne* (London: Tate, 1996), 48–51.

64. Gasquet, *Cézanne* (note 5), 167. Cf. Émile Bernard, *Souvenirs sur Paul Cézanne: Une conversation avec Cézanne* (Paris: R. G. Michel, 1926), 85.

65. Mathilda Lewis mentions this in the letter of 1894 in which she relates his views on the individuality of vision. See Mathilda Lewis to Mrs. Stillman, cited in Gerdts, *Monet's Giverny* (note 36), 118, 253n6.

66. Cézanne admired this work enough to copy several passages from it; see Gasquet, *Cézanne* (note 5), 45.

67. Jean-Jacques Rousseau, *Émile,* in idem, *Oeuvres complètes de J. J. Rousseau* (Paris: Dalibon, 1826), 3:22–23.

68. Wittgenstein, *Philosophical Investigations* (note 1), 226e, 174e; and Ludwig Wittgenstein, *Philosophical Occasions, 1912–1951,* ed. James C. Klagge and Alfred Nordmann (Indianapolis: Hackett, 1993), 397e. See also Barry Curtis, "Forms of Life and Other Minds," in Peter Kampits, Karoly Kokai, and Anja Weiberg, eds., *Angewandte Ethik: Beiträg… = Applied Ethics: Papers of the 21st International Wittgenstein Symposium, August 16–22, 1998, Kirchberg am Wechsel,* Contributions of the Austrian Ludwig Wittgenstein Society/Beiträge der Österreichischen Ludwig Wittgenstein Gesellschaft, 6 (1) (Kirchberg am Wechsel: Austrian Ludwig Wittgenstein Society/Österreichischen Ludwig Wittgenstein Gesellschaft, 1998), 125–30.

69. Cézanne's stated opinions have no clear connection to ideologies related to the categorization of "primitive" people as "children" or the belief (propounded by the biologist and philosopher Ernest Haeckel, among others) that ontogeny recapitulates phylogeny.

70. Paul Cézanne to Camille Pissarro, 2 July 1876; Paul Cézanne to Émile Zola, 14 April 1878; and Paul Cézanne to Émile Zola, 23 June 1879; in Cézanne, *Correspondance* (note 9), 154, 165, 184.

71. Paul Cézanne to Émile Zola, 24 September 1879, in Cézanne, *Correspondance* (note 9), 185.

72. For Cézanne's presence at Nina de Villard's salon, see Vollard, *En écoutant* (note 14), 29; and Paul Cézanne to Paul Cézanne fils, 3 August 1906, in Cézanne, *Correspondance* (note 9), 318–19.

73. Paul Alexis, *Madame Meuriot: Moeurs parisiens* (Paris: Bibliothèque-Charpentier, 1890), 311–12.

74. On Cézanne and Cabaner, see Cézanne, *Correspondance* (note 9), 183–84; Félicien Champsaur, "Le rat mort," *L'étoile française,* 21 December 1880; Félicien Champsaur, "Le rat mort," *Revue moderne et naturaliste* (1880): 435–41; Paul Alexis, "Trubl' au vert," Le cri du peuple, 2 September 1887; cited in Robert J. Niess, *Zola, Cézanne, and Manet: A Study of* L'Oeuvre (Ann Arbor: Univ. of Michigan Press, 1968), 264n100; Georges Rivière, *Renoir et ses amis* (Paris: H. Floury, 1921), 32, 21–23, 25–32; George Moore, *Confessions of a Young Man* (Harmondsworth: Penguin, 1939), 90–99; Paul Gachet, *Le docteur Gachet et Murer: Deux amis des impressionnistes* (Paris: Éditions des Musées Nationaux, 1956), 77; and Jean-Jacques Lefrère and Michael Pakenham, *Cabaner, poète au piano* (Paris: L'Échoppe, 1994), 76–80.

75. Vollard, *En écoutant* (note 14), 154–55.

76. See Walter Benjamin, "Paris, the Capital of the Nineteenth Century (1935)," in idem, *The Arcades Project,* trans. Howard Eiland and Kevin McLaughlin (Cambridge: Belknap, 1999), 3–13; Benjamin, "Paris" (this note), 14–26; Walter Benjamin, "The Paris of the Second Empire in Baudelaire," in idem, *Charles Baudelaire: A Lyric Poet in the Era of High Capitalism,* trans. Harry Zohn (London: Verso, 1983), esp. 55–57, 61–62; Walter Benjamin, "Some Motifs in Baudelaire," in idem, *Charles Baudelaire: A Lyric Poet in the Era of High Capitalism,* trans. Harry Zohn (London: Verso, 1983), 163–71; and Karl Marx, *Capital: A Critique of Political Economy,* trans. Ben Fowkes and D. Fernbach (Harmondsworth: Penguin, 1976), 1:163–65.

77. See Georg Lukács, *History and Class Consciousness: Studies in Marxist Dialectics,* trans. Rodney Livingston (Cambridge: MIT Press, 1971), 88–90; Benjamin, "The Paris of the Second Empire" (note 76), 53–54; Benjamin, "Some Motifs" (note 76), 129; and Christopher Prendergast, *Paris and the Nineteenth Century* (Oxford:

Blackwell, 1992), 189–93. Baudelaire treats "mechanical time" in, for example, "Les dons des fées," "Portraits de mâitresses," "Le galant tireur," and "L'horloge"; see Charles Baudelaire, *Oeuvres complètes,* ed. Claude Pichois (Paris: Gallimard, 1975), 1:305–7, 1:345–49, 1:349–50, 1:81.

78. Cézanne was a self-confessed "bohemian." See Bernard, "Souvenirs" (note 5), 394, 402. Cf. Vollard, *En écoutant* (note 14), 18.

79. Goncourt and Goncourt, *Manette Salomon* (note 43), 2:316.

80. See Andrew Benjamin, "Tradition and Experience: Walter Benjamin's *Some Motifs in Baudelaire,*" in idem, ed., *The Problems of Modernity: Adorno and Benjamin* (London: Routledge, 1989), 125.

81. For Cézanne's complaints about the encroachment of modernity into Aix, see Borély, "Cézanne" (note 8), 493; and Bernard, "Souvenirs" (note 5), 403–4.

82. See Paul Smith, "Joachim Gasquet, Virgil, and Cézanne's Landscape: 'My Beloved Golden Age,'" *Apollo,* n.s., 148, no. 439 (1998): 13.

83. See Smith, "Joachim Gasquet" (note 82), 11–17.

84. Cézanne, *Correspondance* (note 9), 48. Zola's letter is now in the Research Library at the Getty Research Institute; see Émile Zola, "Letters, 1858–1860, to Paul Cézanne," Research Library, Getty Research Institute, acc. no. 861128.

85. See Smith, "Joachim Gasquet" (note 82), 11–12. Cf. Athanassoglou-Kallmyer, *Cézanne* (note 24), 187–95, 216–31.

86. On this theme in Gasquet, see Smith, "Joachim Gasquet" (note 82), 17–19.

87. On this novel, see Smith, "Joachim Gasquet" (note 82), 18.

88. Numa Coste to Émile Zola, 5 March 1891, cited in Cézanne, *Correspondance* (note 9), 235.

89. See Richard Verdi, *Cézanne and Poussin: The Classical Vision of Landscape,* exh. cat. (London: Lund Humphries, 1990), 28–29, 98–101 (nos. 18–19). On the iconography of these paintings, see Richard Verdi, *Nicolas Poussin, 1594–1665,* exh. cat. (London: Zwemmer, 1995), 276–78 (nos. 67–68).

90. See, for example, Madame de Sévigné, "Musées du Louvre, Salon de 1834—exposition de peinture: *Mort de Poussin,* par M. Granet," *Magasin pittoresque* 2 (1834): 137–38. Cézanne was an enthusiast of the *Magasin pittoresque* in his youth; see Bernard, "Souvenirs" (note 5), 606; Vollard, *En écoutant* (note 14), 62; and Chappuis, *The Drawings* (note 39), nos. 272, 469, 491, 492, 673, 832, 1132.

91. See Balzac, "Le chef d'oeuvre inconnu" (note 10), 294, 296, 300, on Frenhofer's "doubt(s)," and 287, 292, 296, on his "despair"; and Goncourt and Goncourt, *Manette Salomon* (note 43), 1:193–94, on Coriolis's "despair" and "doubt."

92. See, for example, Gasquet, *Cézanne* (note 5), 43, 61–62, 82–83; Rewald, *Cézanne* (note 21), 47, 63–64; and Émile Zola to Cézanne, 25 June 1860; Émile Zola to Cézanne, July 1860; and Zola to Jean-Baptistin Baille, late June or early July 1861; in Émile Zola, *Correspondance,* ed. B. H. Bakker et al. (Montréal: Presses de l'Université de Montréal, 1978–95), 1:191, 1:213, 1:300–301. Claude Lantier's "doubt" is described in Zola, *L'oeuvre* (note 21), 15, 31, 49, 57, 94, 181, 204, 206, 222, 234, 235, 245, 263–64, 311. On Germain Rambert's despair, cf. Roux, *La proie* (note 16), 150.

93. See Roux, *La proie* (note 16), 21, 138, which states of Germain Rambert that "only he alone understood what he made." Cf. Paul Cézanne to Paul Cézanne fils, 15 October 1906; see Cézanne, *Correspondance* (note 9), 332.

94. Paul Cézanne to Ambroise Vollard, 9 January 1903, in Cézanne, *Correspondance* (note 9), 292; Chappuis, *The Drawings* (note 39), 1:50, 1:52; and Alfred de Vigny, "Moïse," in idem, *Oeuvres complètes,* ed. Fernand Baldensperger (Paris: Gallimard, 1948), 1:57–60.

95. See Verdi, *Cézanne and Poussin* (note 89), 178–79 (no. 59).

96. Cézanne was greatly touched by the dedication printed in the book, which Geffroy sent to him: *Le coeur et l'esprit* (Paris: Charpentier & Fasquelle, 1894), 107–27; see Paul Cézanne to Gustave Geffroy, 31 January 1895, in Cézanne, *Correspondance* (note 9), 243–44. On Cézanne's enthusiasm for this story, see Paul Cézanne to Joachim Gasquet, 21 May 1896, in Cézanne, *Correspondance* (note 9), 250–51;

Vollard, *En écoutant* (note 14), 67; John Rewald, "Preface," in *Joachim Gasquet's Cézanne: A Memoir with Conversations,* trans. Christopher Pemberton (London: Thames & Hudson, 1991), 11; and Gustave Geffroy, *Paul Cézanne et autres textes,* ed. Christian Limousin (Paris: Séguier, 1995), 23–25, 90.

97. Gustave Geffroy, "Les vrais primitifs," in idem, *La vie artistique: Huitieme et dernière série* (Paris: H. Floury, 1903), 1–31.

98. Paul Cézanne to Roger Marx, 23 January 1905, in Cézanne, *Correspondance* (note 9), 311–12.

99. Paul Cézanne to Marius Roux, circa 1878, in Cézanne, *Correspondance* (note 9), 178–79.

100. Paul Cézanne to Émile Zola, 20 May 1881, in Cézanne, *Correspondance* (note 9), 199–200.

101. Gasquet, *Cézanne* (note 5), 192.

102. On Cézanne and Louis Séguin, see Mario Petrone, "'La double vue de Louis Séguin' de Duranty," *Gazette des beaux-arts,* ser. 6, 88 (1976): 235–39, esp. 236; Crouzet, *Un méconnu* (note 13), 239n32; and Shiff, *Cézanne* (note 3), 280n2, which identifies Cézanne as the model for Duranty's eponymous antihero.

103. On Paul, see Émile Zola, "Le bois," in idem, *Le capitaine burle….* (Paris: G. Charpentier, 1883), 207–17; on Bernicaud, Émile Zola, "Bohèmes en villégiature," *Les types de Paris* 2 (1889): 17–26; see also Rewald, *Cézanne* (note 21), 126–27; and Rodolphe Walter, "Cézanne à Bennecourt en 1866," *Gazette des beaux-arts,* ser. 6, 59 (1962): 103–18, esp. 105, 111, 116n7, 117n10. On Claude, see Émile Zola, *La confession de Claude* (Paris: Librairie Internationale, 1866).

104. See Wittgenstein, *Philosophical Investigations* (note 1), 31e–36e (§§66–77), esp. 32e (§67).

105. On the importance of subjectivity and intentionality to what works of art are, see Paul Smith, "Wittgenstein, Description, and Adrian Stokes (on Cézanne)," in Paul Smith and Carolyn Wilde, eds., *A Companion to Art Theory* (Oxford: Blackwell, 2002), 198.

106. See Sluga, "Whose House" (note 10), 332–42. This includes an analysis of how, in the "Cogito," Descartes forces the *I* in "I am" to appear as a name referring to an object of sorts, and of how, being unable to identify this in the same way as a normal object, we endorse the idea that it must be an incorporeal something: a thinking "thing" that somehow nevertheless exists like a body—effectively a nonsensical object-subject or "chimera."

107. Sluga, "Whose House" (note 10), 335, citing Ludwig Wittgenstein, *The Blue and Brown Books,* 2nd ed. (Oxford: Blackwell, 1960), 66.

108. Paul Cézanne to his niece Paule Conil, 1 September 1902, in Cézanne, *Correspondance* (note 9), 290. Cézanne's comment to Bernard, "I am too old," appears to be a simple report of a state of physical being, but it is not: see the section "I/dentification and I/magination" below.

109. Paul Cézanne to Philippe Solari, 23 July 1896, in Cézanne, *Correspondance* (note 9), 253.

110. Paul Cézanne to Joachim Gasquet, 30 April 1896, in Cézanne, *Correspondance* (note 9), 249–50. Cf. Cézanne's remark about the landscape at L'Estaque: "I have here some beautiful views but they do not quite make *motifs*" (emphasis added); Paul Cézanne to Émile Zola, 24 May 1883, in Cézanne, *Correspondance* (note 9), 211.

111. Cf. Wittgenstein, *Philosophical Investigations* (note 1), 124e–125e (§413), which argues for the irreducibility of intentional statements to statements about a self in a remark about William James.

112. See Mathilda Lewis to Mrs. Stillman, 1894; cited in Gerdts, *Monet's Giverny* (note 36), 118, 253n6.

113. On intention as a criterion of the meaning of a work of art, see Richard Wollheim, *Painting as an Art* (London: Thames & Hudson, 1987), 13–41.

114. See Gustave Courbet to M. and Mme Francis Wey, 26 November 1849; and Gustave Courbet to Champfleury, February–March 1950; in Gustave Courbet, *Letters of*

Gustave Courbet, ed. and trans. Petra ten-Doesschate Chu (Chicago: Univ. of Chicago Press, 1992), 88 (no. 49-8), 92–93 (no. 50-1).

115. See Benjamin Harvey, "Cézanne and Zola: A Reassessment of *L'eternel féminin,*" *Burlington Magazine* 140 (1998): 312–18, which dates the painting to circa 1880. Even if the painting does predate *Nana*'s serialization in late 1879, Cézanne could easily have obtained advance notice of its content from Zola, with whom he often discussed the progress of the Rougon-Macquart series.

116. See Garry L. Hagberg, "The Institutional Theory of Art: Theory and Antitheory," in Paul Smith and Carolyn Wilde, eds., *A Companion to Art Theory* (Oxford: Blackwell, 2002), 493–94.

117. See Wollheim, *Painting as an Art* (note 113), 17–18 (and 13–100), 358–59n8. The theory of "intention in action" (as opposed to "prior intention") is developed in John R. Searle, *Intentionality: An Essay in the Philosophy of Mind* (Cambridge: Cambridge Univ. Press, 1983), esp. 93. It has roots in Ludwig Wittgenstein, *Notebooks, 1914–1916,* ed. G. H. von Wright and G. E. M. Anscombe, trans. G. E. M. Anscombe (Oxford: Blackwell, 1979), 86e–88e (4.11.16); and Wittgenstein, *Philosophical Investigations* (note 1), 160e (§615).

118. See Adrian Stokes, *Colour and Form* (London: Faber & Faber, 1950), esp. 53–54; Richard Shiff, "Cézanne's Physicality: The Politics of Touch," in Salim Kemal and Ivan Gaskell, eds., *The Language of Art History* (Cambridge: Cambridge Univ. Press, 1991), 129–80.

119. See Wittgenstein, *Philosophical Investigations* (note 1), 55e–56e (§141), 185e, 198e.

120. See Wollheim, *Painting as an Art* (note 113), 39–44; and Flint Schier, "Painting after Art? Comments on Wollheim," in Norman Bryson, Michael Ann Holly, and Keith Moxey, eds., *Visual Theory: Painting and Interpretation* (Cambridge: Polity, 1991), 151–53.

121. On the relationship between an agent's role and her or his consciousness, see Alison Assiter, "Philosophical Materialism or the Materialist Conception of History," in Charles Harrison and Fred Orton, eds., *Modernism, Criticism, Realism: Alternative Contexts for Art* (New York: Harper & Row, 1984), 113–21.

122. "Je est un autre." See Arthur Rimbaud to Paul Demeny, 17 April 1871; and cf. Arthur Rimbaud to Georges Isambard, 13 May 1871; in Arthur Rimbaud, *Oeuvres complètes,* ed. Antoine Adam (Paris: Gallimard, 1972), 248–49, 250–51. I am grateful to Fred Orton for bringing these references to my attention.

123. Paul Cézanne to his mother, 26 September 1874, in Cézanne, *Correspondance* (note 9), 148.

124. Paul Cézanne to Numa Coste, early July [18]68, in Cézanne, *Correspondance* (note 9), 131.

125. See Sluga, "Whose House" (note 10), 345–49; and Wittgenstein, *Philosophical Investigations* (note 1), 192e.

126. Paul Cézanne to Zola, 24 September 1879, in Cézanne, *Correspondance* (note 9), 185.

127. See Sluga, "Whose House" (note 10), 349; Michel Foucault, "Technologies of the Self," in Luther H. Martin, Huck Gutman, and Patrick H. Hutton, eds., *Technologies of the Self: A Seminar with Michel Foucault* (Amherst: Univ. of Massachusetts Press, 1988), 16–49; and Michel Foucault, *The Care of the Self,* trans. Robert Hurley (New York, Pantheon, 1986), esp. 39–68.

128. On "central imagining," see Richard Wollheim, "Imagination and Identification," in idem, *On Art and the Mind* (London: Harvard Univ. Press, 1974), 58–60; Wollheim, *Painting as an Art* (note 113), 103–4; and Schier, "Painting" (note 120), esp. 152.

129. See Gasquet, *Cézanne* (note 5), 67, 152.

130. See Wollheim, "Imagination" (note 129), 76–79, for a psychoanalytical explanation of identification citing Sigmund Freud and Melanie Klein.

131. Cf. Jacques Lacan, "The Mirror Stage as Formative of the Function of the I as Revealed in Psychoanalytic Experience," in idem, *Ecrits: A Selection,* trans. Alan Sheridan (New York: W. W. Norton, 1977), 1–7.

132. See Theodore Reff, "Pissarro's Portrait of Cézanne," *Burlington Magazine* 109

(1967): 626–31, 623, for an illuminating, if somewhat conservative, discussion of this work.

133. On "modeling" and "carving" in general, see Richard Wollheim, "Adrian Stokes," in idem, *On Art and the Mind* (London: Harvard Univ. Press, 1974), 315–35; and in Cézanne, see Stokes, *Colour and Form* (note 118), 45, 59–60, 62, 79–84, 105–6. Stokes also insists that Cézanne's late style readmits modeling and thus enriches carving with its antithesis.

134. On individual style, its formation, and its roots in the body, see Wollheim, *Painting as an Art* (note 113), 25–36.

135. See Nicholas Green, "Dealing in Temperaments: Economic Transformation of the Artistic Field in France during the Second Half of the Nineteenth Century," *Art History* 10 (1987): 59–78; and Nicholas Green, "Circuits of Production, Circuits of Consumption: The Case of Mid-Nineteenth-Century French Art Dealing," *Art Journal* 48 (1989): 29–34.

136. Cézanne must have declared an ambition to undertake "commercial painting" to Zola by 1860, since the writer warned him in three letters of that year against the aesthetic "disaster" his plans would entail. See Émile Zola to Paul Cézanne, 25 March 1860; Émile Zola to Paul Cézanne, 26 April 1860; and Émile Zola to Paul Cézanne, 1 August 1860; in Zola, *Correspondance* (note 9), 1:146, 1:150, 1:219.

137. For Cézanne's early strategy vis-à-vis the Salon, see Rewald, *Cézanne* (note 21), 105–7, 127, 143, 167; and Cézanne, *Correspondance* (note 9), 94, 112–15, 150–51. On Cézanne's use of Stock's caricature, see Paul Cézanne to Justin Gabet, 7 June 1870, in Cézanne, *Correspondance* (note 9), 135–36.

138. Rewald, *Cézanne* (note 21), 150; citing Alfred Barr, "Cézanne d'après les lettres de Marion à Morstatt, 1865–1868," *Gazette des beaux-arts,* ser. 6, 17 (1937): 48.

139. For reviews of the first impressionist exhibition singling out Cézanne for censure, see the criticisms by Castagnary and de Montifaud and those by Louis Leroy and Henri Polday in Berson, *The New Painting* (note 48), 1:26, 1:33.

140. Cézanne, *Correspondance* (note 9), 173–74.

141. Cf. Lukács, *History* (note 77).

142. On the inexpressible strength of his "sensations," see, for instance, Paul Cézanne to Émile Zola, 27 September 1879, in Cézanne, *Correspondance* (note 9), 186.

143. Bernard, "Souvenirs" (note 5), 399.

Biography, Brush, and Tools:
Historicizing Subjectivity; The Case of
Vincent van Gogh and Paul Gauguin

DEBORA L. SILVERMAN

Do our inner thoughts ever show outwardly?
　　　—Vincent van Gogh to his brother Theo, July 1880[1]

Nous sommes aujourd'hui ce que nous étions hier [we are today what we were
yesterday], namely "honest men," men who must be tried in the fire of life
to become strengthened and steadied within, and be, by the Grace of God,
what they are by nature.
　　　—Vincent van Gogh to his brother Theo, 3 April 1878[2]

Biography is both an exasperating vehicle perpetuating the myth of romantic
exceptionalism and a promising terrain of cultural history, where the lives of
artists may serve to illuminate broader problems and expose the pressure
points of social transformation. In considering questions regarding "the life
and the work," I'd like to begin by raising two larger issues. One concerns his-
torical models of interiority, and the second centers on religious formation
and varying models of the self.

　　We have done very well, I think, in accounting for the political, social,
and gendered pressures affecting artists' worlds, especially in the nineteenth
century. But we have been less successful in two areas: First, we have sub-
scribed too readily to a single model of the modern bourgeois individual,
liberated from traditional authority and dedicated to unbridled self-mastery
and self-development. We still know relatively little about the forms, mean-
ings, and functions of the individual in varying national and historical con-
texts of the modern period, or about the distinctive cultural resources and
constraints for self-formation in particular countries and phases. G. W. F.
Hegel's concept of *free subjectivity,* and the model of autonomous bourgeois
individuality that developed from it, may be most appropriate, if at all, to
France, where cultural formation was defined by centralized state power,
absolutist clerical authority, and revolution. The cases of the Netherlands,
Belgium, Britain, and Germany were quite different.[3] Interiority needs to be
historicized; categories need to be more historically specific, less monolithic,
and more comparative. Here I am emboldened by Michel Foucault—less the

writer of "What Is an Author?" (1969) than of *The Archaeology of Knowledge* (1969)—who offers us the fundamentally historical insight that the individual is a particular and specifiable social construction, catapulted precipitously from one epistemic eruption and bound inexorably to fall into the pit of another epistemic movement. Foucault's historicism can serve to reverse our analytic priorities, leading us to focus not on the Barthian death but on the *birth* of the author and to reexplore the conditions of the emergence of the self in different national contexts.

Second, we have radically underanalyzed a key site of pressure and transformation for the avant-garde in the nineteenth century: religion, both as an institution and as a mediator of mental life. We tend to oversecularize the avant-garde, and our approach to modernist biography presumes a succession of defiant, anticlerical, and deracinated groups of cultural innovators who engaged in a century-long battle against bankrupt bourgeois philistinism. Now these French-inspired categories lose their hold and reliability when applied to artistic production in nineteenth-century Britain, Netherlands, Germany, and Belgium, and they trivialize the profound and enduring significance of religious legacies and conflicts for artists in the French context. This is particularly evident among those who grew to adulthood in the decades between 1850 and 1890, that is, before the expulsion of the Jesuits in education and the polarizing force of the Dreyfus Affair. Moreover, we assume too readily that the aggressive anticlerical campaign of the Third Republic was wholly successful. But, as historians Alain Corbin, Ralph Gibson, and Ruth Harris have reminded us, in the 1880s this campaign encountered an explosion of robust and emotionalist popular piety that was deeply anticlerical even as it adapted Catholicism to old and new devotional currents.[4] A parallel process of recrudescence and reconfiguration took place in elite culture, from Émile Zola's *Le rêve* (1888) to Émile Bernard's and Maurice Denis's modernist calvaries. Auguste Rodin wrote long essays celebrating France's medieval religiosity and its cathedrals during the same years that Claude Debussy created the piano work "La cathédrale engloutie" (1909–10) and orchestrated the mystery play *Le martyre de Saint-Sébastien* (1911). This wellspring of creativity suggests the rebirth of older cultural legacies in new forms and the shared search by many avant-garde artists to find a replacement for the binding power and totality that had been provided by traditional religion.

In reemphasizing the role of religion in the development of modernism, we begin to encounter glaring omissions in the secular model of the avant-garde. For example, a striking correlation exists between nineteenth-century Catholic formation and the language and practice of abstraction in the arts of the 1880s and 1890s. Abstraction emerged between 1886 and 1890 among Parisian artists who shared a French Catholic seminary education. In these circles, supernaturalist Catholicism, idealist Neoplatonism, and avant-garde symbolism came together in a dynamic cultural mix. Late-nineteenth-century post-Tridentine Catholicism, and the institutions of Catholic education in particular, shaped powerful predispositions to the ideas of abstraction and antinaturalism that were championed by the avant-garde in the 1880s and 1890s. Inwardness and otherworldliness, for example, were at the core of this educational system, facilitating what one of its most famous (and later most anticlerical) students, the scholar of religion Joseph-Ernest Renan, who attended

the Petit Séminaire de Saint Nicholas du Chardonnet, celebrated as a "sur-render to dreams" and a *repli sur soi*—a folding in on the self.[5] Many of the painters, poets, and critics who defined the first language and practice of abstraction in the fin de siècle, such as Octave Mirbeau, Édouard Vuillard, Charles Morice, and Paul Gauguin, were products of such Catholic seminary educations, where they were inculcated in techniques of introspection and in ways to fix their eyes and hearts on an ideal essential order beyond a deficient and corrupt materiality, in transcendent release to the divine.

In highlighting religion, I am interested less in charting the iconography of religious aspiration than in exploring the underlying resources and tensions generated by various religious traditions and their varying conceptions of the status of the self, the value of the image, and the meaning of the visible world. This approach examines religious legacies not as a matter of institutional religious practice, or as the inclusion of overt, surface symbols, but as formative structures, as mental frameworks and filters that are mediated through the institutions of educational formation, and that structure how artists approach reality, the status they accord the sensual in their craft, the density of the artist's touch, the relation between perception and conception, and the vocation of the artist as purveyor of meaning and value.

These issues of religion, modernism, and varying models of the self crystallized in the course of my research for *Van Gogh and Gauguin: The*

Figure 1
Vincent van Gogh
(Dutch, 1853–90)
Wheatfield with Rising Sun, 1889,
oil on canvas, 71 × 90.5 cm
(28 × 35⅝ in.)
Whereabouts unknown

Search for Sacred Art, a book that explored the vexed collaboration of Vincent van Gogh and Paul Gauguin. Van Gogh, the mythic epitome of unmediated interiority, is an artist who emphatically resists introspection and shows almost no autobiographical impulses. He expresses the vicissitudes of his life in dialogue, in the pace and flow of his work, and through an interminable stream of letters and exchanges with brothers, sisters, parents, and fellow artists.[6] I was interested in van Gogh's identification with craft labor—with weaving in particular—and his drive to develop a pictorial language of labor, one that attempted to reproduce the activity of the preindustrial weavers with whom he deeply identified in the coarse palpability of the canvas; in fibrous, interlocking brushwork; and in intersecting checkerboard blocks (fig. 1).

Van Gogh consistently seeks to maximize the materiality of the painting surface, working the image of work on the canvas. He incorporates into the nap of his Arles *Sower* (1888) the soot blown by the mistral, and he thickens the protrusive crust of his impasto with bits of eggshell, aiming to give his paintings the heightened sculptural density of crumbled brick, colored clay, or a troweled or plowed field (fig. 2).[7] Throughout the many phases of his career, van Gogh also builds craft tools and optical devices, such as his perspective frame of 1882, adapted from ones that he studied in popular art manuals (fig. 3). A tinkering experimentalism is evident in van Gogh's many attempts to refine the frame's form and operation, from his exercises in 1885

Figure 2
Vincent van Gogh
(Dutch, 1853–90)
Sower with Setting Sun, 1888,
oil on canvas, 64 × 80.5 cm
(25 1/4 × 31 3/4 in.)
Otterlo, Kröller-Müller Museum

Figure 3
Vincent van Gogh
(Dutch, 1853–90)
Sketch of a perspective frame
in a letter, Vincent van Gogh
to Theo van Gogh, 1882.
Amsterdam, Van Gogh Museum

Figure 4
Vincent van Gogh
(Dutch, 1853–90)
Sketches of siting the tower and a
design for a standing perspective
frame from the Nuenen sketch-
book, 1883–85, pencil, folio:
12.4 × 7.3/7.5 cm (4⅞ × 2¹⁵⁄₁₆ in.)
Amsterdam, Van Gogh Museum

Figure 5
Vincent van Gogh
(Dutch, 1853–90)
Sketches of a head of a man and
a perspective frame, F1637 verso,
June–July 1890, blue chalk,
31 × 24 cm (12¼ × 9½ in.)
Amsterdam, Van Gogh Museum

siting a tower and varying the adjustments of the pedestal notches (fig. 4) to
his late Auvers sketch of a multipurpose frame in 1889 that facilitated vertical
as well as horizontal viewing (fig. 5). And while his colleagues among the
Parisian avant-garde dutifully applied the chemist Michel-Eugène Chevreul's
laws of complementary and contrasting colors, van Gogh alone began by
testing the color theories, taking strands of yarn and bunching them together
into interlacing tonalities—the very method Chevreul employed to discover
these color laws at the Manufacture des Gobelins (fig. 6). Van Gogh stored
the woolly balls of colored yarns in a Chinese tea box; his friend Bernard
described how he would roll them out in their laced pairs across his Paris
worktable as he studied color luminosity and iridescence.[8] In *Van Gogh and
Gauguin,* I explored the role of the perspective frame and the weaving loom in
shaping van Gogh's visual habits of framing and facture. These habits provide
continuity and coherence in van Gogh's stylistic language of craft labor and
are essential to his production not only in the Dutch period but also through-
out the French period.[9]

In tracing the complex sources of van Gogh's identification with labor, I immersed myself in the social and cultural world of mid-nineteenth-century Netherlandish Calvinism. Here I encountered rather surprising materials that led me to question some fundamental assumptions about subjectivity and individualism at the heart of modernist biographies. First, van Gogh absorbed not one but a number of competing strains of Dutch Calvinism; his own family concentrated the religious conflicts shaping Dutch society after 1850. Confessional politics, and internal divisions within the confessional system, set the national agenda of the new Dutch Kingdom of the 1850s and 1860s in which van Gogh grew up. While class tensions surely existed, they remained, until very late in the nineteenth century, subordinate to the religious and regional controversies marking the social order. Van Gogh's grandfather, father, and uncle, all ministers, each participated in different reform movements within the Dutch Calvinist church, exposing him to rival notions of divinity and contending models of justification. These rival theological strains set the terms for van Gogh's ten-year struggle, before he turned to painting, to define the nature and value of his own work and worthiness, his profession or vocation, first as an art dealer and then as a lay preacher and evangelist in England and Belgium. In 1880, when van Gogh decided to become an artist, he related his new calling to his ongoing struggle with the ambiguous Calvinist interpretations of justification and with his culture's contested redefinitions of faith and works, nature and divinity, immanence and transcendence, and earning and deserving. Van Gogh, so often viewed as a "genius artist" isolated from society, here gives way to van Gogh as a carrier of cultural history whose family offered a microcosm of mid-century Dutch theological

Figure 6
Vincent van Gogh
(Dutch, 1853–90)
Lacquer box with colored yarn, 1886
Amsterdam, Van Gogh Museum

culture in transformation: painter and painting absorb, express, and transpose the mid-nineteenth-century crisis of religious conscience.[10]

Van Gogh's cultural formation shared a set of distinctive features that undermine our expectations of Calvinism and the avant-garde. One was a celebration of the visual, or what I call a visual or optical piety. The new Groningen School theology favored by the van Gogh family accorded a privileged place to a seeing God and to sight as a vehicle of salvation. The van Goghs construed their God not as a punitive dispenser of final judgment but as a source of light and love, an all-seeing surveyor whose dominion was expressed in receptive, penetrating sight and in the magnificent book of nature, whose forms were to be enjoyed as sources of perpetual wonder rather than as snares and temptations to corruption and perdition. This was a humanistic, visually oriented Calvinism. Far from antisensual, the van Gogh parish house in Zundert was hung with a variety of etchings, engravings, maps, and mirrors. Mother Anna van Gogh even embellished the family Bible with an ornamental stenciled bookmark and covered the tables with patterned rugs.

A second feature of van Gogh's religious culture was a doctrine called *modernism,* which comprised not an artistic movement but a significant national religious reform within the Dutch church in the 1860s that promoted antisupernaturalism and the special role of the arts as vehicles of divinity. This was essentially a theology of formalist art within the established church. The modernist theologians pursued an ambiguous project of naturalizing divinity without resorting to pantheism, rescuing a space for an unknowable God as a mere postulate or assertion, one that could not be *disproven,* and as a generalized yearning for the infinite. This longing for and approach to divinity could be best expressed, according to the Amsterdam theologian the Reverend Allard Pierson, in the consoling and evocative forms of music, poetry, and painting, for "only the beautiful is true" (*rien n'est vrai que le beau*).[11] For modernists like Pierson, Christ was to be celebrated as an artist, an expressive savior whose forms of language carried a "sensitive and subtle pure sense of beauty."[12] Here the model of Christ's martyrdom and sacrifice was supplanted by Christ's role as laborer, consoler, and communicator who spoke to ordinary people in the simplest of languages, the rustic and moving poetry of the parables.[13]

A third feature of van Gogh's cultural formation was the primacy of the relational or corporate ego, a self defined only in and through association with others, and carrying with it powerful cultural barriers to independent individualism. The particular form of van Gogh's parents' theology affirmed the dissolution of the ego, self-surrender to Christ, and the sanctification of lowly labor. It included a strong social gospel, which led the family to live a life of service in small rural communities. This emphasis on life as *enacted* faith—of work and action, and redemptive labor—also inhibited introspection. In van Gogh's Dutch culture, speculation was associated with idleness, and interiority distrusted as indulgent.[14] I went looking for the so-called work ethic of nineteenth-century Dutch Calvinism; instead I encountered a cultural system in which a discrete and autonomous selfhood, detached from the web of kin, community, and divine dependence, was barely conceivable and where words for ego and subjectivity were never registered.

In recovering these themes of visuality, consolation, and antiegoism in van Gogh's Dutch theological culture, I came to emphasize that the resources for self-formation in nineteenth-century Netherlands were radically different from those available in France, and I gave priority in my analysis to van Gogh's struggle to create a space for the self out of anti-individualist legacies. In part, I considered his visual style of "weaving" paintings and his insistent and heightened materiality as providing van Gogh with formal solutions to the culturally transmitted problems of subjectivity and the sacred, the attempt to register and resolve cultural conflict in paint. The development of a pictorial language of labor was one way that van Gogh responded to a cultural heritage fraught with tension over the meaning and justification of the self. By visually incorporating himself into a community of labor by becoming a weaver-painter, van Gogh discovered those forms of connection, production, and interdependence demanded by a corporate theological culture that afforded few sanctions for a detached, internally generated model of creativity. The physicality and relieflike textural density of van Gogh's canvases, the palpable signs of human labor, and his search for an art of color as comfort and conso-lation all enabled him to find, for a time, salvation by association—a visible and emphatic association with the humble workers he admired for being both worthy of God and useful in the world.

Van Gogh encountered Gauguin and the Parisian avant-garde at the moment a new cult of interiority coalesced in the symbolist movement. In 1886, Gauguin began to define a new language of art—what he called an art of abstraction and inner vision—that rejected impressionism's emphasis on the sensory moment in order to embody the dream and the ideal, a flight to meta-physical mystery and the incorporeal.[15] And in 1886, symbolist manifestos proclaimed the inversion from outer to inner reality. As writer Gustave Kahn stated, "We carry the analysis of the *Self* to the extreme. . . . the essential aim of our art is to objectify the subjective (the externalization of the Idea) instead of subjectifying the objective (nature seen through the eyes of a tempera-ment)."[16] Gauguin exalted the artist as an ecstatic cultivator of his own vision-ary creativity, burning in what he called the "furnace fire" and "volcanic flames that animate the soul of the artist."[17] His friend the painter Emile Schuffenecker produced a fitting portrait of the artist's agonistic process, drawing Gauguin surrounded by the searing flames that fired his imagination, with a sculpted figure resembling Gauguin's *Lust* (1890; Frederikssund, Denmark, J. F. Willumsens Museum) erupting from the fiery burst (fig. 7).[18]

From its inception, the friendship of van Gogh and Gauguin revealed their different assumptions about the self, the physical world, and the physi-cality of the canvas, and I expected to characterize their relationship along the lines of "Protestant modernist meets secular egotist." Yet much to my surprise I found that Gauguin—whom we rightly know to be what Camille Pissarro called a ferocious self-promoter,[19] rapacious egotist, and imperious colonial-ist—was also a product of a French seminary education and was agitated throughout his life by ongoing torments of his lapsed Catholic faith, a suffer-ing unrelieved by the consolation offered by the religion he resisted. Gauguin's religious legacies shaped his artistic temperament in several ways: in his definition of material reality as irrevocably corrupt, deficient, even perfidious; in a language that celebrated the sacrifice and martyrdom of the

Figure 7
Emile Schuffenecker
(French, 1851–1934)
Portrait of Paul Gauguin, drawing,
28 × 18 cm (11 × 7 1/8 in.)
From *Les hommes d'aujourd'hui* 9,
no. 440 (1891), cover

modern artist; and in a linking of the infernal to the internal, where creativity was grounded in an expanded subjectivity and the cultivation of the hell fires of the mind.

One source of this expressive pattern lies in Gauguin's educational formation, which has never been adequately explored. He was enrolled for at least four years, from 1859 to 1862, in a cloister school in a French Catholic seminary near Orléans, the Petit Séminaire de la Chapelle-Saint-Mesmin. The school was directed by the bishop of Orléans, Monseigneur Félix-Antoine-Philibert Dupanloup, the architect of a new Catholicism for a France shaken by the revolution of 1848.[20] Dupanloup drafted the Falloux Law, which granted legal standing to private secondary schools and ensured the church's future security by revitalizing early education. By the time Gauguin came into his orbit in 1859, Dupanloup was celebrated as a brilliant catechizer and gifted educator who had an unusual rapport with his pupils, among whom had been Renan. Dupanloup considered children as "fallen from heaven"; they could recover their "wings" in an inner flight to "invisible regions" through memory, imagination, and self-expression.[21] His teachings centered on a dialectic of admonition and transcendence. On the one hand, Dupanloup emphasized a corrupted nature and transgressive human nature and characterized the children as plagued by their own carnality or concupiscence. The lure and transience of earthly pleasures could yield only desolation and putrefaction, graphically evoked in such texts as the "Misères de la vie présente." On the other hand, the bishop sought to capture the children's consciousness with the spectacle of their supernatural destiny and the joys of ascending to a celestial light and "possessing the heavens."[22] Deeply antipositivist, Dupanloup devised a new, more dynamic catechism, encouraging the children to move beyond dry recitation to sacred silence, to engage in active interior interrogations of supernatural beings, such as angels, eliciting a state of visionary release from an unalterably deficient earthly world.[23] Gauguin assimilated from this particular seminary training a profound receptivity to idealism and antinaturalism, a presumption of man's supernatural destiny and of material reality as a treacherous and temporary way station to divinity, an inculcation in techniques of introspection, and a fluency with the practices of visual memory and interior visualization.

Figure 8
Paul Gauguin (French, 1848–1903)
Where Do We Come From? What Are We? Where Are We Going? 1897–98, oil on canvas, 139.1 × 374.6 cm (54¾ × 147½ in.)
Boston, Museum of Fine Arts

Figure 9
Paul Gauguin (French, 1848–1903)
Eve, 1889, watercolor and pastel on paper, 31 × 33 cm (12¼ × 13 in.)
San Antonio, McNay Art Museum

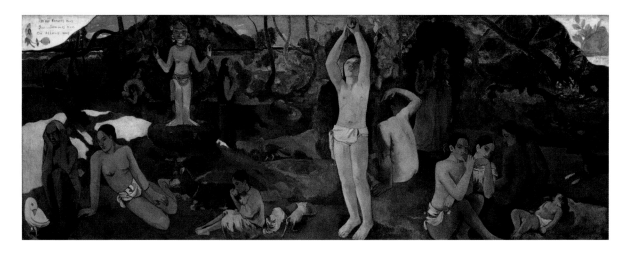

These findings prompted me to reinterpret Gauguin's modernist mani-
festo, *The Vision of the Sermon: Jacob Wrestling with the Angel* (1888; Edinburgh,
National Gallery of Scotland), and to suggest a new reading of the monu-
mental canvas *Where Do We Come From? What Are We? Where Are We Going?*
(fig. 8) as a subversive catechism, composed in the typically interrogatory
form of the seminary training and conceived as a golden fresco painted on
sackcloth.[24] They also offered a new context for understanding a less familiar
dimension of Gauguin's art, one that is usually associated with the lush,
luxuriant indolence of Tahitian nudes: his preoccupation with a dialectic of
sensuality and carnal affliction, of sexuality and suffering. During his time with
van Gogh, Gauguin began to create an allegorical series of images he called
the *misères humaines*—human misery—which represents the fundamentally

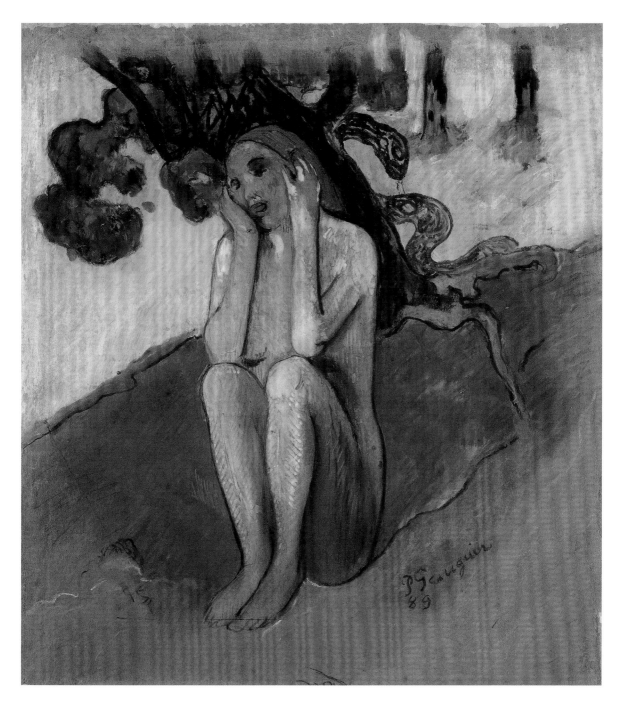

sorrowful nature of a human existence locked in a cycle of earthly pleasure and desolation as a derelict, afflicted female nude (fig. 9). By highlighting Gauguin's religious education and a pattern in his work that inextricably links the joys of the body to its ravages, I came to characterize Gauguin as an ambivalent or penitent sensualist. By contrast, van Gogh's oeuvre of roughly eleven hundred drawings and nine hundred paintings contains very few nudes and reveals little interest in allegory; he explored production and the visual forms of what he called *agir-créer*—action painting of working figures in action.[25] The pairing of corporeal pleasure and perdition lay beyond the "limits of the thinkable" for the Dutch modernist, who sought tangible signs of earning and deserving, as well as consolational force, on his picture sur-faces. The lamentational register of Gauguin's scrutiny of the human condi-tion suggests that he aspired to create a new language of art to fill the void left by the religious system that he resisted. Nevertheless, he brought to his paintings theological concepts and attitudes generated by the particular Catholic culture that shaped him.

By focusing a cultural lens on the interiority of each artist's life, van Gogh and Gauguin emerge anew, and the expressive forms of their visual prac-tices carry new meaning. Van Gogh's labor theology pressed him to maximize the materiality of the painting surface, embedding the sacred in the stuffs of matter—a sacred realism of the worked landscape and the faces of ordinary people, what he called that "complete thing [that] . . . renders the infinite tan-gible."[26] Gauguin's quest for sacrality led him to develop techniques to dimin-ish and dematerialize the physical surface of the canvas as much as possible. He emulated the matte effect of the fresco, for example, and experimented with ways to flatten the canvas, such as ironing it. He also, on occasion, washed the painting to degrease the oily gloss, applied a wax coating to decrease the sheen, and leached out the oil on the brush. Sometimes he blotted the surface with newspaper, as he did to the top layer of *The Yellow Christ* (1889; Buffalo, Albert Knox Gallery).[27] Gauguin exhorted van Gogh to flatten or smooth what Gauguin contemptuously called his *tripotages* of paint—messy accidents, the breaking and loading of the surface. But to van Gogh these types of paint handling were mottled and not accidental densities he likened to the work of the artist Adolphe Joseph Thomas Monticelli and to crude earthenware, both of whose qualities he praised and aimed to emulate.[28] Gauguin considered such *tripotages* as coarse muck and mire that weighed the artist down, imped-ing his release from a deficient material reality to the ineffable heavenly world of the divine.

I'd like to conclude with an example of a pair of paintings that van Gogh and Gauguin produced during their time together in Arles. The exploration of "the life and the work" requires a continuous move back and forth from cul-tural formation to stylistic practices and technical procedures, from biography to brush and tools. The close reading of the two paintings also suggests the benefits of a comparative method for interpreting visual objects.

During the first two weeks of November 1888, van Gogh and Gauguin each made a painting from memory of a scene that they had observed together while out on an evening walk near Arles, described by van Gogh in a letter as an empty vineyard at sunset, sparkling from a recent rainstorm.[29] The resulting two canvases provide a vivid example of memory reconfigured

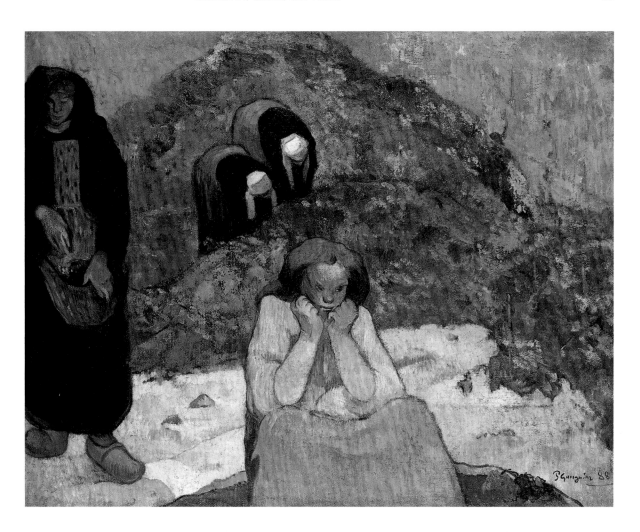

Figure 10
Paul Gauguin (French, 1848–1903)
The Grape Harvest at Arles: Human Misery, 1888, oil on coarse jute canvas, 73.5 × 92.5 cm
(29 × 36⅜ in.)
Copenhagen, Ordrupgaard

by culture. Gauguin titled his painting *Grape Harvest at Arles: Human Misery* (fig. 10). He considered it his best yet, second only to the *Vision* of a few months earlier. The saturated fields at harvesttime—a time of maximum exchange between man and a beneficent nature—are reimagined as a study of misery and mournful self-consciousness. Gauguin reduced his harvest scene to a meditation on the futility of production amid a corrupted nature and transgressive human nature.[30]

Gauguin's *Grape Harvest* features a seated, hunched, and brooding woman, the first of his repetitions of the figure of the *misère.* His letters described the central, disheveled figure as a poor, dejected female, bewitched in the open fields. A woman whom Gauguin described to Schuffenecker as a sisterly figure (*comme une soeur*) wearing black, the color of mourning, stands near her.[31] Most scholars have interpreted the image as symbolizing sexual transgression and death and have suggested that Gauguin borrowed the seated female type from a Peruvian mummy he had seen in the Musée d'Ethnologie du Trocadéro,[32] a gruesome figure "in a foetal burial position,"[33] "offset by a hideous, wide-mouthed, rictal scream" (fig. 11).[34] Why does he associate pleasure and perdition? The Orléans seminary had introduced Gauguin to a vision of the dismal infirmity of mortal life, and in canticles like the "Misères de la vie présente" Dupanloup identified the source of human suffering in the lure of an ephemeral sensuality leading only to death. Gauguin's notebooks listed this painting with the title *Splendor and Misery*

(*Splendeur et misère*)—once again evoking the dialectic of sensuality and reckoning in Dupanloup's teachings.[35]

The dramatic power of *Grape Harvest* is conveyed by a number of techniques that Gauguin devised to express the sorrowful condition of the *misères humaines* in formal terms. He applied the paint to an unusual type of canvas, a swath of sackcloth. The canvas itself was prepared with a thin, white ground of chalk and glue, a mixture that allowed for greater absorption into the heavy canvas, and he left the rough texture of the fabric visible as an essential element of the composition. Gauguin's pigments melded with the thirsty support, yielding in part a dry, parched surface after the canvas soaked up the greasy base of oils. The artist then used a palette knife to scrape and press the paint across the abrasive canvas skin. The resulting visual field comprises vineyards that appear parched, caked, and clotted, like scabby skin; the woman's arms and face include patches of exposed coarse sacking seen through a thin veil of painted flesh, providing a tactile sense of chafing. Employing these techniques of what I call penitence painting—in the friction of medium and support—Gauguin reenacted in the artist's struggle with his physical materials the agonistic model of human existence he assigned to the content of his allegorical painting. He offered a formal equivalent of the seemingly irrevocable conflict of man and woman living in a corporeal world that lures them to both pleasure and misery even as they maintain the hope of transcending it.[36]

Figure 11
Peruvian mummy from the Andes,
ca. 1100–1400
Paris, Musée de l'Homme

Figure 12
Vincent van Gogh
(Dutch, 1853–90)
The Red Vineyard at Arles, 1888,
oil on canvas, 73 × 93 cm
(28¾ × 36⅝ in.)
Moscow, Pushkin Museum

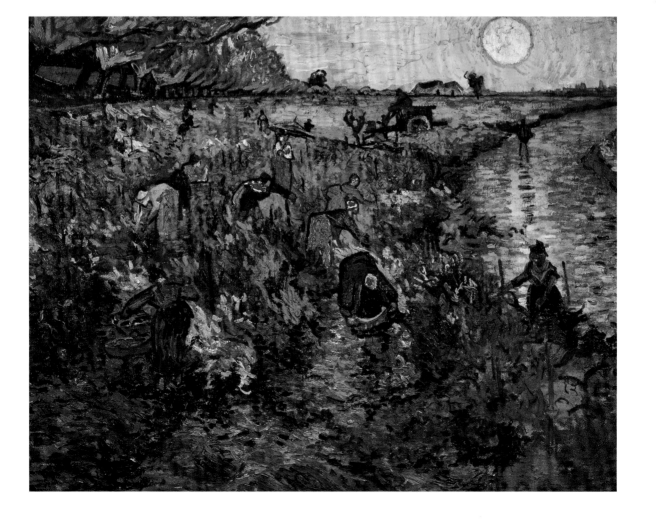

Van Gogh rendered the same scene as *The Red Vineyard* (fig. 12), amplifying in memory the bounty of the harvest. His experiment with a "memory" painting mobilized the expressive forces of his pictorial language of labor. The empty harvest field that he had observed was reimagined in *The Red Vineyard* with twenty-one working figures. The scene itself is a composite of the entire cycle of agricultural labor, combining several phases that van Gogh had depicted earlier in separate paintings in Arles.[37] Saturated with color and brimming with oily gloss, *The Red Vineyard* shows how van Gogh matched the effortful actions of the working figures in the density and vivacity of his handling of paint. As van Gogh deepened his departure from realism—painting, at Gauguin's urging, away from the site and from memory—he reasserted the productive figures and protrusive forms he had continually employed in his images of work.

Thus elements of biography and technique interact as both van Gogh and Gauguin engage the paradoxical goal of achieving spiritual ends through the plastic means of pigment, primer, and canvas, of painting as a mediator of divinity. But the ways in which they tried to accomplish this goal were quite distinct, corresponding in part to different theological cultures and different habits of interiority.

NOTES

Note to the reader: Parts of this essay can be found in expanded form in Debora Silverman, *Van Gogh and Gauguin: The Search for Sacred Art* (New York: Farrar, Straus & Giroux, 2000).

1. Vincent van Gogh, *The Complete Letters of Vincent van Gogh: With Reproductions of All the Drawings in the Correspondence,* 2nd ed. (Boston: New York Graphic Society, 1978), 1:197 (no. 133).

2. Van Gogh, *The Complete Letters* (note 1), 1:167 (no. 121).

3. For the discussion of Hegel's definition of free subjectivity as the condition of post–French Revolutionary modernity and the modern individual, see Jerrold Seigel, *Bohemian Paris: Culture, Politics, and the Boundaries of Bourgeois Life, 1830–1930* (New York: Penguin, 1987), 9–10.

4. Alain Corbin, "The Secret of the Individual," in Michelle Perrot, ed., *A History of Private Life: From the Fires of the Revolution to the Great War,* trans. Arthur Goldhammer (Cambridge: Belknap, 1990), 476–558; Ralph Gibson, *A Social History of French Catholicism, 1789–1914* (London: Routledge, 1989); and Ruth Harris, *Lourdes: Body and Spirit in the Secular Age* (London: Penguin, 2000); see also Pierre Sorlin, *La société française* (Paris: Arthaud, 1969–71), 1:207–33; and Caroline Ford, *Creating the Nation in Provincial France: Religion and Political Identity in Brittany* (Princeton: Princeton Univ. Press, 1993).

5. Joseph-Ernest Renan, *Souvenirs d'enfance et de jeunesse,* ed. Jean Pommier (Paris: Librairie Armand Colin, 1959), 86–89, xxxviii–xxxix. See also Debora Silverman, *Van Gogh and Gauguin: The Search for Sacred Art* (New York: Farrar, Straus & Giroux, 2000), 126–27, 121–43, 3–14. Art historian Kenneth E. Silver has recently explored the interaction of abstraction, Catholicism, and spiritual subjects and mentalities in his important essay, "Matisse at Venice: An Epilogue to *Van Gogh and Gauguin: The Search for Sacred Art,*" *French Politics, Culture and Society* 24, no. 2 (2006): 81–90.

6. Van Gogh kept no diary or journal and relied on his letters as ongoing conversations with varied interlocutors, such as his brother Theo; artists Anthon van Rappard, Bernard, and Gauguin; and his mother and sister.

7. The eggshells were remnants of van Gogh's recipe for "varnishing" some of his

pictures with egg whites. See Cornelia Peres, "On Egg-White Coatings," in Cornelia Peres, Michael Hoyle, and Louis van Tilborgh, eds., *A Closer Look: Technical and Art-Historical Studies on Works by Van Gogh and Gauguin* (Zwolle: Waanders, 1991), 39–43.

8. Émile Bernard, "Émile Bernard on Vincent (1886–87)," in Bogomila Welsh-Ovcharov, ed., *Van Gogh in Perspective* (Englewood Cliffs, NJ: Prentice Hall, 1974), 38; originally published by Bernard in "Vincent van Gogh," *Les hommes d'aujourd'hui* 8, no. 390 (1891).

9. For extensive analysis of van Gogh's perspective frame, his making and refining of optical tools, and the visual habits shaped by his framing devices, see Silverman, *Van Gogh and Gauguin* (note 5), esp. 61–78, 199–218, 374–75, 399–405, 413–19; on the weaving loom and weaving techniques as constitutive of van Gogh's visual practices, see esp. 139–43, 209–22, 256–61, 374–75, 405–23. See also Debora Silverman, "Weaving Paintings: Religious and Social Origins of Vincent van Gogh's Pictorial Labor," in Michael S. Roth, ed., *Rediscovering History: Culture, Politics, and the Psyche* (Stanford: Stanford Univ. Press, 1994), 137–68.

10. Van Gogh's paternal grandfather, the Reverend Vincent van Gogh, represented the traditional Old Calvinism of the early nineteenth century. His father, Theodorus, was a member of the first generation of divinity students trained in a new theology that celebrated a blend of Thomas à Kempis and social evangelicalism called the Groningen School. His uncle, Jan Stricker, an important Amsterdam minister of the Reformed Church who supervised Vincent's studies at divinity school from 1877 to 1878, belonged to a new movement called *modernism* or the *modern direction.* Religious controversies and debates dominated the Dutch Reformed Church throughout the period of van Gogh's development, and confessional conflicts—from the papal restoration of the Dutch bishopry to the "schools question" about state funding for religious and secular education—structured the political crises of the period from 1853 to 1900. On nineteenth-century Dutch religious discord, see, for example, Albert Réville, "Les controverses et les écoles religieuses en Hollande," *Revue des deux mondes,* 2nd ser., 27 (1860), 935–52; Kenneth S. Latourette, *Christianity in a Revolutionary Age: A History of Christianity in the Nineteenth and Twentieth Centuries* (New York: Harper & Row, 1958–62), 2:237–51; Eldred C. Vanderlaan, *Protestant Modernism in Holland* (London: Oxford Univ. Press, 1924); and Daniël Chantepie de la Saussaye, *La crise religieuse en Hollande: Souvenirs et impressions* (Leiden: De Breuk & Smits, 1860). On the van Gogh family's varied affiliations with the Dutch Reformed Church, see Frank Kools, *Vincent van Gogh en zijn geboorteplaats: Als een boer van Zundert* (Zutphen: De Walburg, 1990), esp. 9–14; Tsukasa Kōdera, *Vincent van Gogh: Christianity versus Nature* (Amsterdam: John Benjamins, 1990); and Kathleen Powers Erickson, *At Eternity's Gate: The Spiritual Vision of Vincent van Gogh* (Grand Rapids: Eerdemans, 1998). I have discussed van Gogh's complex religious formation and its conflicting legacies of self and image in Debora Silverman, *"Pilgrim's Progress* and Vincent van Gogh's Métier," in Martin Bailey, ed., *Van Gogh in England: Portrait of the Artist as a Young Man,* exh. cat. (London: Barbican Art Gallery, 1992), 94–115; Silverman, "Weaving Paintings" (note 9), esp. 137–49, 465–69; and Silverman, *Van Gogh and Gauguin* (note 5), esp. 144–79, 457–59nn30–97.

11. Allard Pierson, *Rigting en leven,* 2 vols. (Haarlem: A. C. Kruseman, 1863), 256.

12. Pierson, *Rigting en leven* (note 11), 254.

13. On visual piety, Erasmian legacies, Kempis's redemption through sight, and the Groningen School, see Silverman, "Weaving Paintings" (note 9), esp. 141–48; Silverman, *"Pilgrim's Progress"* (note 10), esp. 96–110; and Silverman, *Van Gogh and Gauguin* (note 5), 146–54. For a discussion of modernism, Pierson's aesthetic theology, and Christ as artist, see Silverman, *Van Gogh and Gauguin* (note 5), esp. 154–63; Pierson, *Rigting en leven* (note 11), esp. 21–27, 254–56, 391–407; and Allard Pierson, *De Beteekenis der kunst voor het zedelijk leven: Redevoering, uitgesproken in een vergadering der Akademie van beeldende kunsten en technische wetenschappen te Rotterdam* (Haarlem: A. C. Kruseman, 1862), esp. 13–15.

14. I develop the ideas of the corporate and relational ego in Silverman, "Weaving Paintings" (note 9); and Silverman, *Van Gogh and Gauguin* (note 5), 3–14, 144–80. An example of the distrust of interiority and the emphasis on enacted faith may

be seen in a work by a favorite Dutch poet of van Gogh's family, the Reverend Petrus Augustus de Genestet, such as "De Practici" and "Werken, Denken, Leeren," quoted and discussed in Silverman, *Van Gogh and Gauguin* (note 5), 147–48.

15. Gauguin had been explicitly interested in exploring dreams and different levels of reality since January 1885, when he wrote to his friend Emile Schuffenecker of his desire to create art that mediated a spiritual world beneath the surface of appearances, an art that could convey what he called "phenomena which appear to us supernatural, and of which, however, we have the *sensation*." Paul Gauguin to Emile Schuffenecker, 14 January 1885, quoted in Linda Nochlin, ed., *Impressionism and Post-Impressionism, 1874–1904: Sources and Documents* (Englewood Cliffs, NJ: Prentice Hall, 1966), 158 (emphasis in the original); original French in Paul Gauguin, *Correspondance de Paul Gauguin: Documents, Témoignages,* ed. Victor Merlhès (Paris: Singer-Polignac, 1984), 87 (no. 65). Immediately before he began working on *The Vision of the Sermon,* Gauguin proposed an art as an abstraction from nature and as a form of ascent to the realm of divinity: "Art is an abstraction; derive this abstraction from nature while dreaming before it. . . . This is the only way of rising toward God—doing as our Divine Master does, create"; Paul Gauguin to Emile Schuffenecker, 14 August 1888, quoted in Robert Goldwater, *Gauguin* (New York: Abrams, 1983), 58; original in Gauguin, *Correspondance* (this note), 210 (no. 159). Gauguin wrote to Bernard in 1890 of the "*glimpse* of dream" that "is more powerful than anything material" and of his hope to "touch the heavens for just a fleeting moment"; quoted in Françoise Cachin, *Gauguin: The Quest for Paradise,* trans. I. Mark Paris (New York: Abrams, 1992), 143–44. He criticized the impressionists as those that "sought for things at the visible level and not at the mysterious center of thought, and for this reason they fell into scientific reasoning"; quoted in Nochlin, *Impressionism and Post-Impressionism* (this note), 168.

16. Quoted in John Rewald, *Post-Impressionism from van Gogh to Gauguin* (Garden City, NJ: Doubleday, 1962), 148–49, see also 147–84; Robert L. Delevoy, "The Time of Manifestos and Demands, 1885–1892," in idem, *Symbolists and Symbolism,* trans. Barbara Bray, Elizabeth Wrightson, and Bernard C. Swift (New York: Rizzoli, 1982), 68–92; Henri Dorra, ed., *Symbolist Art Theories: A Critical Anthology* (Berkeley: Univ. of California Press, 1994); and Debora Silverman, "At the Threshold of Symbolism: Van Gogh's *Sower* and Gauguin's *Vision after the Sermon,*" in *Lost Paradise: Symbolist Europe,* exh. cat. (Montreal: Montreal Museum of Fine Arts, 1995), 104–15.

17. These are the terms of Gauguin's description for his self-portrait as "Les misérables" of 1888. Paul Gauguin to Vincent van Gogh, 1 October 1888, cited in Françoise Cachin, "Gauguin Portrayed by Himself and Others," in Richard Brettell et al., *The Art of Paul Gauguin* (Washington, DC: National Gallery of Art, 1988), xx. For a discussion of the self-portrait and the model of the artist as exalted by tormented creativity, see Silverman, *Van Gogh and Gauguin* (note 5), 15–46.

18. Schuffenecker's drawing of Gauguin is reproduced on the cover of the special issue of *Les hommes d'aujourd'hui* in 1891 that was devoted to him. On Gauguin's *Lust,* see the illustration and discussion in Christopher Gray, *Sculpture and Ceramics of Paul Gauguin* (Baltimore: Johns Hopkins Univ. Press, 1963), 208 (no. 88).

19. Pissarro identified in Gauguin a capacity for extreme self-aggrandizement. Noting in 1891 his revulsion at Gauguin's shameless exploitation of others, Pissarro called him "terribly ambitious" and asserted that Gauguin knew exactly how to "get himself elected (that is the word) man of genius" and also had an ability to "crush whoever stands in [his] path." Camille Pissarro to Lucien Pissarro, 13 May 1891, in Camille Pissarro, *Letters to His Son Lucien,* ed. John Rewald, trans. Lionel Abel (New York: Pantheon, 1943), 170.

20. The Orléans junior seminary, founded in 1856, was Bishop Dupanloup's personal laboratory for educational and religious reform; he lived near the grounds and supervised everything from curricula to building renovations. His role in forming and transforming the Orléans Petit Séminaire de la Chapelle-Saint-Mesmin during and after the time Gauguin was a student there is discussed in François Lagrange, *Vie de Mgr. Dupanloup, évêque d'Orléans* (Paris: Librairie Poussielgue frères,

1883–84), 2:99–123; Christianne Marcilhacy, *Le diocèse d'Orléans sous l'épiscopat de Mgr. Dupanloup, 1849–1878: Sociologie religieuse et mentalités collectives* (Paris: Plon, 1962), 82–90; and Émile Huet, *Le petit séminaire d'Orléans: Histoire du petit séminaire de la Chapelle Saint-Mesmin; souvenirs d'un rhétoricien de 1866–1867* (Orléans: P. Pigelet & fils, 1913), 107–30, 157–65, 203–16.

> The record of Gauguin's stay at the Orléans junior seminary was first presented in Ursula Frances Marks-Vandenbroucke, "Gauguin: Ses origines et sa formation artistique," *Gazette des Beaux-Arts* 47 (1956): 29–32. This article established that Gauguin was at the seminary for the four years from 1859 to 1862 and that during most of that time he lived at the school. Ziva Amishai-Maisels briefly notes Gauguin's religious education at the very beginning of her dissertation, *Gauguin's Religious Themes* (New York: Garland, 1985), though she does not examine this period in any detail, and characterizes the Petit Séminaire de la Chapelle-Saint-Mesmin as a Jesuit school, for which I have found no confirmation in the contemporary literature. The only writer to have emphasized the role of Bishop Dupanloup is David Sweetman, who devotes pages 30–32 of his recent Gauguin biography, *Paul Gauguin, A Life* (New York: Simon & Schuster, 1995), to the period at the Orléans seminary. For a fuller discussion of Gauguin's Orléans training and Dupanloup's role, see Silverman, *Van Gogh and Gauguin* (note 5), 181–264. A recent exhibition and accompanying catalog confirms and revisits the role of Catholicism in Gauguin's modernism: Belinda Thomson, Frances Fowle, and Lesley Stevenson, *Gauguin's Vision* (Edinburgh: National Galleries of Scotland, 2005), esp. 61–75.

21. On Dupanloup, French political culture, and educational reform after 1848, see Gibson, *A Social History* (note 4), chaps. 3, 6, 8. For Dupanloup's extraordinary career and full range of activities, see Lagrange, *Vie de Mgr. Dupanloup* (note 20). Dupanloup's emphasis on imagination and memory is presented in Félix-Antoine-Philibert Dupanloup, *L'oeuvre par excellence; ou, Entretiens sur le catéchisme* (Paris: Charles Douniol, 1869); his statement regarding those "fallen from heaven" and the longing for "wings" are from his treatise *De l'education* (1857) and are discussed and quoted in English in Charles E. de Vineau, *Bishop Dupanloup's Philosophy of Education* (Washington, DC: Catholic Education, 1930), 5–6, 20–29. On Dupanloup's unusual rapport with his pupils, see Gabriel Monod, *Souvenirs d'adolescence: Mes relations avec Mgr. Dupanloup* (Paris: Librairie Fischbacher, 1903); see also Silverman, *Van Gogh and Gauguin* (note 5), 121–43.

22. Dupanloup's theories on juvenile concupiscence are elaborated in his book *The Child,* trans. Kate Anderson (Boston: Thomas B. Noonan, [1875]), 160–86, 126–46. Here Dupanloup presents a "classification of defects" and details the "perils" and the "fatal habits of vice" that constantly threaten to "seize and devour" the "open hearts" and "expansive souls" of children. The "Misères de la vie présente," along with other chants on fragility, corruption, and putrefaction, such as the "Sur les vanités du monde," can be found in Félix-Antoine-Philibert Dupanloup, *Manuel des catéchismes; ou Recueil des prières, billets, cantiques, etc.* (Paris: Rocher, 1868), 147–52, 227. The alternating vision of the pure heavenly realm and its joyful expansion through resplendent bursts of light is discussed in Félix-Antoine-Philibert Dupanloup, *De l'éducation* (Paris: Douniol, 1862), 3:506–7; on purity and "possessing the heavens," see Dupanloup, *L'oeuvre par excellence* (note 21), 74–75; and Dupanloup, *Manuel des catéchismes* (this note), 343.

23. The bishop's account of silent, meditative interrogatory practice for the children is given in Dupanloup, *De l'education* (note 22), 3:507–8; angels are discussed in the appendices to Dupanloup, *Manuel des catéchismes* (note 22), 615–40, esp. 624, 615–20. Other treatments of Dupanloup's imaginative renovation of the catechism and his antipositivism are in de Vineau, *Bishop Dupanloup's Philosophy of Education* (note 21), 5–28; Marcilhacy, *Le diocèse d'Orléans* (note 20), 239–53; and Dupanloup, *L'oeuvre par excellence* (note 21), passim.

24. For a full discussion of these themes and the links between visual form and theological culture in the *Vision* and *Where Do We Come From?* paintings, see Silverman, *Van Gogh and Gauguin* (note 5), 91–143, 373–91.

25. Vincent van Gogh to Theo van Gogh, circa August 1885, in van Gogh, *The Complete Letters* (note 1), 2:402–3 (no. 418).

26. Vincent van Gogh to Émile Bernard, July 1888; see van Gogh, *The Complete Letters* (note 1), 3:503 (no. B12).

27. The clues that newspaper was used to blot *The Yellow Christ* in order to dull the glossiness of the paint are detailed in Belinda Thomson, *Gauguin* (London: Thames & Hudson, 1987), 108; see also Brettell et al., *The Art of Paul Gauguin* (note 17), 156. Reinhold Heller first identified Gauguin's impulses "to disguise the medium of oil paint" in his important article "Concerning Symbolism and the Structure of Surface," *Art Journal* 45 (1985): 148–49. I treat these tactics of dematerialization extensively and relate them to patterns of self and cultural mentalities in Silverman, *Van Gogh and Gauguin* (note 5), esp. 43–91, 223–48, 267–312, 373–91. Recent research and technical evidence have bolstered the case for these visual strategies on Gauguin's part, such as the scientific evidence that he mixed beeswax and tallow as a coating for the *Vision* painting, which intensifies the matte effect and flatness of the whole surface; see Lesley Stevenson, "Gauguin's Vision: A Discussion of Materials and Technique," in Thomson, Fowle, and Stevenson, *Gauguin's Vision* (note 20), 111–19. This same Edinburgh conservation team recently re-created the simple, white, flat, wood-strip frame that Gauguin intended for the *Vision,* a frame that serves to enhance the flush fresco-like forms of the painting and its visual qualities as sacred art; see Thomson, Fowle, and Stevenson, *Gauguin's Vision* (note 20).

28. Vincent van Gogh to Theo van Gogh, n.d., in van Gogh, *The Complete Letters* (note 1), 3:6 (no. 520).

29. Vincent van Gogh to Theo van Gogh, [November] 1888, in van Gogh, *The Complete Letters* (note 1), 3:101 (no. 559).

30. This section is based on a much fuller comparative analysis of these two canvases in Silverman, *Van Gogh and Gauguin* (note 5), 223–48, esp. 224–47.

31. "Une pauvresse bien ensorcelée en plein champ de vignes rouges"; Paul Gauguin to Theo van Gogh, 16 November 1888, in Douglas Cooper, *Paul Gauguin: 45 Lettres à Vincent, Théo et Jo van Gogh* (The Hague: Staatsuitgeverij, 1983), 71. Paul Gauguin to Emile Schuffenecker, 20 December 1888, in Gauguin, *Correspondance* (note 15), 306 (no. 193).

32. Wayne Andersen, "Gauguin and a Peruvian Mummy," *Burlington Magazine* 109, no. 769 (1967): 238–42; Henri Dorra, "Gauguin's Dramatic Arles Themes," *Art Journal* 38 (1978): 12–17; Brettell et al., *The Art of Paul Gauguin* (note 17), 144; and Sweetman, *Paul Gauguin* (note 18), 84–85. Another useful discussion of the Peruvian mummy, including a rare study drawing of it by Gauguin, can be found in *Le chemin de Gauguin: Genèse et rayonnement,* exh. cat. (Yvelines: Musée Départemental de Prieuré, 1985), 66.

33. Andersen, "Gauguin and a Peruvian Mummy" (note 32), 238.

34. Sweetman, *Paul Gauguin* (note 20), 85.

35. The title is listed in the facsimile of the notebook, which was also a sketchbook, in René Huyghe, *Le carnet de Paul Gauguin,* vol. 2 (Paris: Quatre Chemins-Editart, 1952), n.p.; see also Ziva Amishai-Maisels, "A Gauguin Sketchbook: Arles and Brittany," *Israel Museum News* 10 (1975): 68–87.

36. Silverman, *Van Gogh and Gauguin* (note 5), 234–37.

37. Silverman, *Van Gogh and Gauguin* (note 5), 238–40.

Partial Accounting: Art & Language

CHARLES HARRISON

I should make it clear from the outset that I am no biographer. My concern is with art and its development, and particularly with problems of theory, criticism, and analysis with regard to the work of the period since the mid-twentieth century. I am aware that the proper art historian proceeds with a complete illustrated oeuvre catalog in one hand and a scholarly biography in the other. Where biographical knowledge is concerned, though, I believe that the really interesting question is how much of it the attentive analysis of a work of art can be made to yield.

But I have written two books on the artistic practice known as Art & Language.[1] They have both been organized chronologically, and they could thus be understood as offering narratives of development. Art & Language is an informal organization with which a number of names have been associated. It nevertheless stands as a single and continuous though complex authorial entity—the possible death of the author (or authors) notwithstanding. If we can conceive of the biography of a collective, insofar as it respects the existence of that entity, it will not be quite the same as a collection of biographies of individual persons. I am interested in the factors that make the difference.

First, some generalities. It can be said from the outset that there is an ordinary problem involved in writing about the lives of artists—one that is independent of the specific difficulties of collective biography. This is the problem of just how the concepts of *life* and *work* are to be related, both as regards the matter of one's study and in one's self-critical consciousness as a writer. I take it that this is a problem bearing on *any* biographical work where the human subject is specifically associated with some significant kind of production, and where that production is open to critical study independent of any interest in biography. It might be said that to see *anyone* as a potential subject of biographical study is to conceive of that person as a producer under *some* description, but the kinds of examples we are most familiar with are those that come from the arts and sciences. In such cases, it matters greatly how relations of priority are maintained between personal information on

the one hand and descriptive analysis of work on the other—that is, how the principles of life, work, and authorship are established.

With a single artist-author, one obvious way to approach the writing of a biography is to organize the account of the life in accordance with the development of an oeuvre. This may at least help to sort out the anecdotal detail. Whatever serves to illumine that development and to further its interpretation counts as prima facie relevant, and whatever does not, as prospectively marginal. This is to subordinate the scholarly biography to the oeuvre catalog—leading to a kind of super catalog raisonné perhaps. The arch-aesthete Clive Bell offered one kind of rationale for according an absolute priority to work over life:

> The artist and the saint do what they have to do, not to make a living, but in obedience to some mysterious necessity. They do not produce to live— they live to produce. There is no place for them in a social system based on the theory that what men desire is prolonged and pleasant existence. You cannot fit them into the machine, you must make them extraneous to it. You must make pariahs of them, since they are not part of society but the salt of the earth.[2]

Of course, if we dogmatically accept the fundamental historical materialist thesis that the need to produce to live is what defines us historically as a species, then Bell's artists are in danger of appearing either more or less than human. If, however, we can conceive of the artist not as an unreal being with no basic needs, but rather as a mere anomaly with respect to the generalizations of historical materialism—one who does indeed live to work in some significant sense—then it should in principle be possible to construct the life from the work without any notable hiatus or remainder.

In fact, though, it is not hard to come up with cases that put some severe strain on the principle of according work an absolute priority—or that at least complicate our sense of what such a priority might mean. It could be said, for instance, that interpretation of Carl Andre's minimalist sculpture should not be affected one way or another by the information that he stood trial for the murder of his wife—a fellow artist—and that there is no occasion in even a chronological survey of the work at which that piece of information would become clearly relevant. But it would certainly be a strangely aspect-blind biography that failed to mention the fact. And it would not be a wholly unreasonable critical enterprise to scrutinize Andre's oeuvre for significant changes following his acquittal.

In general, just what knowledge of the life one rules in or out will necessarily depend on how one goes about interpreting the work—and on where one takes its ontological boundaries to be fixed. One of the problems with psychoanalytical methods of interpretation, for instance, is that where the quest for biographical knowledge is concerned, there is nothing that is not liable to be conscripted to the same complex.

But our theme is collective biography, which makes matters even worse. It should be clear enough that the general problem of the relationship of life to work will be considerably aggravated in the study of any single practice to which there have been various contributors and that therefore involves more

lives than one. Indeed the problems of relevance tend to multiply in complex relation to the number of individuals variously engaged, the more so the more different kinds and levels of contribution are allowed for. Other things being equal, we might assume that whose life gets to be studied will depend on some understanding of who did what. The major players just get more column inches. Yet, as a common authorial name, Art & Language was intended as a partial safeguard against possessive individualism and careerism in the world of art. The tendency of that world always to peer behind the screen of anonymity smacks of Thatcherite individualism, that is to say, of a refusal to believe that there might be such a thing as society and that working in one—even sharing-out the glittering prizes or the brickbats—might be some people's preferred way of going on.

In writing about Art & Language, I find myself continually pulled two ways: on the one hand, wishing to support those individuals by whom the work has been and is being done—a matter about which I have considerable knowledge—and, on the other, wishing to adhere to the ethos of the project, which among other things entails resistance to stereotypes of artistic individualism and authenticity. There is a perhaps surprising consequence: insofar as that ethos determines production, those most centrally involved are actually liable to get the *fewest* column inches. If there is a kind of work that advertises the life behind it, there is also a kind of life that says, "Look at the work." By the same token, a participating individual who either exploited or became disengaged from the morale of shared projects would be the more easily conceived of as the appropriate object of biographical interest and inquiry.

The nature of the problem may become clearer if I provide some further detail. Though the information I shall use is publicly available, it has not always been accurately recounted. It may be acknowledged that Art & Language is never easy to describe. The name was first adopted by four English artists in 1968 as a label under which to gather the various forms of collaboration they had developed over the previous two years and as a business name for purposes of publication. The same four artists were listed as original editors of the journal *Art-Language,* which first appeared in 1969. Though two of these artists were effectively inactive in Art & Language by the early 1970s, the journal attracted additional contributors, some from New York, where it was recognized as an avant-garde medium set strategically at the heart of the original conceptual art movement. In 1972, ten names were associated with a large index exhibited by Art & Language at *Documenta,* an international exhibition of modern art held every five years in Germany. Over the next few years, continuing collaborative projects drew further recruits, and by 1976 some twenty-five people claimed affiliation of some kind with Art & Language. These were more or less equally divided between England and New York, where an Art & Language Foundation published three issues of a journal called *The Fox.*

At this point there was an outbreak of strife, followed by a number of withdrawals, both *of* Art & Language from certain individuals and of certain individuals *from* Art & Language. Not to name names at this point would seem like an evasion. Since 1977, Art & Language has designated the joint practice of the artists Michael Baldwin and Mel Ramsden, with whom I collaborate on literary and theoretical projects. Baldwin is the only survivor of the original

four members; Ramsden first became associated with Art & Language in 1970 when it assimilated a separate collaboration of which he is now the sole survivor; I became editor of the journal *Art-Language* in 1971.

It is hard to see how a collective biographer could avoid *some* initial dependence on the changing artistic and theoretical production issued under the name of Art & Language, however interested he or she might be in the narratives of individual lives. The greater part of that production has been issued as art. But besides the two journals mentioned, Art & Language has published exhibition catalogs and collections of essays in some half-dozen languages; it has contributed numerous papers to symposia and to independent publications; and it has generated a libretto for an opera, a CD-ROM, two long-playing records of songs, and several singles. Collaboration with the Institut für soziale Gegenwartsfragen of Freiburg has resulted in three international conferences, while contacts with the institute's offshoot, the Jackson Pollock Bar, have led to a number of performances by German actors working with scripts supplied by Art & Language.[3]

So the name Art & Language can be associated with a considerable and diverse body of work stretching back over almost forty years. I have suggested that in the case of the single artist-author a biography might be constructed on the basis of an established oeuvre. If the name Art & Language can be accepted as itself a principle of authorship, is there any sense in which it might similarly attract a kind of biography?

It is clear that an organization like Art & Language will lack most of the normal characteristics upon which even a collective biography might be based. As I have suggested, to try to account for the practice is to be faced with contradictory pressures. On the one hand, any such account will inevitably face the demand for individual biography that all artistic authors attract as surely as dogs attract fleas. On the other hand, it will need to be acknowledged that the authorial identity of Art & Language entails a degree of individual anonymity. The biographical information that may be true of the individual is not necessarily true of the art-producing collective. The issue is whether we can conceive an account of Art & Language as author that might offer as much as an account based on the assembled work of a single artist-author about whose life we had no controlling knowledge—or at least not much. Of course this would not be a biography in any proper sense; but it would certainly serve as it were to charge the vacant space that an imagined biography would have to fill, providing a rationale for criticism and interpretation that true biographical knowledge might subsequently be marshaled to disconfirm.

The kind of circumstance I have in mind is as follows. Let us say that someone studies an extensive sequence of works—by Pierre Bonnard, for example—and deduces that the artist had a long and faithful marriage and an idyllic domestic life. Subsequent biographical research reveals that the female companion, whose pictured body appears more or less unchanged in the artist's work over the course of almost fifty years, had spent most of that time as a reclusive and depressive invalid and that Bonnard had waited to marry her until after his mistress had killed herself. In this instance, the interpretation of the work would seem to be severely compromised by the biographical knowledge subsequently acquired; it is, in effect, shown to be a kind of sentimental fiction. And yet what one makes of that knowledge will be inflected

Figure 1

Art & Language

Index 01 ("Documenta Index"), 1972,
8 filing cabinets, texts, and
photostats
Zurich, Daros Collection
Installation, *The Artist Out of
Work: Art & Language 1972–1981,*
PS1, New York, 1999

by a sense of the poignancy of the work that will not entirely go away. If an
understanding of the work must be corrigible in the face of biographical
knowledge, the biographical account may also have to be adequate to some
response to the work and to its development.

 The point to hold on to here is that although work and life may in prin-
ciple be separately studied, they will tend to become braided together as soon
as either is viewed as continuous within a given narrative. So what would it be
like to have equivalent biographical information bearing upon the work of a
collective, where continuity was identified not in terms of the life of an indi-
vidual, but through the nature and morale of a continuous project? What we
can say, at the least, is that ordinary biographical information—information
about the lives of individuals—would count in a different way. For one thing, it
might cast doubt upon the actual consistency and continuity of the project, for
instance, where there had been changes in personnel. I shall offer as illustra-
tion accounts of two substantial projects by Art & Language. These were sepa-
rated by the ten-year period during which the number of those associated with
the name had grown and contracted.

 The first is *Index 01,* the work by Art & Language first shown at
Documenta in 1972 (fig. 1), now in the Daros collection in Zurich. When it was
originally installed, I was one of the ten individuals named as responsible. The
file cabinets contained some eighty-seven texts, of which these individuals and
others were the authors. Papered round the walls was a photographically

reproduced index. Each of the texts was read and related to each of the others in terms of one of three specified relations: compatibility, incompatibility, and incomparability, or transformation.

I suggest that to pursue maximal biographical knowledge about each of the ten named individuals would be so thoroughly to compromise the autonomy of this work as to hopelessly blur its edges and to leave it more or less defenseless against diffusive interpretation. In fact, not many of the people named had had any hand in the design of the indexing system, for which Baldwin was principally responsible. Some had taken part in the working out of the indexical relations; others, like me, had simply helped stick small pieces of paper in the file drawers, or larger pieces of paper on the walls at *Documenta*.[4]

In 1982, Art & Language was invited back to *Documenta*, again with an ample space to fill. Two large paintings were planned on the theme of the artist's studio. A pictorial composition was worked out on a detailed maquette (fig. 2), showing seven figures variously disposed in a studio cluttered with books, journals, posters, prints, paintings, and various other items from Art & Language's production. Four of these figures are apparently at work, with brushes in their mouths, on a picture laid out on the floor. At the left and right are, respectively, a seated guitarist and a standing man at work among the publications on a table. Kneeling against the back wall at the left is a long-haired figure in a bowed pose suggestive of despair.

Once this maquette was completed, it was squared up and copied, at the same size, with a pencil held in the mouth. The resulting line drawing was then enlarged to precisely the size of Gustave Courbet's *Painter's Studio* (1854–55; Paris, Musée d'Orsay)—a flagrant exercise in painted autobiography. Next, the enlarged drawing was colored-in with crayons and, finally, painted over in black ink, again with brushes held in the mouth. The effect of the by-mouth expedient is automatistically to produce the appearance of expressionistic distortion and expressionistic surface, and perhaps to insinuate into the consciousness of the spectator a certain insecurity about the authenticity of authorship. A second painting based on the same composition was made by mouth in black ink alone using the same composition but without squaring

Figure 2
Art & Language
Index: The Studio at 3 Wesley Place;
Drawing (i), 1981–82, pencil, ink,
watercolor, and collage on paper,
76 × 162 cm (29⅞ × 63¾ in.)
London, Tate

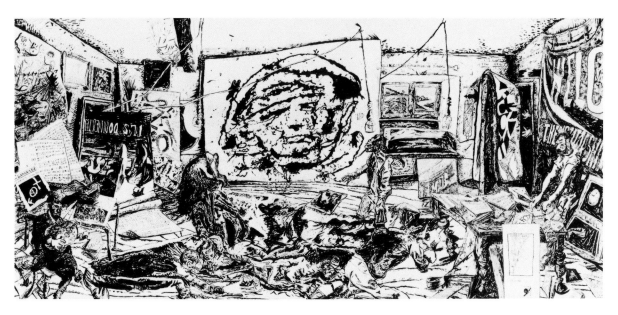

Figure 3

Art & Language

Index: The Studio at 3 Wesley Place Painted by Mouth I, 1982, ink and crayon on paper mounted on canvas, 343 × 727 cm (135 × 286¼ in.)

Ghent, collection of Annick and Anton Herbert

Figure 4

Art & Language

Index: The Studio at 3 Wesley Place Painted by Mouth II, 1982, ink on paper mounted on canvas, 343 × 727 cm (135 × 286¼ in.)

Brussels, private collection

up, so that distortion occurred over a larger scale. The titles of the works shown at *Documenta 7* are *Index: The Studio at 3 Wesley Place Painted by Mouth I* and *II* (figs. 3, 4).[5]

It seems to me that we might read the studio composition on two levels: first, as some kind of evidence of character; and second, as a moment of a biographical narrative. With regard to the question of character, there are enough internal cues to make clear that this is intended as a picture of Art & Language's own studio. The composition contains representations of numerous artworks, the great majority of which are identifiable as works by Art & Language. In this sense, the composition is readable as an index of Art & Language's production. Particularly prominent are *Portrait of V. I. Lenin in July 1917 Disguised by a Wig and Workingman's Clothes in the Style of Jackson Pollock II* (fig. 5) and *Attacked by an Unknown Man in a City Park: A Dying Woman, Drawn and Painted by Mouth* (fig. 6). That these and other details can be confirmed against the existence of things in the world is of course no guaran-

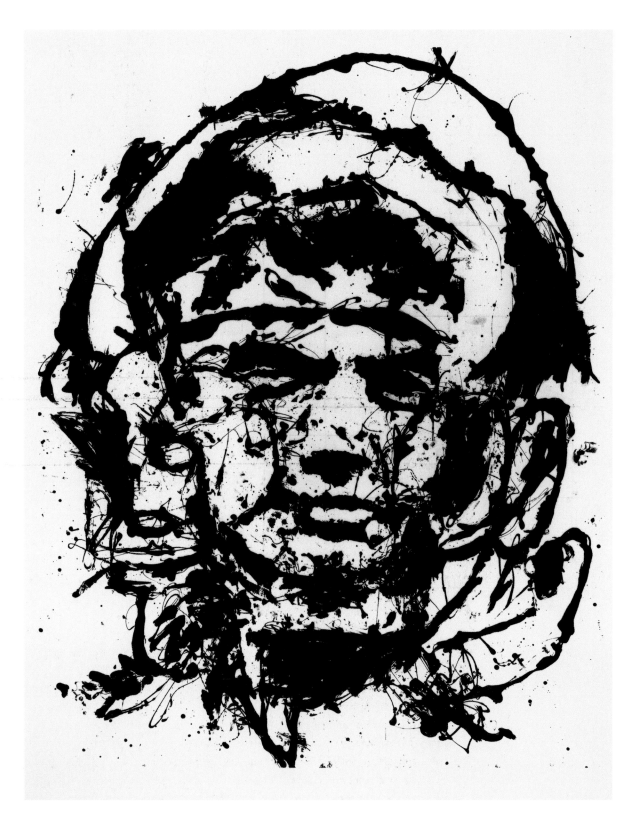

Figure 5
Art & Language
Portrait of V. I. Lenin in July 1917
Disguised by a Wig and
Workingman's Clothes in the Style
of Jackson Pollock II, 1980, enamel
on board mounted on canvas,
239 × 210 cm (94⅛ × 82⅝ in.)
Brussels, collection of Eric Decelle

Figure 6
Art & Language
Attacked by an Unknown Man
in a City Park: A Dying Woman,
Drawn and Painted by Mouth, 1981,
ink and crayon on paper
mounted on wood, 176 × 258 cm
(69¼ × 101⅝ in.)
Nantes, Musée des Beaux-Arts

tee that the paintings tell a consistent documentary truth. The composition
will turn out to be particularly untrustworthy in the matter of its dramatis
personae, one of whom is taken from William Blake's engraving of *Satan
Smiting Job with Sore Boils* (1825; London, Tate), while another is based on
Victorine Meurend, the model for Éduard Manet's *Olympia* (1863; Paris, Musée
d'Orsay). If I had to label the disposition to which the two *Studio* paintings
bear witness, I would describe it as something like ironic reflection, or
what Hegel called "objective humor," referring to the late-romantic art of
his own time.[6]

　　With regard to the composition's ability to reveal aspects of a biographi-
cal narrative, the crucial question to ask is whether the Art & Language
responsible for the two *Studio* paintings can justifiably be considered the same
complex individual as the Art & Language responsible for *Index 01,* shown at
Documenta ten years previously. It has to be said that on the face of things a
painting is not much like an installation of texts, filing cabinets, and wallpa-
pered photostats. We are not going to get much help from the visual analysis
of style—that standby of the connoisseur concerned with correctness of attri-
bution—and the fact that each of the works bears the designation *Index* is not
a lot to go on. There are, however, certain principles of accumulation, juxtapo-
sition, and transformation that are common to both the installation and the
paintings, while components of the original index, as well as of later versions,
are actually illustrated in the *Studio* paintings.

　　What I am feeling for is a position from which it might be possible to
look at one of the *Studio* paintings, or at some more recent work in the name
of Art & Language, and say of it with assurance, "Yes, this is still the same life,

being lived by the same organism; the world has changed, and it has gotten older, but there is significant continuity between what it knows and what it remembers." By analogy with the concerns of single-subject biography, might we identify something like personality as both a distinguishing and a developing characteristic in a collaborative artistic enterprise? And, if so, might that enterprise be accorded the kind of autonomy and potential for development that we would attribute to a single human subject—a person?

Given my long and close association with Baldwin and Ramsden, it should be clear enough that when the issue of continuity in Art & Language's working existence is raised, I am strongly inclined toward the account that would affirm it. My desire in this respect—the desire to have had one kind of life rather than another—will color whatever I write. But I think that there is an independent reason for adopting the affirmative view, at least on a provisional basis. It goes to the second of my reasons for according Art & Language the kind of autonomy and moral status that might be attributed to a single artist-author. Imagine a biographer faced with actions on the part of the same individual that are separated by a period of a decade or more and that are morally different. It would be natural, I think, to ask what had happened to that individual that might account for the difference in question. One would mean this inquiry in two complementary senses: one would be asking what had occurred in the world, such that the subject individual had been led to modify established patterns of behavior; and one would be asking how and why that person had changed, thinking of *person* as an amalgam of self-consciousness, knowledge, moral character, and so forth.

I take it that what we are broadly talking about here is learning, and how it is studied. It is learning of a distinctive kind, however, such that the continuity entailed is conceived by reference to practical projects rather than in any strictly psychological terms. Under these conditions, it is the discontinuities—those withdrawals of commitment or contribution that are negative determinants upon going on—that tend to produce individual biography.

For a collective biography of Art & Language, the advantages of proceeding in this manner should be obvious. The effect would be to direct attention both to the external cultural environment in which the practice might have had to survive and to the internal evidence of adaptation and learning. Among the factors to which the juxtaposition of *Index 01* and the *Studio* paintings would then call attention would be the effective collapse of the conceptual art movement in the mid-1970s; the subsequent widespread promotion of a kind of unreflective expressionist painting; and the expansion and contraction in membership of Art & Language itself. We might expect memories of these and other occurrences to be among the intellectual materials with which the practice would work as it aged.

What I am suggesting is that where what is at issue is continuity of authorship over an extended period, unless and until we know what biographical data might count as decisive, it may be through the evidence of learning, or lack of it, that changes will have to be either seen as part of a continuum or seen as discontinuous. The claim of Art & Language to moral autonomy, and thus to some coherence of biography, will stand or fall on the nature of its practical self-consciousness and on the plausibility of its narration of itself. Of course, the story thus told could not possibly be called a col-

lective biography of all or any of the people variously engaged in the practice. It might nevertheless have a great deal to tell us, for better or worse, about the cultural, moral, and intellectual makeup of the lives of those people.

But this is by no means to rule out more standard forms of biographical knowledge and research. On the contrary, whatever conclusions might be drawn from an account of the work and of its quasi-independent life, it will still be possible, for anyone with access to true biographical data, to argue that those conclusions are mistaken, and that quite another account of the work may be constructed from a study of our various lives.

If an enterprise along these lines is to succeed, however, it cannot simply revert to the mythical principle of the necessary and sufficient individual author. Nor will such an enterprise gain by the kind of narration of the unnecessary and the insufficient that standard artists' biographies tend to purvey as the compelling. The critique that is the raison d'être of the collective project is deflating of individual biography. A fortiori it is critical of the very idea of artistic biography—that is to say, of accounts of individual lives as "artistic"— whether the individuals in question are members of collectives or not.

NOTES

1. Charles Harrison, *Essays on Art & Language,* 2nd ed. (Cambridge: MIT, 2001); and Charles Harrison, *Conceptual Art and Painting: Further Essays on Art & Language* (Cambridge: MIT, 2001).

2. Clive Bell, *Art* (London: Chatto & Windus, 1914), 261.

3. The most recent of these at the time of writing was staged under the title "Theses on Feuerbach" at the Getty Research Institute, Los Angeles, in March 2004.

4. More information on Art & Language's *Index 01* can be found in the chapter "Indexes and Other Figures," in Harrison, *Essays on Art & Language* (note 1), 63–81.

5. More information on these paintings can be found in the chapter "'Seeing' and 'Describing': The Artists' Studio," in Harrison, *Essays on Art & Language* (note 1), 150–74.

6. See, for instance, G. W. F. Hegel, *Werke,* ed. Eva Moldenhauer and Karl Markus Michel (Frankfurt am Main: Suhrkamp, 1969–71), 14:231.

THOMAS CROW

The chief difficulty in taking the individual born Andrew Warhola as a subject for biography is that nearly everyone thinks that they know him already. Warhol's own instructions in the matter have been followed to the letter: "If you want to know all about Andy Warhol, just look at the surface of my paintings and films and me, and there I am. There's nothing behind it."[1] Or, for those observers needing a little more elaboration: "We're pop people. We're formed by television. I think people are becoming plastic. I love plastic. I want to be plastic. A pop person is like a vacuum that eats up everything. He's made from what he's seen."[2] Nowhere else in the literature of art can one encounter such a seamless unity posited between (1) the subject's self-description, (2) the observer's claim to comprehend the subject, and (3) the meaning of the art that the subject produced in the service of (1)—and round it goes in an endless, self-confirming circularity.

But even a single fact of biography can easily undermine the persuasiveness of this tidy descriptive universe. Take Warhol's conspicuous and enthusiastic presence at La Monte Young's performance of his own *Trio for Strings* (1958), a ruthlessly uncompromising drone-composition first conceived under the auspices of Arnold Schoenberg's disciple Leonard Stein. This occurred in October 1962, at the moment when the artist's serial technique was just falling into place and when his film work was about to begin. Warhol acknowledged that Young's preoccupation with sustained tone—the furthest thing from a commercial project—served as a spur to his open-ended sense of film time.[3] And Young's Theater of Eternal Music, suffused by the light effects of his partner Marian Zarzeela, functioned as an incubator for the sound world of the Velvet Underground and the embracing spectacle of the Exploding Plastic Inevitable—the Factory production in which the band first achieved its considerable and enduring fame. Emerging film scholar Marc Siegel astutely declares, "We must move beyond those facile and phobic analyses that only view Warhol in a negative relationship to the 1960s countercultural scene. This means that we need to question those myths about Warhol that describe him as voyeuristic, passive, distanced, distracted, alienated, or bored as a means of absolving him of his commitment to this scene. The moralistic usage of these

terms not only hinders but actively prohibits an understanding of exactly what it is, and why it is, that Warhol did what he did in the 1960s."[4]

While fresh facts of biography documenting Warhol's complex and sophisticated existence can begin to answer Siegel's challenge, any adequate inquiry must also entail an enhanced account of the art, the practice that invests the biography with special consequence. One needs to start with a working hypothesis that Warhol availed himself of the most considered, self-conscious aesthetic devices appropriate to his ambitions (while making no assumptions as to the age or origin of these devices). So, too, his motifs need to be taken as exhibiting a comparatively ambitious range, one that disperses the unsustainable category of "the popular" into its fractious components—the statistically popular, regionally popular, campily popular, shamefully popular, sub-popular, archaically popular, and anti-popular. Out of those devices and that dispersion emerges a distinctive world of the artist's own creation, one that maps familiar points of reference in ways that leave them recognizable but at the same time seductively and disturbingly altered in their meaning.

Having proposed that Warhol's collective output adds up to the description of a world, one can then ask what kind of place it is: Who lives in it? What goes on there? How does its story go? This is another way of saying that there will be an imagined biography encoded across the full extent of his production with a claim equal to that of the documented facts of his life. In the same way that one needs to set aside Warhol's famous self-descriptions in pursuit of his empirical biography, one also needs to proceed as if his paintings, drawings, and prints had remained unseen and unknown before this moment—and indeed one needs to bracket (if such a thing is possible) all knowledge of the exact sources he used to conjure up the distinctive totality of his imagery.

Viewed through the lens of these heuristic premises, Warhol's body of work from the early 1960s might be redescribed as follows:

The most prominent inhabitant of his world is the Woman—or possibly a series
of women, as it is difficult to tell if appearances can be trusted. If she is plural,
there is at least one with golden hair,

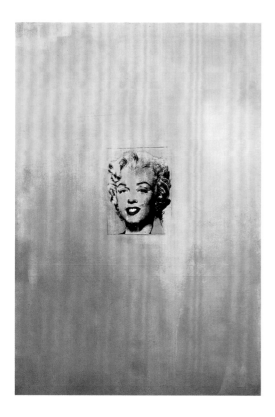

who is accompanied and opposed by a raven-haired counterpart—

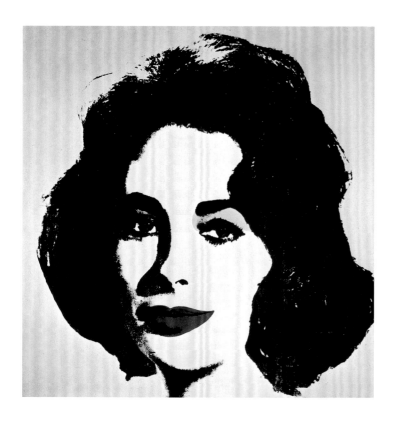

though the second may belong to a pair of twins, one wanton and one chaste.

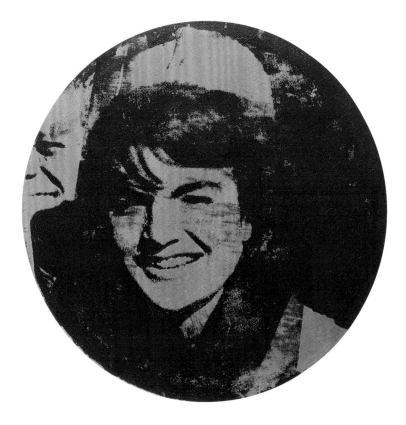

But these apparitions rarely appear as whole bodily entities; rather, they manifest themselves as hovering masks, emblems, or images in a mirror, which can multiply and shift in dizzying profusion.

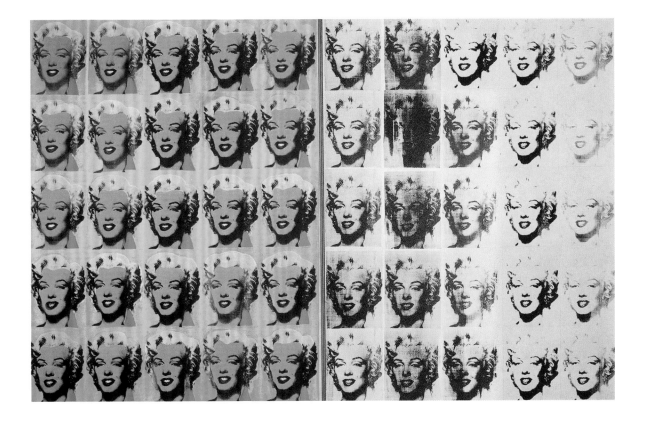

As a result, the observer cannot really be sure if the image is there at all,

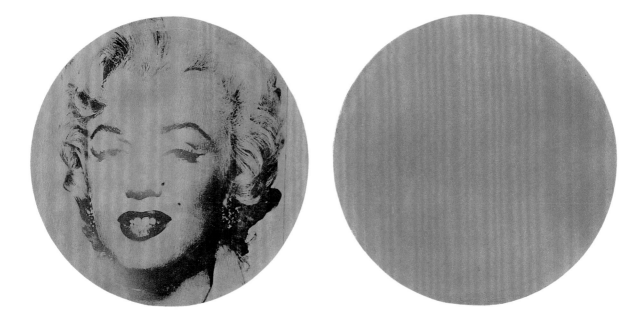

or it may simply vanish, leaving only the empty metallic sheen of the mirror behind.

In the end, the observer finds no relief from such doubts: are there now three women or simply the one revealing herself through differing guises? Each guise (if that is what they are) resembles a legendary personage of the observer's time, known to the observer only via reports of the stylized rituals through which she manifests herself in public. Occasionally, just to complicate things further, the Woman will manifest herself in an emblematic form that is almost impossibly ancient and enigmatic.

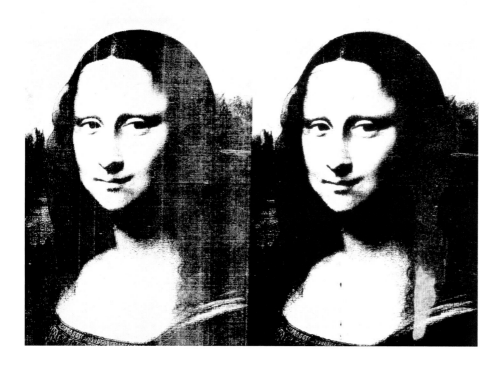

If the Woman—herself a famous lover—

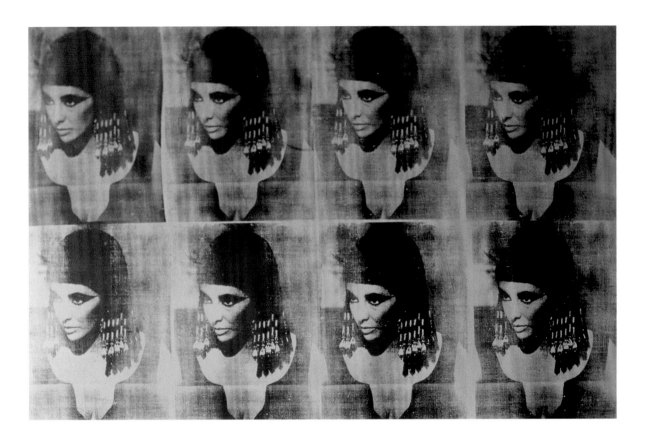

seems peerless in her distant beauty, the observer as protagonist is
continually reminded of his many inadequacies. Despite the aid of a wise
and experienced guide,

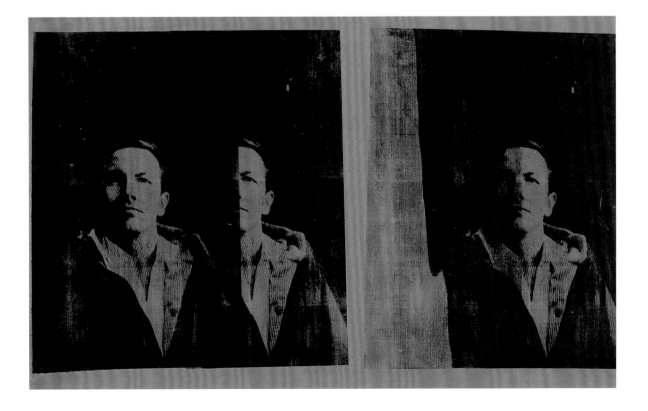

his own physical strength is questionable;

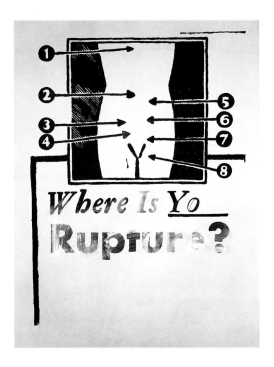

his rations, though abundant, consist of thin gruel that provides little sustenance,

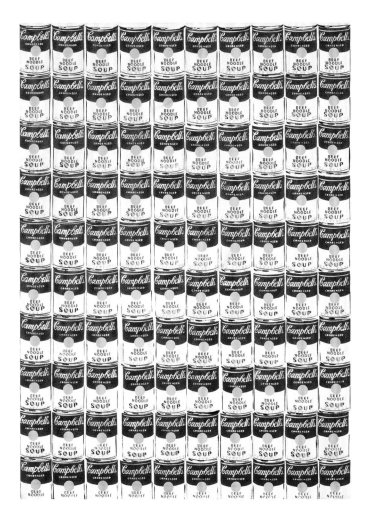

and mortal peril can lie in heartier fare.

He regards his appearance as so flawed that he lends an ear to quacks who promise a more presentable and winning countenance.

He lacks the courtly skills required to please and attempts to remedy his
deficiencies by study.

Perhaps, he thinks, art lessons might help polish his image,

but he cannot quite finish anything he starts, and the right level of aspiration
somehow eludes him.

Compounding the anxiety that he will fail to win favor is the deeper fear that he will not survive to find out—his approach or quest takes place in a world of conflict and constant mortal danger.

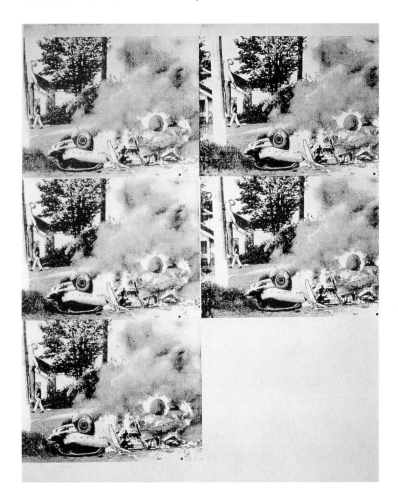

Out on the roads, it seems to be perpetual night.

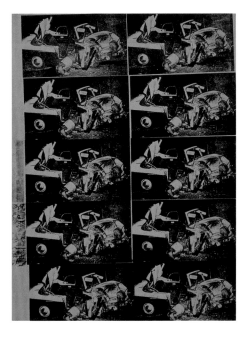

Every conveyance is treacherous and hope of progress is beset by horrific accidents.

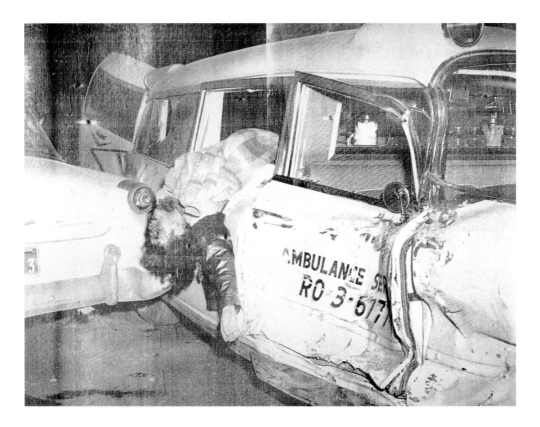

Armed bands beset the innocent and unwary,

while murderous thugs roam freely, unchecked by the slender forces of order.

Certain armed and mounted protector-heroes appear to challenge these
nightmare coalitions.

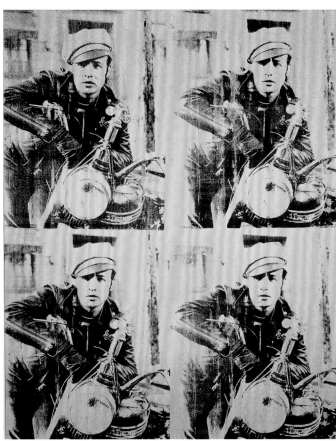

And the king himself once assembled an army behind him.

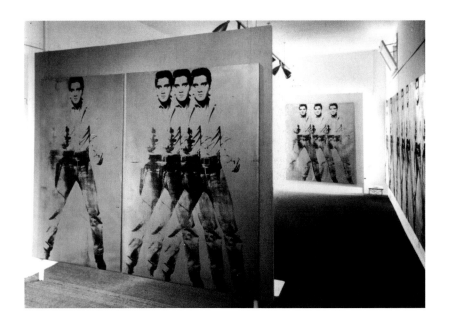

But the Woman—in her queenly guise—now mourns her king,

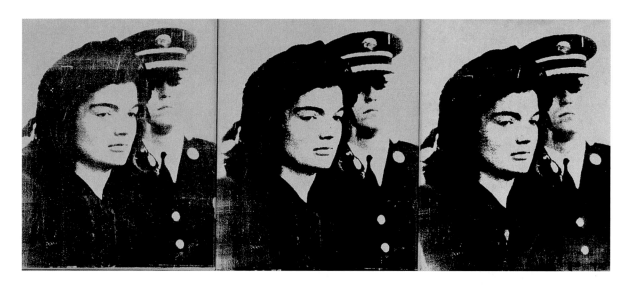

whose death occasions solemn rites.

A minor character, glimpsed fleetingly, gives in to utter despair.

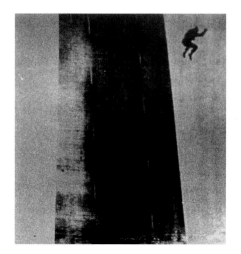

Even the beauty herself seems to have succumbed to a weakness the observer
must fear in himself,

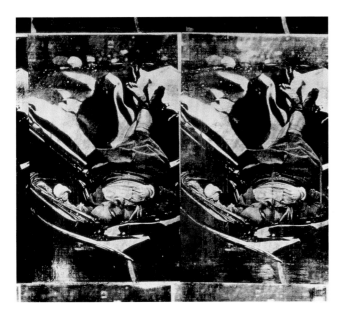

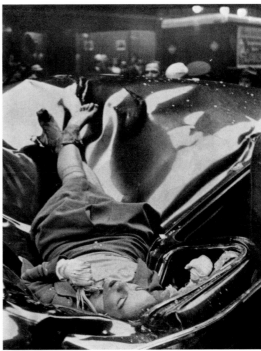

just as the prospect of his own death appears before his eyes in ominous
portents,

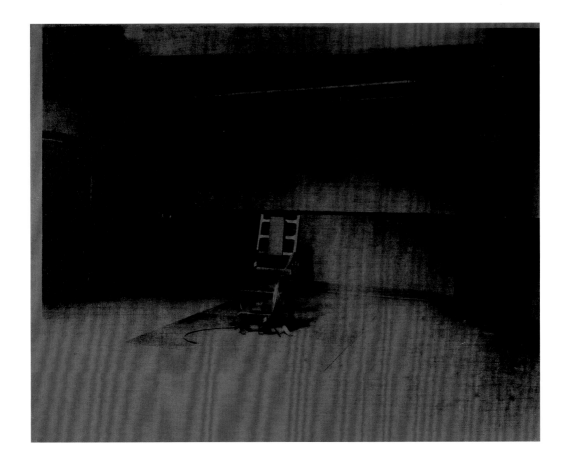

up to and including the very figure of Death itself in universal extinction.

All these menaces stand in the way of the observer achieving the bliss of the garden—

and love's fulfillment,

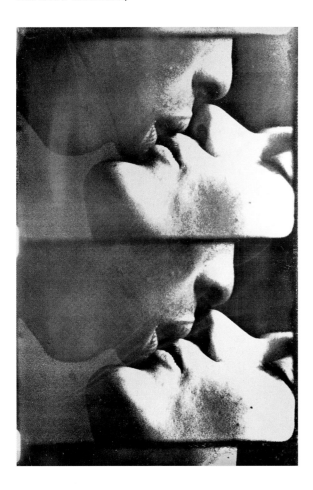

in that place of refuge promised in the countenance of the distant and
enigmatic Woman.

So might run one attempt to paraphrase a suitably comprehensive selection of Warhol motifs in a way that takes account of their emotional and visceral intensity, that is, to act on the plausible assumption that they need to hang together in some way that carries an impact commensurable with the power they possess as individual canvases. Any such exercise will transform the body of his art into an extended allegory, such that the significance of any individual work follows first of all from its place in the larger ensemble, over and above its likeness to anything in the world beyond his art.

Themes of symbolic battle and the obstructed quest have long been the particular province of allegories—and by long, one means a cultural genealogy that reaches back to poetic works like the medieval *Romance of the Rose* or the Elizabethan *Faerie Queene* forward to countless Hollywood narratives from *The Wizard of Oz* to *Apocalypse Now* to *The Matrix*. Angus Fletcher, the leading modern scholar of the allegorical mode, has described its characteristic protagonist as a figure whose uncertainty magnifies the strength of his internal hopes and fantasies as they return to him in the form of threatening or beguiling external apparitions.[5] What might be a traumatic rehearsal of threatening inner turmoil is contained within a two-dimensional patterning of conflict, which imposes its controlling order on disputed territory through incantatory repetitions of familiar elements. Allegorical personages require the semblance of actual personalities, but only that; they exist to exhibit a single trait or perform a single action, as if possessed by some supernatural force.

The success of any allegorical project, furthermore, depends upon deploying its borrowed elements in a deliberately enigmatic way: As Fletcher puts it, "The price of a lack of mimetic naturalism is what the allegorist... must pay in order to force his reader into an analytical frame of mind [and] by bridging the silent gaps between oddly unrelated images we reach the sunken understructure of thought."[6] With the idea of such an understructure in mind, one of Warhol's most famous pronouncements takes on more complex and resonant meaning: "If you want to know all about Andy Warhol, just look at the surface of my paintings and films and me, and there I am. There's nothing behind it." For the purposes of allegory, no more than surface is required. In these drawings and paintings, the protagonist and his projections *represent* a distanced, transformed projection of the self. In their totality they express a far more convincing portrait of their creator—in particular of the actual struggle, doubt, and anxiety that attended his career—than do the verbal self-descriptions that Warhol interposed as a disarming and ingratiating screen between himself and the world.

These have succeeded in making his life and career seem effortless when they were anything but. For a start, consider how impossibly quixotic Warhol's ambitions must have seemed at the close of the 1950s when he acquired the determination to vault himself from the fashion world, where his childish Raggedy Andy persona had so comfortably settled, into an alien realm where bluff, unstylish abstract expressionists still set the tone. Alongside the usual struggles faced by any artist seeking recognition, he encountered a nearly blanket resistance to the taint of his commercial career, indeed to his entire aspect as a human being.[7]

Not the least of these impediments was Warhol's undeniable enthusiasm for the passing parade of popular entertainment, precisely the leveling force

See p. 146 for captions to the illustrations in the preceding portion of this essay.

against which the first wave of the American avant-garde had defined itself. But that opposition had been costly. The relentless high-mindedness of New York's prevailing artistic culture, in particular its insistence on a grandiloquent unity of abstract form, entailed the corresponding embrace of an unrealistically unified account of human agency and self-knowledge (one that broke spirits and took lives). Warhol's art came to serve as the principal antidote to this unsustainable prescription, and therein lies its enduring scandal. When recognition of conflict and division within the self held little place in the reigning orthodoxies of the New York art world, an alternative path—the way of allegory—lay in dispersing one's subjectivity into an array of manageable surrogates. Inner and outer conflicts could be controlled and rendered into art through the incantation of a limited but resonant repertoire of iconic emblems.

Figure 1
Andy Warhol (American, 1928–87)
Untitled (Golden Boy), 1957, gold leaf, ink, and pencil on heavy cardboard, signed and dated in pencil on bottom left of verso, "Andy Warhol 1957," 246.4 × 90.8 cm (97 × 35¾ in.)
Berlin, Stiftung Sammlung Marx, Hamburger Bahnhof—Museum für Gegenwart

A propensity for the emblematic had revealed itself in Warhol's works on paper well before 1960. His frequent gilding of the human body (fig. 1) invested the objects of his desires with an emblem-like, talismanic quality, while the series of fanciful shoes (or simply feet) as portraits manifested the purest sort of allegorical substitution, one that depends upon no sort of resemblance at all (figs. 2, 3).

Figure 2
Andy Warhol (American, 1928–87)
Elvis Presley (Gold Boot), 1956, ink, gold leaf, and collage on paper, signed and annotated in ink, sheet: 50.8 × 35.6 cm (20 × 14 in.) Greenwich, Conn., Stephanie and Peter Brant Foundation

Figure 3
Andy Warhol (American, 1928–87)
Margaret Rutherford, 1957, gold leaf and ink on heavy cardboard, 50.8 × 33 cm (20 × 13 in.) Berlin, Stiftung Sammlung Marx, Hamburger Bahnhof—Museum für Gegenwart

The motif of the foot persists as his fine-art work unfolds through the early 1960s, standing for travel toward the unattainable, for the patterned, ritualized movement imposed upon the observer as protagonist, as well as for his fundamental weakness in the face of overwhelming forces (figs. 4, 5).

But Warhol did not stop at the level of pictorial representation alone, as he increasingly took the allegorical impulse out of the realm of representation and found the means to act it out in lived experience. His turn toward film, however suffused with stringently avant-gardist strategies, provided the necessary magnet to assemble his cast of Superstars, most of whom acquired some new name that designated their assigned part in the ongoing School for Scandal: Baby Jane, Viva, Ultra Violet, Ondine, Ingrid Superstar, International Velvet, Sugar Plum Fairy, Candy Darling, Holly Woodlawn, Paul America, et al. The fact that Warhol could be referred to as Drella—"Pope" Ondine's conflation of Dracula and Cinderella—just completes the picture (fig. 6). He could then sit with seeming impassivity in the center of a cast of obsessives and exhibitionists, each of whom could act out some aspect of his divided self-perception and inner life—with heiress Edie Sedgwick reigning over the

Figure 4
Andy Warhol (American, 1928–87)
Dancestep (Two Feet), 1962,
casein on canvas, 181.6 × 132 cm
(71½ × 52 in.)
New York, Andy Warhol
Foundation for the Visual Arts, Inc.

Figure 5
Andy Warhol (American, 1928–87)
Foot and Tire, 1963, silkscreen ink
and acrylic paint on canvas,
203.8 × 367.7 cm (80¼ × 144¾ in.)
Pittsburgh, Andy Warhol Museum

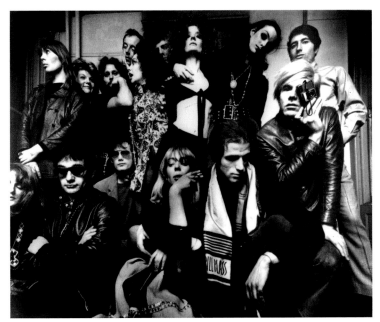

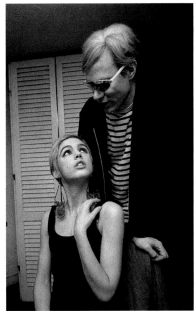

Figure 6
Gerard Malanga (American,
b. 1943)
Warhol Factory group shot, 1968

Figure 7
Bob Adelman (American, b. 1930)
Edie Sedgwick and Andy Warhol,
New York, 1965

ensemble as the Woman, who embodied, in her studied persona and uncan-
nily androgynous beauty, both the subject's displaced object of desire and its
cherished ego-ideal (fig. 7).

––––––––––––

Allegory entails animating symbols with the semblance of life; its corollary is
that lives can be petrified into the semblance of symbols. So far, this way of
comprehending Warhol's early painting remains a matter of interpretation,
one that would have only its measure of internal coherence and completeness
to recommend it. To test it further, one would need to observe Warhol's alle-
gory being processed and transformed in some other sphere of creative prac-
tice. And this appears to have happened twice over: the first occurred in the
translation of the artistic construct underlying Warhol's body of painted work
into the Factory's realm of life as performance; the second represented a
translation of the Factory scene back into the register of art, eminently impor-
tant art, but not by Warhol and not in painting or anything like it.

　　Attention to the first, that is, the living phenomenon of Warhol's Factory,
requires reckoning the real price of giving oneself over to an allegorical exis-
tence, nowhere better exemplified than by the famous case of Sedgwick, the
New England and Californian blueblood *Vogue* model and quintessential New
York scene-maker of the mid-1960s, who herself became the subject of the
hugely successful biography by Jean Stein with George Plimpton (the book
that did the most to popularize the model of biography as cut and pasted frag-
ments of oral testimony from an array of witnesses).[8] Sedgwick died in 1971, at
the age of twenty-eight, following some years of heavy drug use, a habit that
seems to have begun or at least intensified after she left the Factory circle
early in 1966, professing a fed-up frustration with Warhol's taking advantage
of her name, her unpaid film performances, and her family allowance.

But her escape route from being subjected to one allegory was becoming the subject of another, one that commanded equal power in the emergent culture of the 1960s. Consider the following lines:

> You said you'd never compromise
> With the mystery tramp, but now you realize
> That he's not selling any alibis
> As you stare into the vacuum of his eyes
> And ask him, do you want to make a deal?

Or these:

> You used to be so amused
> With Napoleon in rags and the language that he used.
> Go to him now, you can't refuse.
> When you've got nothing, you got nothing to lose.
> You're invisible now, you got no secrets to conceal.

These verses come, of course, from the leading edge of popular music in mid-1965: Bob Dylan's "Like a Rolling Stone." And Warhol figures in its lyrics under various thin disguises: he is the Mystery Tramp and Napoleon in Rags (remembering that kinder, gentler nickname of Raggedy Andy); he also appears as the Diplomat, who rides a chrome horse—here Dylan gestures toward the famous silver iconography of the Factory—and "took from you everything he could steal." It follows that the "you" and "your" addressed in this relentless second-person rant can only be Sedgwick—who had "gone to the finest school" (St. Timothy's boarding school in Maryland)—the "Princess on the steeple" among "all the pretty people," etc. In his memoir of the 1960s, Warhol recounts being told by intermediaries that Dylan "feels you destroyed Edie . . . you're 'the diplomat on the chrome horse.'"[9]

No song can be reduced to its lyrics, least of all one that gripped its listeners like Dylan's breakthrough radio single.[10] None of its words would have resonated without its inspired cobbling together of scattered musical elements (fig. 8): According to Dylan himself, it started with the rhythm and chord changes of Ritchie Valens's early rock-and-roll hit "La Bamba" (itself an electrified version of a Mexican folk song, which Dylan had probably internalized in one of his Minnesota high school bands).[11] The final effect relies on the preternatural virtuosity of blues guitarist Mike Bloomfield set against the inspired sub-musicianship of Al Kooper's organ fills (he had never played the instrument before), which Dylan kept in the mix over his producer's objections.[12] Nonetheless, as the success of the record cannot be imagined without every contribution to its startling sound, so it is with the biting narrative, enunciated by Dylan with an incised clarity.

According to Dylan's closest friend of the time, the charismatic painter and musician Bob Neuwirth, they had first met Sedgwick before her initial encounter with Warhol, that is, since December of the previous year (she only began coming to the Factory in January): "Bob Dylan and I occasionally ventured out into the poppy nightlife world. I think somebody who had met Edie said, 'You have to meet this terrific girl.' Dylan called her, and she chartered a

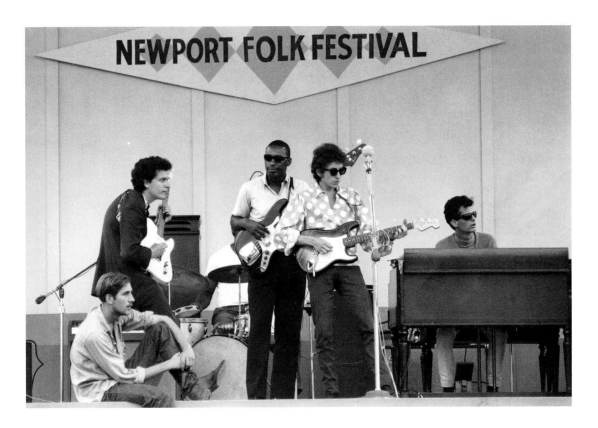

Figure 8
David Gahr (American, b. 1922)
Bob Dylan at the Newport Folk
Festival [Mike Bloomfield and
Al Kooper flanking Bob Dylan
with Jerome Arnold at the
Newport Folk Festival], July 1965

limousine and came to see us. . . . I think we met in the bar upstairs at the
Kettle of Fish on McDougal [*sic*] Street, which was one of the great places
of the Sixties. It was just before the Christmas holidays."[13] Neuwirth would
eventually embark upon an intense love affair with Sedgwick, but to the world
she was soon unveiled as Warhol's social alter ego and the reigning beauty
among the Factory Superstars.

While it has been a commonplace in the extensive Dylan literature that
the later (and lesser) songs of 1966, "Leopard-Skin Pill-Box Hat" and "Just Like
a Woman," take Sedgwick as their subject, similar recognition has largely been
withheld from "Like a Rolling Stone," and Warhol himself attracts virtually no
attention at all.[14] The narrative embedded in the song, it must be said, repre-
sents no simple piece of reportage dressed up in allusive imagery. During that
spring and summer, Warhol and Sedgwick seemed both to have been riding
high, the golden couple of an international avant-garde. Her precipitous
decline and disaffection of the coming winter could only have been guessed
at. Thus the rather standard riches-to-rags theme of "Like a Rolling Stone"
represents less a feat of insight or prescience than a projection of Dylan's own
needs and frustrations onto an actually existing scenario, one already cast in
terms of striking and slightly unreal personae (fig. 9).

The scenario of Warhol and Sedgwick gave Dylan a story to tell, one that
plainly channeled his artistic and personal frustrations into a work capable
of overcoming them. It would indeed be safe to posit that there is a strong
element of self-reflection in the accusatory "How does it feel?" of the song's
chorus: the song emerged—so witnesses and Dylan himself make plain—dur-
ing a period of drift and of alienation from his own art. His British tour in
May 1965 had given him his first real taste of pop-star adulation, both in terms
of ecstatically adoring crowds and record sales that thrust his older albums

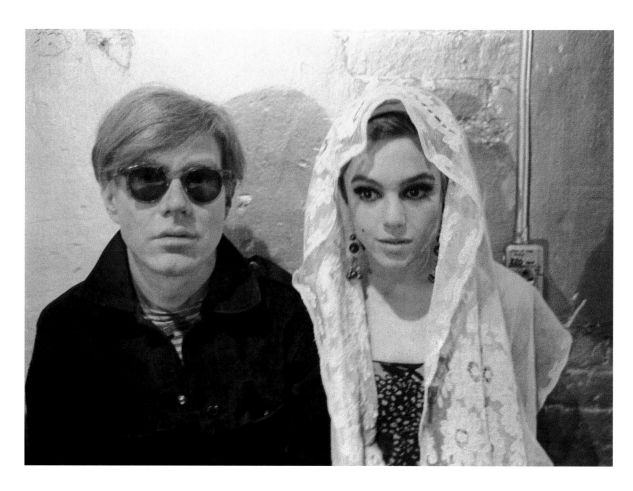

simultaneously into the United Kingdom top twenty—a phenomenon that reverberated back to America.[15] At the same time, he was short of ideas for new material, and it was unclear how he could match the worldwide hit recordings of his own songs by the Animals and the Byrds (he made one abortive attempt to record with an all-star backing group, including Eric Clapton, during his London stay).[16] Friendship with the Beatles redoubled his envious astonishment at their ability to combine aesthetic experimentation with mass success, while the all-acoustic concerts that he was playing in Britain, essentially greatest-hits packages, felt to him repetitive and stale.[17]

At that juncture, Warhol and Sedgwick themselves turned up in London (accompanied by Gerard Malanga and Chuck Wein) just as Dylan's British tour was concluding with two concerts at the Royal Albert Hall.[18] The group had been flown to Paris by the dealer Ileana Sonnabend, who was opening an exhibition of Warhol's flower paintings, an event greeted with delirious enthusiasm in the French press. After making a public announcement that he was renouncing painting for good, Warhol took his group on to London. They were in the audience at a reading by Allen Ginsberg, who was then spending most of his time in the Dylan entourage. Warhol's London dealer, Robert Fraser, derived a large measure of cachet from his public friendships with the Beatles, Rolling Stones, Marianne Faithfull (all present at the Albert Hall), and others of Dylan's peers in the music elite. The same can be said of photographers David Bailey and Michael Cooper, both of whom photographed the Warhol group during their time in London.

Figure 9
Stephen Shore (American, b. 1947)
Andy Warhol and Edie Sedgwick,
New York, ca. 1965

Others in London had by then set out to link the leading edge of pop music with pop art in an explicit way. Beyond the Beatles and the Stones, the Who were undergoing a publicity makeover, whereby their canny manager sought to distinguish his powerful emerging group by identifying them with the visual markers of pop. Drummer Keith Moon appears in contemporary publicity photographs wearing T-shirts emblazoned with Jasper Johns–style targets. Pete Townshend, for his part, adopted a jacket tailored from the Union Jack as his trademark and indirect homage to Johns's displacements (as mediated by English artist Peter Phillips) of its American counterpart.[19] "The Who are linking their image with pop art," reported the music weekly *Melody Maker* just after Dylan's departure, "They describe their current chart success, 'Anyway, Anyhow, Anywhere', as 'the first pop art single'" (fig. 10).[20]

The wave of international enthusiasm over pop art contrasted with a simultaneous waning of energy behind the folk boom of the early 1960s—and Dylan had been looking for a way out. Since the January recording sessions for *Bringing It All Back Home,* he had been struggling with a promised novel under the title of *Tarantula,* and, in the somewhat sour aftermath of the final London concerts, he seriously contemplated the idea of giving up songwriting and performing altogether.[21] Of his detour into literary ambitions, he recalled shortly afterward, "'Like a Rolling Stone' changed it all. I didn't care anymore after that about writing books or poems or whatever."[22] On his return from

Figure 10
Publicity shot of the Who, later used as the cover of the single "Substitute/Instant Party" (1965), date of photograph unknown

England at the beginning of June, he filled some six to twenty pages with barely connected verse, prose, and song lyric, from which a musical, singable core only latterly emerged—but with it a fresh and urgent sense, so he tells it, of how to go on: "I knew I had to sing it with a band. I always sing when I write, even prose, and I heard it like that."[23]

What Dylan heard in his head he seems to have found at those legendary mid-June 1965 sessions that produced "Like a Rolling Stone." But his restless reflection on other art forms stayed with him. In an interview published in July, he manifests a seemingly gratuitous hostility to the unique and precious status of painting: "Have you ever been in a museum? Museums are cemeteries. Paintings should be on the walls of restaurants, in dime stores, in gas stations, in men's rooms. Great paintings should be where people hang out. . . . It's not the bomb that has to go, man, it's the museums."[24] The vehemence of this judgment suggests he had been brooding on the subject, in particular, disputing the claim that painting could ever be truly pop: "The only thing where it's happening is on the radio and records," he continues, "Music is the only thing that's in tune with what's happening."[25]

Dylan soon found the opportunity to manifest that disdain and sense of aggrieved rivalry with pictorial art, if not with Warhol himself. An invitation in late July to sit for a Factory *Screen Test* turned into something of a ceremonial visit in the company of a large entourage.[26] Photographer Nat Finkelstein's pictures of the event record a scene of wary confrontation: In one particularly resonant shot, Warhol and Dylan appraise one another under the gaze of a doubled gun-slinging *Elvis* on canvas, as if enacting a showdown's moment of truth (fig. 11).

Figure 11
Nat Finkelstein (American, b. 1933)
Andy, Dylan, and Double Elvis, 1965, 1965

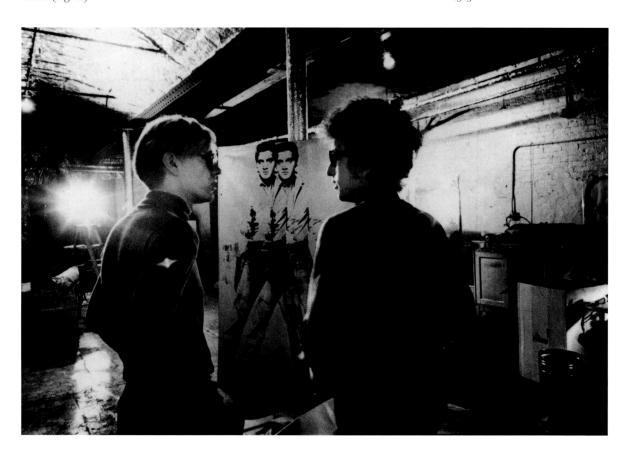

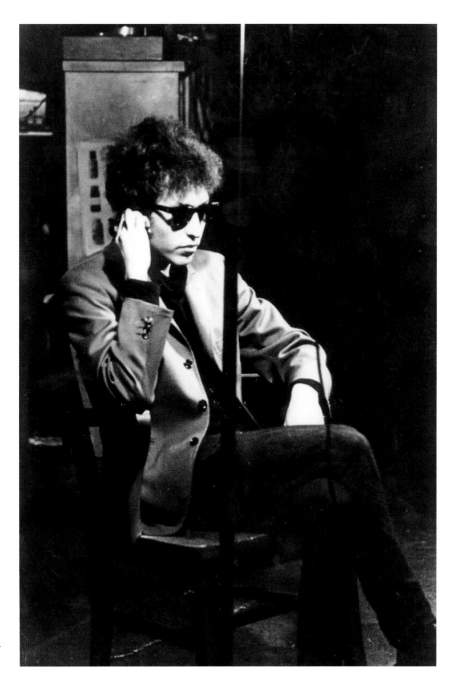

Figure 12
Billy Name (American, b. 1940)
Portrait of Bob Dylan during his
Screen Test at Andy Warhol's Silver
Factory, 1965

His sitting concluded, Dylan commanded in return a gesture of tribute from the artist, who let him take that same silver *Elvis* painting away as a gift. Companions summarily strapped it to the roof of their station wagon and drove it off to his Catskills retreat in Woodstock (where he ultimately traded the canvas to his manager for a couch).[27] Warhol, having publicly renounced painting himself a few months before, was in a poor position to remonstrate. But he had Dylan locked in a film can, one more celebrity trophy for his determined enterprise as a cinema impresario (fig. 12).

While this ritual dance and exchange of portraits counts as Dylan's only docu-
mented visit to the Factory, Warhol testified to a pattern of more frequent and
less fraught encounters "through the MacDougal Street/Kettle of Fish/Café
Rienzi/Hip Bagel/Café Figaro scene."[28] He described Sedgwick bringing Dylan
to a party thrown by a Factory regular, the young curator Sam Green (his
apartment strewn with borrowed furs): "He was already slightly flashy when I
met him, definitely not folksy anymore—I mean he was wearing satin, polka-
dot shirts. He'd released *Bringing It All Back Home,* so he'd already started his
rock sound at this point." To which he added blandly, "I even gave him one of
my silver Elvis paintings in the days when he was first around."[29]

 That encounter punctuated the period of Dylan's frenzied new songwrit-
ing for the remainder of the tracks on *Highway 61 Revisited* (recorded between
29 July and 4 August 1965, released on 30 August).[30] "They're selling postcards
of the hanging," Dylan writes in the opening line of "Desolation Row," the
album's culminating track:

> They're painting the passports brown.
> The beauty parlor's filled with sailors.
> The circus is in town.

 Where else in the culture but in the circle of Warhol and his Superstars
would transformations of gruesome and mundane photographs naturally con-
nect with a spectacle of gender-crossing, homosexual desire, and outlandish
performance? While the first line evokes old photographs of lynchings, the
nightmare confronting the civil rights movement (all part of Dylan's left-
populist inheritance), it just as inescapably, for any acute listener, calls to
mind Warhol's *Race Riot* and *Electric Chair* paintings. And Dylan flirts in a
later verse of the same song with an explicit citation of the source: "the super-
human crew" rounds up victims at midnight to "bring them to the factory."

 On his return from England, the Factory spectacle lay before Dylan as
an amalgam of pop art's glamour and the dark carnival of allegory toward
which his own art was setting its course. If Warhol's collective production
reenacted subjectivity as dangerous, strange, and sprawling terrain, nearly
every line on the album *Highway 61 Revisited* fits that description. "Like a
Rolling Stone" anchored the cycle of songs that gave the world such resonant
landscapes of allegory—populated from the deep resources of ancient blues
and minstrelsy—as Highway 61 itself, Desolation Row, the wonderfully redun-
dant Rue Morgue Avenue, and that unnamed country stumbled upon by the
hapless Mr. Jones, some hopeless square lost in a countercultural scene like a
fever dream of the Factory: "Something is happening, but you don't know
what it is, do you, Mr. Jones?" The late Robert Shelton, Dylan's long-serving
Boswell, writes tellingly of the singer's "own poetic otherworld, into whose
dreams we enter half-fearfully … a host of unsettling demons, spirits, devils,
and malignant muses. Rilke saw his angels, Blake met his prophets Isaiah and
Ezekiel, Dylan painted freaks and geeks."[31]

 Looking back on the seismic change that "Like a Rolling Stone" had
wrought on his old Greenwich Village scene, Dylan reflected that folk music
had "got swept away by fashionable things … British invasions and pop art and
medium-is-the-message type of things."[32] And while he offers this observation

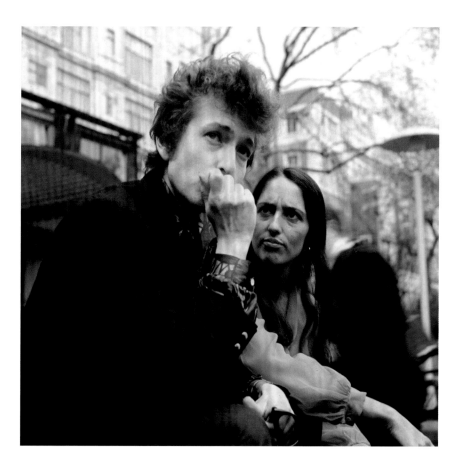

Figure 13
Monty Fresco (British, b. 1919)
Bob Dylan and Joan Baez, 1965

with a note of regret, he returned to America at the beginning of June 1965—as
Warhol was careful to note—immersed in precisely these currents, and they
fortified him as he faced down a folk-revival subculture as committed to sin-
gle-minded sincerity as the abstract expressionists had been. Alongside the
provocation of a drum kit and electric instrumentation, his style of dress left
behind all traces of workingman's authenticity in favor of Carnaby Street
plumage in striking colors and patterns (fig. 13).

———

So this account might in the end revolve around two neatly opposed and sym-
metrical reversals: Dylan, once the prophet of folk authenticity, veers sharply
toward pop ephemera and then has to reckon with the consequences of his
apostasy; Warhol, long assumed to be the prophet of mass-cultural superficial-
ity, turns out to be channeling a deep and ancient vein of Western culture.
The latter proposition represents the counterintuitive argument of the present
essay, while the former represents long-unchallenged conventional wisdom
dating back to the summer of 1965 itself. The affinities and parallels in
Dylan's music with the underlying logic of Warhol's art may, however, open
that conventional wisdom to question. While Dylan certainly saw his new
devices from the broad spectrum of pop as lethal to the authority of "folk
music," his own consistent comments about the conception of *Highway 61
Revisited* suggest that he was consciously returning his art form to older, if not

archaic, templates. Some unusually trenchant and consistent passages from
the interviews he gave in 1965 insist upon a distinction between two notions of
folk music or, alternatively, between folk and what he called "traditional"
music. He tells his young interviewers Nora Ephron and Susan Edmiston (in
the course of the same conversation during which he attacks museums of
painting) that the whole idea of folk had been betrayed by the assumption of
its simplicity, a code enforced by "all the authorities who write about what it is
and what it should be, when they say keep things simple, they should be easily
understood."[33] In the first of several such recorded outbursts, he protests that
"folk music is the only music that isn't simple. It's never been simple. It's
weird, man, full of legend, myth, Bible, and ghosts.... 'I bought a little brown
dog, its face is all gray. Now I'm going to Turkey flying on my bottle.' And
'Nottamun Town,' that's like a herd of ghosts passing through on the way to
Tangiers. 'Lord Edward,' 'Barbara Allen,' they're full of myth."

That interview took place right after the near-riot by "folk" diehards
during his first major electric concert, staged at Forest Hills, Queens, in front
of fifteen thousand spectators on 28 August (that event's atmosphere of
unpredictable menace verging on violence set his alarmed musicians thinking
about the Kennedy assassination and spurred two of them to quit on the
spot).[34] When he encountered seasoned jazz critic and journalist Nat Hentoff
for his *Playboy* interview at the end of the year, he had sharpened his termi-
nological distinctions:

> Folk music is a word I can't use.... I have to think of all this as traditional
> music. Traditional music is based on hexagrams. It comes from legends,
> Bibles, plagues, and it revolves around vegetables and death. There's nobody
> that's going to kill traditional music. All those songs about roses growing out
> of people's brains and lovers who are really geese and swans that turn into
> angels—that's not going to die.[35]

With the possible exception of that outlying reference to vegetables, the alle-
gorical nature of this terrain is unmistakable. The motive behind each of these
remarks, with their emphasis on the enigmatic strangeness of anonymous
traditional songs ("too unreal to die"), was to link the new music of *Highway
61 Revisited* with their allusive complexities, qualities that had been masked by
the simplistic and condescending populism of the orthodox folk revival.

Two sample verses from the aforementioned "Nottamun [Nottingham]
Town" indeed match anything of Dylan's own invention:

> Met the King and the Queen and a Company more
> A-riding behind and a-marching before
> Came a stark naked drummer a-beating a drum
> With his heels in his bosom a-marching along
>
> .
>
> Sat down on a hard, hot cold frozen stone
> Ten thousand stood round me and yet I's alone
> Took my hat in my hand for to keep my head warm
> Ten thousand got drownded that never was born[36]

Revivalist musicians were certainly permitted to sing the true old ballads, but there was a prohibition in place, Dylan is asserting, against anyone creating new music in their spirit. For him, such creation entailed both the kaleidoscopic profusion of imagery and the layered electric sound that he had hit upon the previous June. "I could give you descriptive detail of what they do to me," he continues to Hentoff, "but some people would probably think my imagination had gone mad. It strikes me funny that people actually have the gall to think that I have some kind of fantastic imagination. It gets very lonesome."[37]

That connection remained salient for him years afterward: in 1978 a second *Playboy* interviewer asks him how he felt still performing "Like a Rolling Stone," to which Dylan replies: "That was a great tune, yeah. It's the dynamics in the rhythm ... and all the lyrics. I tend to base all my songs on the old songs. . . . They always make sense."[38]

———————

Such remarks provide prime fodder for the biographer seeking to delineate the state of mind and introspective intentions of his or her subject—and so they are being used here. But the thread of thought that links them serves also to mark a territory of inner life that bears directly upon the problem of artistic biography in particular. That problem, as stated at the outset of this essay, lies in correlating the observable actions and events of an artist's life to the thing that makes the biography worth the effort in the first place: the conception and execution of the art. All too often, that link is simply asserted through various rhetorical tricks and hedges, the realms of reportage and aesthetic interpretation remaining in stubbornly incommensurable registers.

The category of art toward which both Warhol and Dylan were directing their personal projects during the mid-1960s may in itself help bridge this divide. John Keats, in one of his letters, offers what has become a famously enigmatic observation on the subject of biography: "A Man's life of any worth is a continual allegory—and very few people can see the Mystery of his life—a life like the scriptures, figurative—... Shakespeare led a life of Allegory; his works are the comments on it."[39] Keats provides no further elaboration of the concept, but the terms of the remark posit allegory as a mediating term between the life and the work, one that might serve as a descriptive framework for both. Why single out William Shakespeare, apart from his unparalleled literary stature (and the fact that Keats had just been reading him)? Is it perhaps his hazy presence as a person on the stage of history that fragments the identity "Shakespeare" across the range of characters he created and the close company of players that embodied those types on the actual stage of the Globe, as Shakespeare the actor did himself?

It is standard allegorical practice that the unresolved components and experiences of the authorial self distribute themselves over an array of external substitutes, none of which need represent its complete or permanent state. Warhol, fudged and indistinct as a personality even while standing in the full glare of modern publicity, had of course his own company of players—and no

account of him is complete without them.[40] Any adequate reckoning of this
collective biographical subject would constitute another, necessary descrip-
tion of his art.

Dylan the artist, all edgy aggressivity by comparison to Warhol's stu-
diously passive demeanor, nonetheless took on a similarly collective charac-
ter, as his growing entourage inevitably invited comparison with the Factory's
"superhuman crew."[41] But there remained an asymmetry between them that
demands to be resolved on a more imaginative level, because even Dylan's
most inspired accompanying musicians did not serve as extensions of his art
in the way that the Factory denizens served Warhol. He had another company
in his mind's eye. In 1993, bristling at the American-roots pretensions of late-
comers like Bruce Springsteen, he snaps to an interviewer: "They weren't
there to see the end of the traditional people. But I was."[42]

"The traditional people" were the embodiments of the "traditional
music" he took as his compass. And they are easy to identify: As early record-
ings of Appalachian ballads and Delta blues began to be collected and reis-
sued, certain enthusiasts woke up to the fact that many of the musicians
recorded in the late 1920s and early 1930s were still alive—and there were
more where they came from. So the clubs, festivals, and college concerts of
the early 1960s became suddenly populated with living bearers of memory,
conjured from the hollers and plantations of the rural American South
(figs. 14, 15).[43]

It was a short-lived moment, as most of these performers were then in
their sixties or seventies. The memories carried by many of them reached
back to the British popular ballads of the seventeenth century, borne to the
New World by the rough Scots-Irish immigrants who had bypassed the coastal
cities for isolated inland settlements.[44] The younger Dylan had assiduously

Figure 14
Alan Lomax (American, 1915–2002)
Almeda Riddle, ca. 1959

mastered these forms. Then, as their living exponents began to fade from view, the Dylan of 1965 embarked upon his own inspired notion of their continuity. He declared to the *New York Times* as recently as 1997: "Those old songs are my lexicon and my prayer book.... My songs, what makes them different, is that there's a foundation to them. That's why they're still around.... It's not because they're such great songs. They don't fall into the commercial category. They're not written to be performed by other people. But they're standing on a strong foundation, and subliminally that's what people are hearing."[45]

Subliminally, then, they would be hearing echoes from the courtly verse romances of the Middle Ages, the primary source material selected and adapted in the folk traditions of both Old and New Worlds.[46] In America, "Lady Isabel and the Elphin Knight" might have been decanted into a "Pretty Polly," but Dylan took it upon himself to repopulate the American song-world with a plethora of reinvented heraldic characters to make good the loss—with some unintended help from Warhol. And Warhol himself, to the extent that the above redescription of his early paintings holds good, had likewise reached back to a well of medieval romance that persisted in mid-twentieth-century culture through more diffuse and pervasive channels than the particular vehicle of the Appalachian popular ballad. What such atavism provided was a *system* of representations commensurable with the systems of process and formal arrangement (mechanical reproduction, repetition) that governed the appearance of his art.

A certain awareness of this phenomenon may be just emerging in the art-critical literature. Heiner Bastian, who organized the last major Warhol retrospective exhibition, sets about framing his account of the artist in terms of a modern connoisseur's aesthetic discrimination. But his recurrent choices of words display a pronounced gravitational pull toward the terminology of

Figure 15
Alan Lomax (American, 1915–2002)
Left to right: Ed Young with a flute (fife) and Hobart Smith with a banjo, 1960

allegorical interpretation: "In these works," he asserts, "the hyper-icons of Pop turn into icons of demonic emptiness. . . . What Warhol subjected to the magic ritual in his pictures was the tradeable consciousness of the world of things . . . suggesting the endlessness of the emblematic character of the image. . . . The monochrome canvases are juxtaposed—almost like demiurges—to the depictions of horrific reports. . . . secretly they are ciphers for gold, which has been metaphysically exhausted over the centuries."[47] In that this level of recognition remains no more than implicit, Bastian does not address the apparent paradox implied by his rhetoric, which is that such recourse to extremely old artistic means occurred as part and parcel of two artists enjoying a degree of public attention that only the modern mass media could deliver. More than that, each seemed to have its machinery firmly in his grasp. Greil Marcus has memorably written that the Dylan of 1965 "seemed less to occupy a turning point in cultural space and time than to *be* that turning point, as if the culture would turn according to his wishes or even his whim; the fact was, for a long moment it did."[48] While hyperbolic in tone, this judgment comes close to the mark, with the single proviso that one could substitute the name Andy Warhol—who laid down the one claim for visual art that could stand up to the juggernaut of the post-Dylan rock industry—and it would be just as true.

Allegory once flourished as an art of courts, and each of these artists commanded a court of his own, accompanied by a following beyond the reckoning of passing consumer choices—in each case one that plainly carried the shadow of palpable danger as well. By any objective measure—demand from collectors, say, or record sales—neither Warhol nor Dylan was the most "popular" artist in his field, but both had in common an unreachable kind of sovereignty, an exceptional reckoning with the power of fame and how it could be figured in an aesthetic practice. Both in the process altered the fundamental terms on which their respective art forms were conducted. And the work of both, Warhol's perhaps the more, has only grown in perceived currency long past the immediate circumstances that gave rise to their defining innovations. That phenomenon awaits a comprehensive explanation, but, in the meantime, it can be asked whether it is possible to lay hold of the contemporary at all— either as an artist in the eye of the storm or as an interpreter after the fact— without the services of Dylan's old and revered "foundation."

NOTES

1. Andy Warhol, "Nothing to Lose: An Interview with Andy Warhol," interview by Gretchen Berg, in Michael O'Pray, ed., *Andy Warhol: Film Factory* (London: British Film Institute, 1990), 56.

2. Quoted in Gerard Malanga, *Archiving Warhol: An Illustrated History* (n.p.: Creation, 2002), 93.

3. La Monte Young, personal communication, June 2002. Warhol and Young collaborated on a sound-video installation to accompany the Lincoln Center Film Festival in 1964; see Branden W. Joseph, "'My Mind Split Open': Andy Warhol's Exploding Plastic Inevitable," in Christoph Grunenberg and Jonathan Harris, eds., *Summer of Love: Psychedelic Art, Social Crisis and Counterculture in the 1960s* (Liverpool: Liverpool Univ. Press, 2005), 243–45. Warhol also attended a performance of Erik Satie's *Vexations* in September 1963. Organized by John Cage, the performance— consisting of a single eighty-seven-second piece of music repeated 840 times—

took nearly nineteen hours to complete. Ten pianists were required to meet the physical demands of the performance, in which no break in continuity was permitted; see Steven Watson, *Factory Made: Warhol and the Sixties* (New York: Pantheon, 2003), 107–8.

4. Marc Siegel, "Doing It for Andy," *Art Journal* 62, no. 1 (2003): 12.

5. Angus Fletcher, *Allegory: The Theory of a Symbolic Mode* (Ithaca, NY: Cornell Univ. Press, 1964), 34–35 and passim.

6. Fletcher, *Allegory* (note 5), 107.

7. See Victor Bockris, *The Life and Death of Andy Warhol* (New York: Bantam, 1989), 92–93.

8. See Jean Stein and George Plimpton, eds., *Edie: An American Biography* (New York: Knopf, 1982).

9. Andy Warhol and Pat Hackett, *POPism: The Warhol '60s* (New York: Harcourt Brace Jovanovich, 1980), 108.

10. Descriptions of the first hearing of "Like a Rolling Stone" constitute in themselves a subliterature of the abstract sublime, each encomium more expansive than the last. Bruce Springsteen, "Speech at the Rock and Roll Hall of Fame," in Elisabeth Thomson and David Gutman, eds., *The Dylan Companion* (New York: Da Capo, 2000), 286–87, was channeling legions of the less luminous when he recalled, "I was in my car with my mother listening to WMCA and on came that snare shot that sounded like somebody'd kicked open the door to your mind.... I heard a guy who had the guts to take on the whole world and made me feel that I had to too." Frank Zappa, quoted in Clinton Heylin, *Behind the Shades Revisited* (New York: HarperCollins, 2001), 205 (whose strictly musical training and ambition dwarfed Dylan's), ups the ante: "When I heard 'Like a Rolling Stone,' I wanted to quit the music business, because I felt: 'If this wins and does what it's supposed to do, I don't need to do anything else.'" The extended cover title of Greil Marcus, *Like a Rolling Stone: Bob Dylan at the Crossroads; An Explosion of Vision and Humor That Forever Changed Pop Music* (New York: PublicAffairs, 2005), marks it as a late, literary manifestation of the same phenomenon.

11. Bob Dylan, in liner notes to *Biograph,* Columbia CSX 38830, 1986: "It just came. It started out with that 'La Bamba' riff." Dylan recalls attending a concert early in 1958 in Duluth, Minnesota, of the fatal package show that included Buddy Holly and Ritchie Valens, only three days before those musicians died in an Iowa air crash; see the 1984 *Rolling Stone* interview with Kurt Loder, reprinted in Jonathan Cott, *Bob Dylan: The Essential Interviews* (New York: Wenner, 2006), 294. The D. A. Pennebaker documentary film *Don't Look Back* (1967) contains a scene of Bob Neuwirth and Dylan performing an impromptu version of Hank Williams's "Lost Highway" in a hotel room on the 1965 British tour: the song begins with the line, "I'm a rolling stone, all alone and lost."

12. See Derek Barker, "So You Want to Be a Rock and Roll Star: The Story of 'Like a Rolling Stone,'" in idem, ed., *A Bob Dylan Anthology,* vol. 2, *20 Years of ISIS* (New Malden, UK: Chrome Dreams, 2005), 93–95, for the most up-to-date parsing of the various accounts of the sessions. Kooper, who has produced several, somewhat contradictory accounts himself, was an accomplished guitarist and precocious pop veteran, having belonged to the Royal Teens ("Short Shorts") in the late 1950s and co-written the hit "This Diamond Ring" for Gary Lewis and the Playboys.

13. Quoted in Stein and Plimpton, *Edie* (note 8), 166; on Sedgwick's joining the Factory entourage, see Bockris, *Life and Death* (note 7), 162.

14. One guarded exception can be found in the valuable study by C. P. Lee, *Like the Night (Revisited): Bob Dylan and the Road to the Manchester Free Trade Hall* (London: Helter Skelter, 2004), 162, in which he describes his younger self at Dylan's performance at Manchester in 1966: "Now, this may or not be another song about Edie Sedgwick.... We didn't know the ins and outs of the New York Glitterati's love affairs. We knew little of contemporary Popular Culture, except for the dribs and drabs that were spoon fed to us via the medium of the Sunday broadsheet colour supplements. Suddenly, here was Dylan, offering us a view of the Socialite life of the Big Apple, that we wouldn't have known much about anyway, but still, thank you Bob for offering it." A similar lack of curiosity prevails

in the equally voluminous literature on Warhol. Though Victor Bockris, his reliable biographer, allows that the song "contained some acerbic comments about the Warhol-Sedgwick relationship," he makes the point merely as support for the Factory-wide assessment of Dylan as "the creep." Bockris, *Life and Death* (note 7), 171–72. Another, recent exception can be found in a single footnote in the rather overlooked but insightful study by Kelly M. Cresap, *Pop Trickster Fool: Warhol Performs Naivete* (Urbana: Univ. of Illinois Press, 2004), 183n116, who states that the "Napoleon in Rags" verse "is commonly taken as referring to the dynamic between Sedgwick and Warhol [which] exacerbated the border tensions between Warhol's and Dylan's alternate scenes in mid-sixties New York." While this view is succinct and correct, Cresap exaggerates its currency among other writers.

15. See Barker, "So You Want to Be" (note 12), 91: Columbia Records took out advertisements in music trade publications at the end of May headlined, "NOW BOB IS BIGGER THAN BIG BEN!"

16. See Clinton Heylin, *Bob Dylan: A Life in Stolen Moments; Day-by-Day, 1941–1995* (New York: Schirmer, 1996), 74.

17. See the 1966 *Ramparts* interview with Ralph J. Gleason, "The Children's Crusade," reprinted in Craig MacGregor, ed., *Bob Dylan, The Early Years: A Retrospective* (New York: Da Capo, 1990), 186: "That was the end of my older program. I knew what was going to happen all the time, y'know. I knew how many encores there was, which songs they were going to clap loudest at and all this kind of thing." According to Barker, "So You Want to Be" (note 12), 102, the interview was conducted in December 1965.

18. See Warhol and Hackett, *POPism* (note 9), 113–14. See also Bockris, *Life and Death* (note 7), 167–68.

19. On the transformations of this motif, see David Mellor, *The London Art Scene in the 1960s* (London: Phaidon, 1992), 119–26. On Phillips's *Purple Flag* (1960), see Marco Livingstone, *Pop Art* (London: Royal Academy of Arts, 1991), 170.

20. "They Think the Mod Thing Is Dying … But They Don't Intend to Go Down with It," *Melody Maker,* 5 June 1965, 7. Townshend was quoted the next month declaring: "We stand for pop art clothes, pop art music and pop art behavior. This is what everybody seems to forget—we don't change offstage. We live pop art." See Nick Jones, "Well, What Is Pop Art?" *Melody Maker,* 3 July 1965, 11.

21. See the March 1966 *Playboy* interview with Nat Hentoff (doubtless conducted late in 1965); reprinted in Cott, *Bob Dylan* (note 11), 129; also interview with Gleason, "Children's Crusade" (note 17), 187.

22. Interview with Hentoff (note 21), 129.

23. Gleason, "Children's Crusade" (note 17), 187.

24. See the interview conducted shortly after 28 August 1965 with Nora Ephron and Susan Edmiston, reprinted in Cott, *Bob Dylan* (note 11), 54.

25. Interview with Ephron and Edmiston (note 24), in Cott, *Bob Dylan* (note 11), 54.

26. For images and a verbal account, see Nat Finkelstein, *Andy Warhol: The Factory Years, 1964–1967* (Edinburgh: Canongate, 1999), n.p. See also Bockris, *Life and Death* (note 7), 172. Billy Name (Linich) also took photographs of the visit and Dylan sitting for the *Screen Test,* dated July 1965; see Debra Miller, *Billy Name: Stills from the Warhol Films* (Munich: Prestel, 1994), 16, 20. The visit had been arranged by filmmaker Barbara Rubin, on whom see Daniel Belasco, "The Vanished Prodigy," *Art in America* 93, no. 11 (2005): 61–65, 67. On the *Screen Tests,* see Callie Angell, *Andy Warhol Screen Tests: The Films of Andy Warhol: Catalogue Raisonné* (New York: Abrams, 2006). The entry for the Dylan *Test* appears on page 66, mistakenly dated to 1966.

27. Eventually sold by Sally Grossman, the widow of manager Albert Grossman, the painting is now in the collection of the Museum of Modern Art, New York. For previous provenance information, see Georgi Frei and Neil Prinze, eds., *The Andy Warhol Catalogue Raisonne,* vol. 1, *Paintings and Sculpture, 1961–1963* (London: Phaidon, 2002), 378, 367 (fig. 407).

28. On Dylan's distance from the Factory itself, Bob Neuwirth, personal communica-

tion, April 2006; on the Dylan contacts, Warhol and Hackett, *POPism* (note 9), 107–8.

29. Warhol and Hackett, *POPism* (note 9), 107–8.

30. See Clinton Heylin, *Bob Dylan: The Recording Sessions (1960–1994)* (New York: St. Martins, 1995), 41–43.

31. Robert Shelton, *No Direction Home: The Life and Music of Bob Dylan* (New York: Da Capo, 1986), 267–68. Gleason, a similarly seasoned commentator, wrote in 1966 ("Children's Crusade" [note 17], 177): "Dylan's world is a nightmare world.... In his world are all sorts of carnival freak show figures, 'Einstein disguised as Robin Hood...with his friend a jealous monk,' 'the motorcycle black madonna two wheel gypsy queen,' 'Dr. Filth...his nurse, some local loser, she's in charge of the cyanide hole,' 'Mack the Finger,' etc. Recurrent figures in the Dylan poetry include the monk, the hunchback, the sideshow geek and clown and Napoleon. It's a gaudy, depressing grotesquerie."

32. Quoted in Heylin, *Behind the Shades* (note 10), 215.

33. Interview with Ephron and Edmiston (note 24), in Cott, *Bob Dylan* (note 11), 50.

34. See Greil Marcus, *Invisible Republic: Bob Dylan's Basement Tapes* (New York: Henry Holt, 1997), 17–18.

35. Interview with Hentoff (note 21), in Cott, *Bob Dylan* (note 11), 98.

36. Dylan, who had already borrowed its melody for "Masters of War," would have learned the song from the Kentucky singer and folk scholar Jean Ritchie, who was active at that moment (and for many years since). The song had been collected by Cecil Sharp from her older sister, Una, at the Hindman Settlement School in Knott County, Kentucky, around 1917; see Cecil J. Sharp and Maud K. Karpeles, *Eighty English Folk Songs from the Southern Appalachians* (Cambridge: MIT Press, 1968), 89.

37. Interview with Hentoff (note 21), in Cott, *Bob Dylan* (note 11), 98.

38. *Playboy* interview in March 1978 with Ron Rosenbaum; reprinted in Cott, *Bob Dylan* (note 11), 225–26.

39. John Keats to the George Keatses, 19 February 1819, in Hyder Edward Rollins, ed., *The Letters of John Keats, 1814–1821* (Cambridge: Harvard Univ. Press, 1958), 2:67.

40. In this vein, see the studies by Stephen Koch, *Stargazer: Andy Warhol's World and His Films* (New York: Praeger, 1973) and, most recently, Watson, *Factory Made* (note 3).

41. See Finkelstein, *The Factory Years* (note 26), n.p., who refers—with some hyperbole—to the two groups as "the Guelphs and Ghibellines of the New York underground scene engaged in a fraternal rumble deep in that insulated New York culture womb."

42. Quoted in Marcus, *Invisible Republic* (note 34), 195.

43. Dylan, in his memoir *Chronicles,* vol. 1 (New York: Simon & Schuster, 2004), 70, writes about sessions convened by the song collector and musicologist Alan Lomax in his Greenwich Village loft: "You might see Roscoe Holcomb or Clarence Ashley or Dock Boggs, Mississippi John Hurt, Robert Pete Williams or even Don Stover and the Lilly Brothers—sometimes, even real live section gang convicts that Lomax would get out of state penitentiaries on passes and bring them to New York to do field hollers in his loft." In contrast to this warm—and probably embellished memory—Dylan, in his *Rolling Stone* interview in December 1968 with Mikal Gilmore (reprinted in Cott, *Bob Dylan* [note 11], 423–24), bridles at the suggestion by Marcus and others that Harry Smith's collection of recordings, issued in 1952 by Folkways Records as *The Anthology of American Folk Music,* was the key to this transmission: "You could see those people live and in person. They were around."

44. The literature on this pattern of settlement is vast: for the most comprehensive account, see David Hackett Fischer, *Albion's Seed: Four British Folkways in America* (New York: Oxford Univ. Press, 1989). Clinton Heylin, in his invaluable *Bob Dylan's Daemon Lover: The Tangled Tale of a 450-Year-Old Pop Ballad* (London: Helter Skelter, 1999), 104–15 and passim, provides a capsule description of the

phenomenon as it bears on the transmission of the ballad "The House Carpenter"
to the New World.

45. Bob Dylan, interview by John Pareles, *New York Times,* September 1997; reprinted
 in Cott, *Bob Dylan* (note 11), 396. In these later remarks on this theme, Dylan
 understandably expands his range of examples to include African American blues
 and sacred music, as well as early commercial country-and-western songs. In that
 light, it makes the restriction of his examples in the interviews of 1965 to the
 British ballad tradition all the more striking, as he was conversant with all of these
 genres at the earliest stages of his career.

46. Hence, as Heylin, *Bob Dylan's Daemon Lover* (note 44), 132, observes, "the pre-
 ponderance of ladies in their bowers and reckless knights in these 'new' [late-
 sixteenth- and early-seventeenth-century] popular ballads."

47. Heiner Bastian, "Rituals of Unfulfillable Individuality—the Whereabouts of
 Emotions," in idem, ed., *Andy Warhol: Retrospective* (London: Tate Publishing,
 2002), 27–31. Cresap, *Pop Trickster Fool* (note 14), 18, gets closer: "The artist that
 Bob Dylan dubbed 'Napoleon in Rags' marshaled an army composed of recycled
 icons and logos, scandalous movies, and assorted class fugitives."

48. Marcus, *Invisible Republic* (note 34), ix.

Captions for illustrations on pp. 110–24

110, top
Andy Warhol (American, 1928–87)
Gold Marilyn Monroe, 1962, silkscreen ink on synthetic polymer paint and oil on canvas,
211.4 × 144.7 cm (83 1/4 × 57 in.)
New York, Museum of Modern Art

110, bottom
Andy Warhol (American, 1928–87)
Liz #3, 1963, silkscreen ink and acrylic on linen, 101.6 × 101.6 cm (40 × 40 in.)
Turin, private collection

111, top
Andy Warhol (American, 1928–87)
Gold Jackie, 1964, silkscreen ink and gold paint on canvas; two tondi, each 45.1 cm
(17 3/4 in.) in diameter
Stuttgart, Collection Froehlich

111, bottom
Andy Warhol (American, 1928–87)
Marilyn Diptych, 1962, silkscreen ink and acrylic paint on canvas; two panels,
each: 208.3 × 144.8 cm (82 × 57 in.); overall: 208.3 × 289.6 cm (82 × 114 in.)
London, Tate Gallery

112, top
Andy Warhol (American, 1928–87)
Gold Marilyn, 1962, silkscreen ink and gold paint on canvas; two tondi, each 45.3 cm.
(17 7/8 in.) in diameter
Stuttgart, Collection Froehlich

112, bottom
Andy Warhol (American, 1928–87)
Double Mona Lisa, 1963, silkscreen ink on linen, 72.4 × 94.3 cm (28 1/2 × 37 1/8 in.)
Houston, Menil Collection

113, top
Andy Warhol (American, 1928–87)
Blue Liz as Cleopatra, 1963, silkscreen ink and acrylic paint on canvas,
208.3 × 165.1 cm (82 × 65 in.)
Zurich, Daros Collection

113, bottom
Andy Warhol (American, 1928–87)
Triple Rauschenberg, 1962, acrylic and silkscreen ink on linen, 53.3 × 86.4 cm (21 × 34 in.)
Private collection

114, top
Andy Warhol (American, 1928–87)
Where Is Your Rupture? 1960, casein on canvas, 177.2 × 137.2 cm (69$3/4$ × 54 in.)
Santa Monica, Broad Art Foundation

114, bottom
Andy Warhol (American, 1928–87)
100 Cans, 1962, oil paint on canvas, 183 × 132 cm (72 × 52 in.)
Buffalo, Albright-Knox Art Gallery

115, top
Andy Warhol (American, 1928–87)
Tunafish Disaster, 1963, silkscreen ink and acrylic paint on canvas, 316 × 211 cm
(124$3/8$ × 83 in.)
Zurich, Daros Collection

115, bottom
Andy Warhol (American, 1928–87)
Before and After [1], 1961, casein on canvas, 172.7 × 137.2 cm (68 × 54 in.)
New York, Metropolitan Museum of Art

116, top
Andy Warhol (American, 1928–87)
Dance Diagram (Fox Trot), 1962, casein on canvas, 183 × 137.2 cm (72 × 54 in.)
Private collection

116, bottom
Andy Warhol (American, 1928–87)
Do It Yourself (Landscape), 1962, acrylic paint, pencil, and Letraset on canvas, 177.8 × 137.2 cm
(70 × 54 in.)

117, top
Andy Warhol (American, 1928–87)
White Burning Car III, 1963, silkscreen ink and synthetic polymer paint on canvas,
254 × 200 cm (100 × 78$3/4$ in.)
Pittsburgh, Andy Warhol Museum

117, bottom
Andy Warhol (American, 1928–87)
Green Disaster 10 Times, 1963, silkscreen ink and acrylic paint on canvas, 267.5 × 201 cm
(105$3/8$ × 79$1/8$ in.)
Frankfurt am Main, Museum für Moderne Kunst

118, top
Andy Warhol (American, 1928–87)
Ambulance Disaster, 1963, silkscreen ink and acrylic paint on canvas, 315 × 203 cm
(124 × 80 in.)
Berlin, Stiftung Sammlung Marx, Hamburger Bahnhof–Museum für Gegenwart

118, bottom
Andy Warhol (American, 1928–87)
Race Riot, 1963, silkscreen ink and acrylic paint on canvas, 307 × 210 cm (120⅞ × 82⅝ in.)
Zurich, Daros Collection

119, top
Andy Warhol (American, 1928–87)
Cagney, 1962, silkscreen ink and silver paint on canvas, 520 × 208 cm (204¾ × 817⁄8 in.)
Berlin, Stiftung Sammlung Marx, Hamburger Bahnhof–Museum für Gegenwart

119, bottom
Warhol's *Thirteen Most Wanted Men* on the facade of the New York Pavilion at the
1964 New York World's Fair
Pittsburgh, Andy Warhol Museum

120, top left
Andy Warhol (American, 1928–87)
Single Elvis [Ferus Type], 1963, silkscreen ink, silver paint, spray paint, and pencil on linen,
208.3 × 106.7 cm (82 × 42 in.)
Budapest, Ludwig Museum–Museum of Contemporary Art

120, top right
Andy Warhol (American, 1928–87)
Four Marlons, 1966, silkscreen ink on canvas, 204 × 150 cm (80¼ × 59 in.)
Private collection

120, bottom
Frank J. Thomas (American, 1916–93)
Elvis paintings in Warhol exhibition at Ferus Gallery, October 1963
Sierra Madre, Calif., Frank J. Thomas Archives

121, top
Andy Warhol (American, 1928–87)
Twenty Jackies, 1964, silkscreen ink on canvas; twenty panels, each: 50.8 × 40.6 cm
(20 × 16 in.); overall: 204.5 × 204.5 cm (80½ × 80½ in.)
Los Angeles, Eli and Edythe L. Broad Collection

121, middle
Andy Warhol (American, 1928–87)
Gangster Funeral, 1963, silkscreen ink, acrylic paint, and pencil on canvas, 266.7 × 187.3 cm
(105 × 75¾ in.)
Pittsburgh, Andy Warhol Museum

121, bottom
Andy Warhol (American, 1928–87)
Suicide (Purple Jumping Man), 1963, synthetic polymer paint and silkscreen ink on canvas,
229.9 × 201.9 cm (90½ × 79½ in.)
Tehran, Tehran Museum of Contemporary Art

122, top left
Andy Warhol (American, 1928–87)
Suicide (Fallen Body), 1963, silkscreen ink and silver paint on canvas, 284.5 × 204.2 cm
(112 × 80⅜ in.)
Private collection

122, top right
Robert Wiles
Photograph published in *Life,* 12 May 1947.

122, bottom
Andy Warhol (American, 1928–87)
Little Electric Chair, 1965, synthetic polymer paint and silkscreen ink on canvas, 56 × 71 cm
(22 × 28 in.)
Houston, Menil Collection

123, top
Andy Warhol (American, 1928–87)
Atomic Bomb, 1965, silkscreen ink and acrylic paint on canvas, 264.2 × 204.5 cm
(104 × 80½ in.)
London, Saatchi Collection

123, bottom
Andy Warhol (American, 1928–87)
Flowers, 1964, silkscreen ink and acrylic paint on canvas, 177.8 × 356 cm (70 × 140⅛ in.)
Greenwich, Conn., Stephanie and Peter Brant Foundation

124, top
Andy Warhol (American, 1928–87)
Kiss, 1965, screenprint on Plexiglas, 160 × 108.3 cm (63 × 42⅝ in.)
Pittsburgh, Andy Warhol Museum

124, bottom
Andy Warhol (American, 1928–87)
Mint Marilyn, 1962, silkscreen ink and acrylic paint on canvas, 50.8 × 40.6 cm (20 × 16 in.)
Collection Jasper Johns

THOMAS CROW is director of the Getty Research Institute and professor of history of art at the University of Southern California. A contributing editor to *Artforum,* he writes frequently on contemporary art and cultural issues. Since his award-winning first book, *Painters and Public Life in Eighteenth-Century Paris* (1985), he has authored several volumes on the art of the later twentieth century, including *Modern Art in the Common Culture* (1996), *The Rise of the Sixties: American and European Art in the Era of Dissent* (1996; 2nd ed. 2005), and a survey of the life and work of Gordon Matta-Clark (2003). Translations of his works appear in French, German, Italian, and Spanish.

CHARLES HARRISON has been associated with the artistic practice Art & Language since 1971. Professor of the history and theory of art at the Open University (UK), he has been a visiting professor at the University of Chicago and at the University of Texas at Austin, as well as a Getty Scholar (2001–2) and a visiting fellow at the Getty Research Institute (2004). He is a coeditor of Blackwell's *Art in Theory* series (1992–2003) and author of *English Art and Modernism 1900–1939* (1981; 2nd ed. 1994), *Essays on Art & Language* (1991; 2nd ed. 2001), *Modernism* (1997), *Conceptual Art and Painting: Further Essays on Art & Language* (2001), and *Painting the Difference: Sex and Spectator in Modern Art* (2005).

ROSALIND KRAUSS is University Professor at Columbia University, specializing in the history of twentieth-century art and theory. The founding editor of *October* magazine and associate editor of *Artforum,* she has served as curator of the Guggenheim Museum's retrospective *Robert Morris: The Mind/Body Problem* (1994) and, with Yve-Alain Bois, of *L'informe: Mode d'emploi* (1996) for the Centre Georges Pompidou, Paris. Her books include *The Originality of the Avant-Garde and Other Modernist Myths* (1985), *The Optical Unconscious* (1993), and, most recently, *The Picasso Papers* (1998) and *Bachelors* (1999).

CHARLES G. SALAS is head of the Research and Education Department at the Getty Research Institute. He has published in diverse areas, including mathematics, historiography, and the philosophy of history. His most recent publications are *Looking for Los Angeles: Architecture, Film, Photography, and the Urban Landscape* and *Disturbing Remains: Memory, History, and Crisis in the Twentieth Century.* Both were coedited with Michael S. Roth and published by the Getty Research Institute in 2001.

DEBORA L. SILVERMAN is a professor of history and art history at the University of California, Los Angeles, where she holds the University of California Presidential Chair in Modern European History, Art, and Culture. The recipient of numerous awards and grants, she studies the links between modernist artworks and their social contexts, and is currently at work on a new project focusing on colonial modernism in fin-de-siècle Belgium. Her books include *Selling Culture: Bloomingdale's, Diana Vreeland, and the New Aristocracy of Taste in Reagan's America* (1986), *Art Nouveau in Fin-de-Siècle France: Politics, Psychology, and Style* (1989), and *Van Gogh and Gauguin: The Search for Sacred Art* (2000).

PAUL SMITH is Professor of the history of art at the University of Warwick and previously was Professor of the history of art at the University of Bristol and a visiting professor at the University of California, Berkeley. He has recently edited an annotated translation of Marius Roux's novel *La proie et l'ombre* (1878) and is working on books on Seurat and Cézanne. His books include *Impressionism: Beneath the Surface* (1995), *Interpreting Cézanne* (1996), *Seurat and the Avant-Garde* (1997), and *A Companion to Art Theory* (2002), which he coedited with Carolyn Wilde.

ROBERT WILLIAMS is a professor of the history of art at the University of California, Santa Barbara. A specialist in Italian art of the Renaissance and early modern period, he is the author of *Art, Theory, and Culture in Sixteenth-Century Italy: From Techne to Metatechne* (1997) and *Art Theory: An Historical Introduction* (2004). Among his articles and conference lectures is a study in *Rinascimento* titled "Italian Renaissance Art and the Systematicity of Representation" (2003).

Illustration Credits

The following sources have granted permission to reproduce illustrations in this book:

48	Research Library, Getty Research Institute, acc. no. 861128B. Photo: © 2007 J. Paul Getty Trust	
49	© Réunion des Musées Nationaux/Art Resource, New York. Photo: Hervé Lewandowski	
53	Museum of Fine Arts, Boston, bequest of Robert Treat Paine, 2nd, 44.776. Photograph: © 2007 Museum of Fine Arts, Boston	
55	Research Library, Getty Research Institute, acc. no. 861128. Photo: © 2007 J. Paul Getty Trust	
57	The Samuel Courtauld Trust, Courtauld Institute of Art Gallery, London	
64	Photo: courtesy Acquavella Galleries, Inc.	
65	© Réunion des Musées Nationaux/Art Resource, New York. Photo: Hervé Lewandowski	
78	Photo: courtesy the author	
79	Coll. Kröller-Müller Museum, Otterlo	
80, fig. 3	Van Gogh Museum, Amsterdam, letter 223. Photo: courtesy the author	
80, fig. 4	Van Gogh Museum, Amsterdam, SB 1	50, 51. Photo: Research Library, Getty Research Institute. © 2007 J. Paul Getty Trust
81	Van Gogh Museum, Amsterdam, F1637v. Photo: courtesy the author	
82, 84	Photo: courtesy the author	
86	Museum of Fine Arts, Boston, Tomkins Collection, 36.270. Photo: © 2007 Museum of Fine Arts, Boston	
87	Collection of McNay Art Museum, Bequest of Marion Koogler McNay, 1950.45	
89	Ordrupgaard, Copenhagen. Photo: Pernille Klemp	

90	Photo: courtesy the author
91	Photo: Erich Lessing/Art Resource, New York
101–4	© 2007 Art & Language
105	© 2007 Art & Language. Photo: Konstantinos Ignatiadis
110, top	© 2007 Andy Warhol Foundation for the Visual Arts/Artists Rights Society (ARS), New York. 2007 Marilyn Monroe, LLC by CMG Worldwide, Inc./www.MarilynMonroe.com. Photo: The Andy Warhol Foundation/Art Resource, New York
110, bottom	© 2007 Andy Warhol Foundation for the Visual Arts/Artists Rights Society (ARS), New York. Photo: The Andy Warhol Foundation, Inc./Art Resource, New York
111, top	Collection Froehlich, Stuttgart. © 2007 Andy Warhol Foundation for the Visual Arts/Artists Rights Society (ARS), New York
111, bottom	© 2007 Andy Warhol Foundation for the Visual Arts/Artists Rights Society (ARS), New York. 2007 Marilyn Monroe, LLC by CMG Worldwide, Inc./www.MarilynMonroe.com. Photo: Tate Gallery, London/Art Resource, New York
112, top	© 2007 Andy Warhol Foundation for the Visual Arts/Artists Rights Society (ARS), New York. 2007 Marilyn Monroe, LLC by CMG Worldwide, Inc./www.MarilynMonroe.com. Photo: The Andy Warhol Foundation, Inc./Art Resource, New York
112, bottom	© 2007 Andy Warhol Foundation for the Visual Arts/Artists Rights Society (ARS), New York. Photo: The Andy Warhol Foundation, Inc./Art Resource, New York
113, top	© 2007 Andy Warhol Foundation for the Visual Arts/Artists Rights Society (ARS), New York. Photo: The Andy Warhol Foundation, Inc./Art Resource, New York
113, bottom	© 2007 Andy Warhol Foundation for the Visual Arts/Artists Rights Society (ARS), New York. Photo: courtesy Sonnabend Collection
114, top	The Broad Art Foundation, Santa Monica. © 2007 Andy Warhol Foundation for the Visual Arts/Artists Rights Society (ARS), New York
114, bottom	© 2007 Andy Warhol Foundation for the Visual Arts/Artists Rights Society (ARS), New York/TM Licensed by Campbell's Soup Co. All rights reserved. Photo: The Andy Warhol Foundation, Inc./Art Resource, New York
115, top	Daros Collection, Switzerland. © 2007 Andy Warhol Foundation for the Visual Arts, Inc./Artists Rights Society (ARS), New York
115, bottom	© 2007 Andy Warhol Foundation for the Visual Arts/Artists Rights Society (ARS), New York. The Metropolitan Museum of Art, Gift of Halston, 1981 (1981.536.1). Photograph, all rights reserved, The Metropolitan Museum of Art

123, bottom	Courtesy The Stephanie and Peter Brant Foundation. © 2007 Andy Warhol Foundation for the Visual Arts/Artists Rights Society (ARS), New York.
124, top	Founding Collection, The Andy Warhol Museum, Pittsburgh, Contribution The Andy Warhol Foundation for the Visual Arts, Inc. 1998.1.2378. © 2007 Andy Warhol Foundation for the Visual Arts/Artists Rights Society (ARS), New York. Photo: Richard Stoner
124, bottom	© 2007 Andy Warhol Foundation for the Visual Arts/Artists Rights Society (ARS), New York. 2006 Marilyn Monroe, LLC by CMG Worldwide, Inc./www.MarilynMonroe.com. Photo: The Andy Warhol Foundation, Inc./Art Resource, New York
126	Stiftung Sammlung Marx, Hamburger Bahnhof—Museum für Gegenwart, Berlin. © 2007 Andy Warhol Foundation for the Visual Arts/Artists Rights Society (ARS), New York. Photo: Jochen Littkemann, Berlin
127, fig. 2	Courtesy The Stephanie and Peter Brant Foundation, Greenwich, Conn. © 2007 Andy Warhol Foundation for the Visual Arts/Artists Rights Society (ARS), New York
127, fig. 3	Stiftung Sammlung Marx, Hamburger Bahnhof—Museum für Gegenwart, Berlin. © 2007 Andy Warhol Foundation for the Visual Arts/Artists Rights Society (ARS), New York. Photo: Jochen Littkemann, Berlin
128, fig. 4	© 2007 Andy Warhol Foundation for the Visual Arts/Artists Rights Society (ARS), New York. Photo: The Andy Warhol Foundation, Inc./Art Resource, New York
128, fig. 5	Founding Collection, The Andy Warhol Museum, Pittsburgh, Contribution Dia Center for the Arts, 2002.4.2. © 2007 Andy Warhol Foundation for the Visual Arts/Artists Rights Society (ARS), New York. Photo: Richard Stoner
129, fig. 6	© 199 Gerard Malanga
129, fig. 7	© Bob Adelman/Magnum Photo
131	© David Gahr
132	© Stephen Shore
133	Michael Ochs Archives.com
134	© Nat Finkelstein
135	Billy Name/OvoWorks, Inc.
137	© Monty Fresco/Rex Features
140–41	© Alan Lomax Archives and The Association for Cultural Equity

Index

Page references to illustrations are in italic.

Adelman, Bob, *129*
"The Age of the World Picture"
 (Heidegger), 30, 33n17
Alberti, Leon Battista, 37
Alexis, Paul, 54
The Ambassadors (Holbein), 36
Ambulance Disaster (Warhol), *118, 147*
Andre, Carl, 31, 98
Andy, Dylan, and Double Elvis
 (Finkelstein), 134, *134*
The Animals, 132
anti-intentionalist movement, 6–7
Anti-Oedipus (Deleuze and Guattari), 41, 42
"Anyway, Anyhow, Anywhere" (The Who),
 133
Aretino, Spinello, 8
Aristotle, 3
Arnold, Jerome, *131*
Art & Language
 artists associated with, 99–100
 *Attacked by an Unknown Man in a City
 Park: A Dying Woman, Drawn and
 Painted by Mouth,* 103, *105*
 on critics, 12
 history of, 99–100, 101–2
 *Index: The Studio at 3 Wesley Place;
 Drawing (i), 102*
 *Index: The Studio at 3 Wesley Place
 Painted by Mouth I and II, 103,* 103–6
 Index 01 ("Documenta Index"), 101, 101–2,
 105, 106
 philosophy underlying, 1, 99
 *Portrait of V. I. Lenin in July 1917
 Disguised by a Wig and Working-
 man's Clothes in the Style of Jackson
 Pollock II, 103, 104*
 possibility of biography of, 19–20, 97,
 99, 100–107
Art & Language Foundation, 99
"Art and Objecthood" (Fried), 31
Art Bulletin, 15
Art-Language (journal), 99, 100
Ashes of Phocion (Poussin), 58
Ashton, Dore, 25n68
L'assommoir (Zola), 54
Atomic Bomb (Warhol), *123, 149*
*Attacked by an Unknown Man in a City
 Park: A Dying Woman, Drawn and
 Painted by Mouth* (Art & Literature),
 103, *105*
avant-garde movement
 Art-Language journal and, 99
 biography and, 25n67
 color theory, 81
 defining concepts of, 125–26
 Gauguin and, 85
 religion and, 77
 Warhol and, 127, 131

Baez, Joan, *137*
Bailey, David, 132
Baldinucci, Filippo, 8, 21n3
Baldwin, Michael, 99–100, 102, 106
Balzac, Honoré de, 50, 58
"La Bamba" (Valens), 130
Baptism of Christ (Piero della Francesca),
 16
Barthes, Roland, 2–3, 18, 28–29
Bastian, Heiner, 141–42
Bathers at Rest (Cézanne), 54
Baudelaire, Charles, 34–35, 36
Baxandall, Michael, 16, 23n38, 27n105
Beardsley, Monroe C., 6–7
The Beatles, 132
Beecher, Henry Ward, 17
Before and After [1] (Warhol), *115, 147*

Bell, Clive, 98
Bellori, Giovanni Pietro, 8, 23n42
Bembo, Pietro, 18, 38–39
Benjamin, Walter, 32, 54
Benveniste, Émile, 29–30
Bering, James M., 20n2
Bernard, Émile, 46, 51, 63, 77, 81, 92n6
"Beyond the Pleasure Principle" (Freud),
 32
Blake, William, 105
Bloomfield, Mike, 130, *131*
Blue Liz as Cleopatra (Warhol), *113*, 147
Boccaccio, Giovanni, 38
Bockris, Victor, 144n14
Bonnard, Pierre, 100
Borély, Jules, 46
Boy Bitten by a Lizard (Caravaggio), 9
Bringing It All Back Home (Dylan), 133, 136
Buonarroti, Michelangelo
 on art, 21n3, 37
 on identity and self, 39–40
 influence of, 39
 The Last Judgment, 40
 Panofsky on, 11
 Pietà, 40
Burckhardt, Jacob, 18, 36, 40, 41
Burke, Seán, 7, 23n37
The Byrds, 132

Cabaner, Ernest, 54
Cadava, Eduardo, 28
Cage, John, 142n3
Cagney (Warhol), *119, 148
Camoin, Charles, 46
Camus, Albert, 32
Caravaggio
 Boy Bitten by a Lizard, 9
 Caravaggio: The Final Years exhibition,
 9
 David with the Head of Goliath, 9
 and relevance of biography, 1, 8–9,
 23n42, 24n45, 24n47
Caravaggio: The Final Years (National
 Gallery exhibition), 9
Carlyle, Thomas, 5
Castagnary, Jules, 51
Castagno, Andrea del, 8
"La cathédrale engloutie" (Debussy), 77
Cézanne, Paul
 Aix and, 56
 Bathers at Rest (Cézanne), 54
 characteristics of, 1, 19
 childlikeness in, 51–56
 concept of self, 45–56, 58–67
 The Eternal Feminine, 61
 influence of, 47
 Madame Cézanne in a Red Armchair,
 52, *53*
 "Mes confidences," 69n32
 Montagne Sainte-Victoire, 57, *57,* 58, 63
 Portrait of the Painter Achille Emperaire,
 47, *49*

 as primitive, 45–46, 47, 51–52, 67
 relevance of biography in, 25n67
 as seer, 57–58
 Self-Portrait ca. 1866, 63, *64*
 Self-Portrait ca. 1873–76, 63, *65*
 selves of, 19, 59, 62
 Still Life: Green Pot and Pewter Jug, 50
 style development in, 66
 subjectivity and, 41
 temperament and, 46–51, 58–59, 66
 Zola and, 19, 52, 54–56, *55,* 57, 59, 61, 63,
 67, 68n14, 75n136
Chevreul, Michel-Eugène, 81
Christie, J. R. R., 12, 13
Cicero, 38
Cioffi, Frank, 22n24
Clapton, Eric, 132
Le coeur et l'esprit (Geffroy), 72n96
College Art Association, 15
Collingwood, R. G., 16
conceptual art movement, 99, 106
Conil, Paule, 60
Cooper, Michael, 132
Corbin, Alain, 77
Coste, Numa, 56, 57, 62
Courbet, Gustave, 16–17, 35, 61, 102
 Painter's Studio, 102
 Still Life with Apples and a Pomegranate,
 16–17
 The Stone-breakers, 61
Cresap, Kelly M., 144n14
Crow, Thomas, 17, 20, 27n111, 27n112, 108

Dance Diagram *(Fox Trot)* (Warhol),
 116, 147
Dancestep (Two Feet) (Warhol), *128*
Danto, Arthur, 26n91
David with the Head of Goliath
 (Caravaggio), 9
da Vinci, Leonardo
 on art, 18–19, 37–38, 39
 characteristics of, 1
 influence of, 39
"The Death of the Author" (Barthes), 28
Debussy, Claude, 77
deconstructionism, 3, 7
Delacroix, Eugène, 34, 36
Deleuze, Gilles, 41, 52
de Man, Paul, 3, 32
Denis, Maurice, 77
Derrida, Jacques, 7, 32n12
Descartes, René, 73n106
"Desolation Row" (Dylan), 136
Documenta, 1972, 99, 101, 102, 105
Documenta, 1982, 102–3
Do It Yourself (Landscape) (Warhol), *116,* 147
Double Mona Lisa (Warhol), *112,* 146
Dupanloup, Félix-Antoine-Philibert, 86,
 94n20, 95n22
Duranty, Louis-Edmond, 46, 59, 63, 66
Dürer, Albrecht, 11, 36, 37, 42n14
Duveen, Joseph, 9

Dylan, Bob, *131, 134, 135, 137*
 allegory and, 20, 140–42
 on art, 134
 Bringing It All Back Home, 133, 136
 career evolution, 131–32, 133–34, 136–37,
 137–38, 142, 144n17
 "Desolation Row," 136
 on folk/traditional music, 138–39,
 140–41
 Forest Hills concert, 138
 Highway 61 Revisited, 136, 137–38
 "Just Like a Woman," 131
 "Leopard-Skin Pill-Box Hat," 131
 "Like a Rolling Stone," 129, 131, 134, 136,
 139, 143n10, 143n11, 143n14
 "Masters of War," 145n36
 musical roots of, 138–39, 140–42
 Sedgwick and, 130–31, 136, 143n14
 and sense of self, 140
 Tarantula, 133
 Warhol and, 129–37, 141, 144n14

Edmiston, Susan, 138
Eisler, Colin, 9, 13–14
Elias, Norbert, 40
Eliot, T. S., 5, 7, 9, 17, 22n17
Elvis (Warhol), *120, 134,* 134–35, 136, 148
Elvis Presley (Gold Boot) (Warhol), *127*
Émile; ou, De l'éducation (Rousseau), 52
Emperaire, Achille, 47, *49,* 50
L'enfant (Gasquet), 56
Ephron, Nora, 138
Erasmus, 39
The Eternal Feminine (Cézanne), 61
Eve (Gauguin), *87,* 87–88
L'événement (newspaper), 47, 68n14
Exploding Plastic Inevitable, 108

The Factory, 127, 129, *129,* 130, 131, 134–36,
 135, 136, 144n26
Faithfull, Marianne, 132
Felman, Shoshana, 32
feminist criticism, 14–15, 26n90
Finkelstein, Nat, 134, *134*
Fletcher, Angus, 125
Flowers (Warhol), *123,* 149
Foot and Tire (Warhol), *128*
Forest Hills concert (Dylan), 138
formalism, 6
Foucault, Michel
 on individualism, 40, 76–77
 on life and work, 7, 18, 29–30
 life and work of, 3, 4
Four Marions (Warhol), *120,* 148
The Fox (journal), 99
Fraser, Robert, 132
Fresco, Monty, *137*
Freud, Lucian, 17
Freud, Sigmund, 21n8, 32
Fried, Michael, 31
Friedlaender, Walter, 9
"From Work to Text" (Barthes), 28

Funeral of Phocion (Poussin), 57

Gahr, David, 131
Gangster Funeral (Warhol), *121,* 148
Gasquet, Joachim, 46, 50, 52, 56, 59, 60
Gauguin, Paul
 characteristics of, 85, 88
 dialectic of sexuality and suffering in,
 87–88, 88–91
 education of, 19, 78, 85–88, 89
 Eve, 87, 87–88
 *The Grape Harvest at Arles: Human
 Misery,* 88–91, *89*
 Lust, 85
 misères humaines series, 87–88, *89*
 religion and, 19, 85–88, *89,* 94n15
 Schuffenecker portrait of, *84,* 85
 Splendor and Misery, 89–91
 and symbolist movement, 85, 94n15
 technique, 88, 91, 96n27
 van Gogh and, 85, 87, 88–92, 92n6
 *The Vision of the Sermon: Jacob
 Wrestling with the Angel,* 87, 89,
 94n15, 96n27
 *Where Do We Come From? What Are We?
 Where Are We Going? 86,* 87
 The Yellow Christ, 88, 96n27
Geffroy, Gustave, 58, 72n96
Genestet, Petrus Augustus de, 93n14
Gibson, Ralph, 77
Gilmore, Mikal, 145n43
Ginsberg, Allen, 132
Ginzburg, Carlo, 11
Gleason, Ralph J., 145n31
Godeau, Abigail Solomon, 14
Gold Jackie (Warhol), *111,* 146
Gold Marilyn (Warhol), *112,* 146
Gold Marilyn Monroe (Warhol), *110,* 146
Gombrich, E. H., 9, 11
Goncourt, Edmond-Louis-Antoine, 50–51,
 58
Goncourt, Jules-Alfred, 50–51, 58
The Grape Harvest at Arles: Human Misery
 (Gauguin), 88–91, *89*
Green, Nicholas, 13
Green, Sam, 136
Greenberg, Clement, 6
Greenblatt, Stephen, 36
Green Disaster 10 Times (Warhol), *117,* 147
Grossman, Albert, 144n26
Grossman, Sally, 144n26
Guattari, Félix, 41, 52
Guillaumin, Armand, 63
Guys, Constantin, 36

Hacking, Ian, 32
Hammerstein, Oscar II, 45
Harris, Ruth, 77
Harrison, Charles, 16–17, 19–20, 97
Hegel, G. W. F., 76
Heidegger, Martin
 Gestell and *Gestalt* in, 18, 30–31, 33n17

influence of, 32n12
life and work of, 3–4
Heller, Reinhold, 96n27
Hibbard, Howard, 9
Highway 61 Revisited (Dylan), 136, 137–38
Hirsch, E. D., 7, 14
Histoire de la peinture en Italie (Stendhal), 50, 51
historicism, of Foucault, 76–77
Holbein, Hans, the Younger, 11, 36
Holly, Buddy, 143n11
Horace, 56

Il y a une volupté dans la douleur (Gasquet), 56
Index: The Studio at 3 Wesley Place; Drawing (i), 102
Index: The Studio at 3 Wesley Place Painted by Mouth I and II (Art & Language), *103*, 103–6
Index 01 ("Documenta Index") (Art & Language), *101*, 101–2, 105, 106
Institut für soziale Gegenwartsfragen, 100
"The Intentional Fallacy" (Wimsatt and Beardsley), 6–7

Jackson Pollock Bar, 100
Jacques Vingtrasè: L'enfant (Vallès), 52–54
Jacquette, Dale, 26n102
Johns, Jasper, 12
Johnson, Samuel, 4–5
Judd, Donald, 31
"Just Like a Woman" (Dylan), 131

Kahn, Gustave, 85
Kant, Immanuel, 4
Das Kapital (Marx), 14
Keats, John, 139
Kemp, Martin, 23n38, 27n105
Kiss (Warhol), *viii, 124,* 149
Klinger, Linda, 15
Koerner, Joseph, 36, 37, 42n14
Kooper, Al, 130, *131,* 143n12
Krauss, Michael, 4
Krauss, Rosalind, 3, 11–13, 14, 18, 28
Kubler, George, 10

The Last Judgment (Michelangelo), 40
Lavin, Irving, 15
Lee, C. P., 143n14
"Leopard-Skin Pill-Box Hat" (Dylan), 131
Levine, Sherrie, 14
Lewis, C. S., 5
Lewis, Mathilda, 50, 60, 71n65
"Like a Rolling Stone" (Dylan), 129, 131, 134, 136, 139, 143n10, 143n11, 143n14
Little Electric Chair (Warhol), *122,* 136, 149
Liz #3 (Warhol), *110,* 146
Lomax, Alan, *140, 141,* 145n43
Lukács, Georg, 54–56
Lumpkin, Libby, 15–16

Luncheon on the Grass (Manet), 35
Lust (Gauguin), 85

Madame Cézanne in a Red Armchair (Cézanne), 52, *53*
Madame Meuriot (Alexis), 54
Malanga, Gerard, *129, 132*
Manet, Éduoard, 34, 35–36, 69n29, 105
Manette Salomon (Goncourt and Goncourt), 50–51, 54, 70n43
Marcus, Greil, 142
Margaret Rutherford (Warhol), *127*
Marilyn Diptych (Warhol), *111,* 146
Marion, Fortuné, 66
Le martyre de Saint-Sébastien (Debussy), 77
Marx, Karl, 14, 21n8
Marx, Roger, 58
Marxist criticism, 14, 60, 67
"Masters of War" (Dylan), 145n36
Matisse, Henri, 6
McEvilley, Thomas, 3
Melody Maker (periodical), 133
Merleau-Ponty, Maurice, 18
"Mes confidences" (Cézanne), 69n32
Meurend, Victorine, 105
Michelangelo. *See* Buonarroti, Michelangelo
Mint Marilyn (Warhol), *124,* 149
Mirbeau, Octave, 78
"Misères de la vie présente" (Dupanloup), 86, 89, 95n22
misères humaines series (Gauguin), 87–88, 89
modernism
and autonomy, 6
religion and, 77
and subjectivity, 41
"Moïse" (Vigny), 58
MOMA, Picasso retrospective (1980), 14
Monet, Claude, 41, 47
Mon salon (Zola), 47, *48,* 68n14
Montagne Sainte-Victoire (Cézanne), 57, *57,* 58, 63
Monticelli, Adolphe Joseph Thomas, 88
Moon, Keith, 133, *133*
Morice, Charles, 78
Morris, Robert, 31
Morstatt, Heinrich, 66
Moses (prophet), 58, 63

Name, Billy, *135,* 144n26
Nana (Zola), 61
National Gallery (London), *Caravaggio: The Final Years* exhibition, 9
Nehamas, Alexander, 4
Neuwirth, Bob, 130–31
New Criticism, 6–7, 21n8
New Historicism, 18, 36–37, 41
Newman, Barnett, 6
Newport Folk Festival, *131*
New York Times, 141

Nietzsche, Friedrich, 4
"Nottamun Town" (anonymous), 138

L'oeuvre (Zola), 47
Olympia (Manet), 105
100 Cans (Warhol), *114,* 147
The Order of Things (Foucault), 29
Origen, 21n5
Orton, Fred, 12, 13

Painter's Studio (Courbet), 102
Panofsky, Erwin, 11
Patterns of Intention (Baxandall), 16
Paul (apostle), 2
"Le peintre Marsabiel" (Duranty), 46
Perugino, 39
Peruvian mummy, 89, *90*
Petrarch, Francesco, 38
Phillips, Peter, 133
Philosophie de l'art (Zola), 50
Phocion, 57, 58, 63
Picasso, Pablo, 13
Pico della Mirandola, Giovanni Francesco,
 18, 38–39
Piero della Francesca, 16
Pierson, Allard, 83
Pietà (Michelangelo), 40
Pissarro, Camille
 Cézanne and, 51, 52, 63, 66
 on Gauguin, 85, 94n19
Playboy magazine, 138–39
Plimpton, George, 129
Plutarch, 57
Pollack, Jackson, 6
Pollock, Griselda, 14–15
Popper, Karl, 16
Portrait of the Painter Achille Emperaire
 (Cézanne), 47, *49*
*Portrait of V. I. Lenin in July 1917 Disguised
 by a Wig and Workingman's Clothes
 in the Style of Jackson Pollock II* (Art
 & Language), 103, *104*
Posner, Donald, 9
Postel, Danny, 4
postmodernism, 15, 26n90
post-structuralism
 on life and work, 13, 16, 18, 30, 60
 New Historicism and, 36
Poussin, Nicolas, 57, 58, 59
La proie et l'ombre (Roux), 47, 50, 59, 66,
 69n31
psychoanalytic criticism, 15, 60

"The Question Concerning Technology"
 (Heidegger), 30

Race Riot (Warhol), *118,* 136, 148
Ramsden, Mel, 99–100, 106
Raphael, 37, 39
Rauschenberg, Robert, 43n31
Red on Maroon (Rothko), 12

The Red Vineyard at Arles (van Gogh),
 91, 92
Renan, Joseph-Ernest, 77–78, 86
Le rêve (Zola), 77
Rewriting the Soul (Hacking), 32
Riddle, Almeda, *140*
Rifkin, Adrian, 27n105
Rimbaud, Arthur, 41, 62
Ritchie, Jean, 145n36
Rivière, R. P., 46
Rodin, Auguste, 77
Rolling Stone magazine, 145n43
The Rolling Stones, 132
romanticism, 8–9
Rosenberg, Harold, 11–12
Rothko, Mark, 1, 11–12, 25n68
Rousseau, Jean-Jacques, 52
Roux, Marius, 19, 47, 50, 59, 63, 66, 69n31
Rowland, Ingrid, 9
Rubin, Barbara, 144n26
Rubin, William, 14
Ruskin, John, 8–9

Satan Smiting Job with Sore Boils (Blake),
 105
Satie, Eric, 142n3
Saxl, Fritz, 11
Schier, Flint, 62
Schnerb, Jacques, 46
School for Scandal, 127
Schuffenecker, Emile, *84,* 85, 89
Sedgwick, Edie
 Dylan and, 130–31, 136, 143n14
 Warhol and, 127–32, *129, 132,* 136, 143n14
Self-Portrait (Dürer), 36, 37, 42n14
Self-Portrait ca. 1866 (Cézanne), 63, *64*
Self-Portrait ca. 1873–76 (Cézanne), 63, *65*
"Le sentiment de l'impossible" (Geffroy),
 58
Shakespeare, William, 139
Shelton, Robert, 136
Shiff, Richard, 61–62
Shore, Stephen, *132*
Siegel, Marc, 108–9
Silver, Kenneth E., 92n5
Silverman, Debora, 2, 19, 76
Single Elvis [Ferus Type] (Warhol), *120,* 148
Sluga, Hans, 63
Smith, Hobart, *141*
Smith, Paul, 25n67
Smithson, Robert, 31
Sohm, Philip, 8
Solari, Philippe, 60
Sonnabend, Ileana, 132
Soussloff, Catherine, 15
Sower with Setting Sun (van Gogh), 79, *79*
Spear, Richard, 24n48
Spector, Jack, 15
Splendor and Misery (Gauguin), 89–91
Springsteen, Bruce, 140, 143n10
Stallman, R. W., 6–7

Stanley, Liz, 26n90
Stein, Jean, 129
Stein, Leonard, 108
Steinberg, Leo, 43n31
Stendhal, 50–51, 67, 69n32
Still Life: Green Pot and Pewter Jug
 (Cézanne), 50
Still Life with Apples and a Pomegranate
 (Courbet), 16–17
Stock (caricaturist), 47, 50, 59, 63, 66
Stokes, Adrian, 61–62, 66
The Stone-breakers (Courbet), 61
Strabo, 4
Stricker, Jan, 93n10
"Substitute/Instant Party" (The Who), 133
Suicide (Fallen Body) (Warhol), *122,* 148
Suicide (Purple Jumping Man) (Warhol),
 121, 148
Summers, David, 6
Superstars, 127, 131, 136
Surrealism, 41
symbolist movement, self and, 85
S/Z (Barthes), 2–3, 28

Taine, Hippolyte-Adolphe, 35, 50, 51–52
Tarantula (Dylan), 133
Testimony (Felman and Laub), 32
Theater of Eternal Music, 108
Theory of Literature (Wellek and Warren),
 5–6
Thirteen Most Wanted Men (Warhol), *119,*
 148
Thomas, Greg M., 10, 21n4, 25n67
Thomson, James, 4
Tillyard, E. M. W., 5
Townshend, Pete, 133, *133,* 144n20
Trio for Strings (Young), 108
Triple Rauschenberg (Warhol), *113,* 147
Tunafish Disaster (Warhol), *115,* 147
Twenty Jackies (Warhol), *121,* 148

"The Unknown Masterpiece" (Balzac), 50
Untitled (Golden Boy) (Warhol), *126*

Valens, Ritchie, 130, 143n11
Vallès, Jules, 52–54
van Gogh, Anna, 83
van Gogh, Theo, 92n6
van Gogh, Theodorus, 82, 93n10
van Gogh, Vincent
 characteristics of, 1, 79–81, 88–89, 92
 conception of self, 83–85
 cultural formation, 19, 82–85
 Gauguin and, 85, 87, 88–92, 92n6
 identification with craft labor, 19,
 79–82, *80, 81, 82,* 85, 88, 92
 on inner thoughts, 76
 on life, 76
 The Red Vineyard at Arles, 91, 92
 religion and, 19, 82–85, 88, 93n10
 Sower with Setting Sun, 79, 79

technique, 19, 79–81, 88
Wheatfield with Rising Sun, 78
van Gogh, Vincent (grandfather), 82, 93n10
*Van Gogh and Gauguin: The Search for
 Sacred Art* (Silverman), 19, 78–79, 81
van Rappard, Anthon, 92n6
Vasari, Giorgio
 Baxandall on, 16
 on divinity of artists, 37
 on life and work, 8, 21n3, 21n4
 on Raphael, 39
Velázquez, Diego, 11, 17
Velvet Underground, 108
Vexations (Satie), 142n3
Vigny, Alfred de, 58
Villard, Nina de, 54
Virgil, 38, 56
*The Vision of the Sermon: Jacob Wrestling
 with the Angel* (Gauguin), 87, 89,
 94n15, 96n27
*Le vite de piu eccellenti architetti, pittori, et
 scultori* (Vasari), 8
Vollard, Ambroise, 47, 58, 63
"Les vrais primitifs" (Geffroy), 58
Vuillard, Édouard, 78

Walter, James, 21n8
Warburg, Aby, 9–11
Warhol, Andy, *129, 132,* 134
 allegory and, 20, 125–29, 139–40, 141–42
 Ambulance Disaster, 118, 147
 Atomic Bomb, 123, 149
 Before and After [1], 115, 147
 biography encoded across works,
 109–25
 Blue Liz as Cleopatra, 113, 147
 Cagney, 119, 148
 and concept of self, 1, 20, 108, 125–26,
 139–40
 Dance Diagram (Fox Trot), 116, 147
 Dancestep (Two Feet), 128
 Do It Yourself (Landscape), 116, 147
 Double Mona Lisa, 112, 146
 Dylan and, 129–37, 141, 144n14
 Elvis, 120, 134, 134–35, 136, 148
 Elvis Presley (Gold Boot), 127
 The Factory and, 127, 129, *129,* 130, 131,
 134–36, *135,* 136, 144n26
 Flowers, 123, 149
 Foot and Tire, 128
 Four Marions, 120, 148
 Gangster Funeral, 121, 148
 Gold Jackie, 111, 146
 Gold Marilyn, 112, 146
 Gold Marilyn Monroe, 110, 146
 Green Disaster 10 Times, 117, 147
 Kiss, viii, 124, 149
 Little Electric Chair, 122, 136, 149
 Liz #3, 110, 146
 Margaret Rutherford, 127
 Marilyn Diptych, 111, 146

Mint Marilyn, 124, 149
100 Cans, 114, 147
Race Riot, 118, 136, 148
relevance of biography to, 108–9
Sedgwick and, 127–32, *129, 132,* 136,
 143n14
Single Elvis [Ferus Type], 120, 148
Suicide (Fallen Body), 122, 148
Suicide (Purple Jumping Man), 121, 148
Thirteen Most Wanted Men, 119, 148
Triple Rauschenberg, 113, 147
Tunafish Disaster, 115, 147
Twenty Jackies, 121, 148
Untitled (Golden Boy), 126
Where Is Your Rupture? 114, 147
White Burning Car III, 117, 147
Warren, Austin, 5–6
Weber, Max, 40
Wein, Chuck, 132
Wellek, René, 5–6
"What Is an Author?" (Foucault), 29–30
Wheatfield with Rising Sun (van Gogh), *78*
Where Do We Come From? What Are We?
 Where Are We Going? (Gauguin),
 86, 87
Where Is Your Rupture? (Warhol), *114,* 147
White Burning Car III (Warhol), *117,* 147
The Who, 133, *133*
Wiles, Robert, *122,* 148
Williams, Robert, 18–19, 34
Wimsatt, William K., Jr., 6–7
Wittgenstein, Ludwig, 45, 52, 60, 61, 62
Wittkower, Rudolf, 9, 24n47
Wollheim, Richard, 12, 62
Wordsworth, William, 5

The Yellow Christ (Gauguin), 88, 96n27
Young, Ed, *141*
Young, La Monte, 108, 142n3

Zappa, Frank, 143n10
Zarzeela, Marian, 108
Zola, Émile
L'assommoir, 54
Cézanne and, 19, 52, 54–56, *55,* 57, 59, 61,
 63, 67, 68n14, 75n136
influences on, 50
on Manet, 34, 35–36, 69n29
on meaning in art, 1, 18, 34–36, 41
Mon salon, 47, 48, 68n14
Nana, 61
L'oeuvre, 47
Philosophie de l'art, 50
religion and, 77
Le rêve, 77
on temperament, 47

Other books based on the events and programs of the Getty Research Institute

In Print

Rethinking Boucher
Edited by Melissa Hyde and Mark Ledbury
ISBN 978-0-89236-825-9 (paper)

*Late Thoughts: Reflections on Artists and
Composers at Work*
Edited by Karen Painter and Thomas Crow
ISBN 978-0-89236-813-6 (paper)

Seeing Rothko
Edited by Glenn Phillips and Thomas Crow
ISBN 978-0-89236-734-4 (paper)

Situating El Lissitzky: Vitebsk, Berlin, Moscow
Edited by Nancy Perloff and Brian Reed
ISBN 978-0-89236-677-4 (paper)

Representing the Passions: Histories, Bodies, Visions
Edited by Richard Meyer
ISBN 978-0-89236-676-7 (paper)

*Claiming the Stones/Naming the Bones: Cultural Property
and the Negotiation of National and Ethnic Identity*
Edited by Elazar Barkan and Ronald Bush
ISBN 978-0-89236-673-6 (paper)

The Archaeology of Colonialism
Edited by Claire L. Lyons and John K. Papadopoulos
ISBN 978-0-89236-635-4 (paper)

*Looking for Los Angeles: Architecture, Film, Photography,
and the Urban Landscape*
Edited by Charles G. Salas and Michael S. Roth
ISBN 978-0-89236-616-3 (paper)

*Disturbing Remains: Memory, History, and Crisis
in the Twentieth Century*
Edited by Michael S. Roth and Charles G. Salas
ISBN 978-0-89236-538-8 (paper)

Nietzsche and "An Architecture of Our Minds"
Edited by Alexandre Kostka and Irving Wohlfarth
ISBN 978-0-89236-485-5 (paper)

*Dosso's Fate: Painting and Court Culture
in Renaissance Italy*
Edited by Luisa Ciammitti, Steven F. Ostrow, and
Salvatore Settis
ISBN 978-0-89236-505-0 (paper)

*Censorship and Silencing: Practices of Cultural
Regulation*
Edited by Robert C. Post
ISBN 978-0-89236-484-8 (paper)

Otto Wagner: Reflections on the Raiment of Modernity
Edited by Harry Francis Mallgrave
ISBN 978-0-89236-258-5 (hardcover),
ISBN 978-0-89236-257-8 (paper)

*American Icons: Transatlantic Perspectives on Eighteenth-
and Nineteenth-Century American Art*
Edited by Thomas W. Gaehtgens and Heinz Ickstadt
ISBN 978-0-89236-246-2 (hardcover),
ISBN 978-0-89236-247-9 (paper)

*Art in History/History in Art: Studies in Seventeenth-Century
Dutch Culture*
Edited by David Freedberg and Jan de Vries
ISBN 978-0-89236-201-1 (hardcover),
ISBN 978-0-89236-200-4 (paper)

In Preparation

*Waxing Bodies: The Mimetic Power of Wax Sculpture from
Portraiture to Anatomical Fragments*
Edited by Roberta Panzanelli
ISBN 978-0-89236-877-8

Harry Smith: The Avant-Garde in the American Vernacular
Edited by Robert Cantwell, Andrew Perchuk, and
Rani Singh
ISBN 978-0-89236-735-1 (paper)

Designed by Catherine Lorenz

Production coordinated by Suzanne Watson

Type composed by Diane Franco in Veljovic and Interstate

Printed in China through Asia Pacific Offset, Inc., on Gold East Matte